The iPad
FOR PHOTOGRAPHERS
THIRD EDITION

Master the Newest Tool in Your Camera Bag

JEFF CARLSON

PEACHPIT PRESS

The iPad for Photographers:
Master the Newest Tool in Your Camera Bag, Third Edition

Jeff Carlson

Peachpit Press
www.peachpit.com

To report errors, please send a note to errata@peachpit.com
Peachpit Press is a division of Pearson Education

Copyright © 2014 by Jeff Carlson

Senior Editor: Susan Rimerman
Production Editor: Tracey Croom
Copyeditor/Proofreader: Scout Festa
Indexer: Karin Arrigoni
Composition: Jeff Carlson
Cover Design: Mimi Heft
Interior Design: Mimi Heft
Cover Image: Jeff Carlson

ISBN 13: 978-0-133-88847-8
ISBN 10: 0-133-88847-9

9 8 7 6 5 5 4 3 2 1
Printed and bound in the United States of America

For Steve. Thank you.

Acknowledgments

It's fabulous to experience a whisper of an idea turn into a completed book, but without the encouragement and assistance of many people, that whisper could easily have dissipated into the ether. I owe a lot of gratitude, and no doubt coffees or martinis (or both) to the following good folks.

Susan Rimerman, Ted Waitt, Cliff Colby, Nancy Aldrich-Ruenzel, Nancy Davis, Scott Cowlin, Sara Jane Todd, and everyone else at Peachpit Press who encouraged this project and made it happen.

Mimi Heft designed the book and provided first-class templates in which I could work. Unlike many authors, I write directly into the book's layout using Adobe InDesign, so working in a template that's properly styled and professionally designed is a privilege.

My editing and production team, led by Susan Rimerman, made all the practicalities happen: Scout Festa made me wish I could write as fast and as sharp as she's able to copyedit my text; Karin Arrigoni managed the crush at the end of the project to produce a top-rate index; and Tracey Croom put her production talents to good use shepherding the laid-out files and keeping my work on the up-and-up.

Chris Morse and Chris Horne gave me access to pre-release versions of their app Photosmith in previous editions, and Brian Gerfort helped me better understand the underpinnings of how iOS works with images.

Glenn Fleishman helped maintain my link to the outside world as virtual officemate—and occasional in-person lunch or coffee companion—and patiently listened to my laments and successes.

Dana and David Bos granted permission for me to use photos I've shot of their daughter, Ainsley.

Jackie Baisa contributed advice and insight into professional workflows.

Peter Loh provided invaluable photo studio equipment.

Tor Bjorklund donated the wood used in many of the studio photos.

Mason Marsh helped with information about using Wi-Fi–equipped cameras.

Kim Carlson served as a fantastic photographer's assistant and propmaster, but most importantly kept me sane and supported this project from my first inkling of an idea.

And Ellie Carlson continues to serve as a great model and a good sport when I turn the camera on her. She'll thank me when she's older. Right?

Contents

Introduction. xiii

 Can You Really Leave the Laptop Behind? xiii

 Which iPad Should You Use?. xiv

 What's New in the Third Edition xv

 Notes About This Book . xvii

CHAPTER 1 **Capture Photos with the iPad** **3**

 Shoot with the Camera App. 4

 Shoot with Advanced Apps .5

 Set Focus and Exposure 6

 Filters and Editing in Camera Apps 7

 Time Your Shots. 7

 Shoot HDR Photos . 8

 Create a Panorama . 9

CHAPTER 2 **Build an iPad Photo Workflow** **11**

 Raw vs. JPEG. 12

 Shoot JPEG . 13

 Shoot Raw . 14

 Shoot Raw+JPEG . 16

CHAPTER 3 **The iPad on Location** **21**

 Prepare for a Photo Shoot . 22

 Find Photo Locations. 22

 Use GPS to Mark Locations to Revisit 23

 Keep Reference Materials Ready. 23

 Review Photos in the Field . 24

 Import Using the iPad Camera Adapters 24

 Import from a memory card or camera 25

 The Secretly Versatile iPad USB Camera Adapter. 28

 What About Importing from
 CompactFlash (CF) Cards? 28

 Import from an iPhone. 29

 Import Wirelessly from the Camera. 30

Shoot and import wirelessly using ShutterSnitch 31

ShutterSnitch as Photographer's Assistant *32*

Import wirelessly from another iOS device 33

Record Location Information . 34

Record Location Using Geotag Photos Pro 34

Record Location Using GeoSnitch 35

Record Reference Photos Using the iPad 36

Back Up Your Photos . 36

iCloud Photo Stream . 38

Other Cloud Services . 40

Automatic photo uploads . 40

Manual photo uploads . 41

Portable Storage . 42

Dedicated media storage devices 42

Seagate Wireless Plus . 42

Kingston MobileLite Wireless 43

CHAPTER 4 **The iPad in the Studio** 45

Control a Camera from the iPad 46

Tethered Shooting Using Capture Pilot HD 46

Wireless Remote Control Devices 46

Compose and shoot . 47

Use Live View . 49

Use bracketing/HDR . 50

Shoot at specified intervals . 51

Triggertrap . 52

Control a Wireless Camera . 53

Control Another iOS Device . 53

Make a Stop-Motion or Time-Lapse Video 54

Create a Stop-Motion Video in iStopMotion 54

Create a Time-Lapse Video in iStopMotion 56

Mount the iPad . 57

Tether Tools Wallee System . 57

The Stump . 58

Extend Your Computer Desktop with Air Display *59*

CHAPTER 5 **Rate and Tag Photos** 61

Rate and Tag Using Photosmith . 62
 Import Photos . 62
 Importing from ShutterSnitch into Photosmith. 63
 Rate Photos . 64
 Rate multiple photos simultaneously 65
 Assign Keywords . 66
 Create or assign keywords. 66
 Build keyword hierarchies . 67
 Remove keywords. 67
 Edit Metadata . 68
 Create metadata presets . 68
 Filter Photos. 70
 Filter by metadata . 70
 Change the sort order and criteria 71
 Filter using Smart Groups . 71
 Group Photos into Collections 73
 Sync with Photoshop Lightroom 74
 Set up the Photosmith publish service. 74
 Sync photos. 75
 Apply Develop settings . 76
 Apply a metadata preset . 76
 Sync keywords. 76
 Sync photos from Lightroom to Photosmith 77
 Export to Photosmith. 78
 Export to Other Destinations. 78
 Dropbox . 78
 XMP Export . 79
 PhotoCopy . 80
 Delete Photos . 80
 The Proxy JPEG Workflow . *80*

Rate and Tag Using PhotosInfoPro.81
 Import Photos . 81
 Rate a Photo . 81

Add Metadata to a Photo . 82
Add Metadata to Multiple Photos 83
Export Metadata . 84
Rate and Tag Using Editing Apps .85
Rate Photos . 85
Add IPTC Information . 86
Create and use IPTC sets .86
Export IPTC Information . 87
Sync and Flag Photos in Adobe Lightroom mobile 88
Create and Sync Collections . 88
Add photos to a collection .90
Remove photos from a collection91
Remove a Collection from Lightroom mobile 91
Flag Photos as Picks or Rejects 92
Review and Rate in PhotoScope 93

CHAPTER 6 Edit Photos on the iPad 95
Make Photo Adjustments . 96
Edit Photos in the Photos App .97
An Important Note About Color Management 98
Edit Photos in Snapseed . 99
Recompose . 99
Adjust Tone and Color . 100
Adjust Specific Areas . 101
Apply Creative Presets . 103
Edit Photos in Photogene . 104
Recompose . 104
Adjust Tone and Color . 105
Adjust brightness and contrast 105
Adjust color cast .108
Adjust white balance .108
Adjust saturation and vibrance 108
Apply Selective Edits . 109
Apply Creative Presets . 110

Edit Photos in iPhoto . 111
 Recompose . 112
 Straighten the image . 112
 Crop the frame . 113
 Adjust Exposure and Color 114
 Brightness and contrast . 114
 Color . 115
 Adjust Specific Areas . 116
 Apply Creative Effects . 117
Edit Photos in Adobe Lightroom mobile 119
 Recompose . 119
 How Lightroom mobile Syncing Works *120*
 Adjust Tone and Color . 121
 White Balance, Temperature, and Tint 121
 Exposure . 122
 Contrast and Clarity . 123
 Saturation and Vibrance . 124
 The Helpful Histogram . *124*
 Apply Presets . 125
 Apply Previous Edits . 125
 Reset Adjustments . 126
 Lightroom mobile's Offline Editing Mode *126*
Edit Raw Files Directly . 127
Retouch Photos . 128
 Photogene . 128
 Handy Photo . 129

CHAPTER 7 **Edit Video on the iPad** **133**
Work with Projects in iMovie for iOS 134
 Open an Existing Project . 134
 Apply a Fade In or Fade Out to the Movie 135
Add Video to a Project . 136
 Add Clips from the Media Library 136
 Capture Video Directly . 137

Import from an iPhone or iPod touch 137

Edit Video . 138

Play and Skim Video . 138

Edit Clips . 139

Move a clip on the timeline . 139

Trim a clip . 139

Split a clip . 140

Delete a clip . 140

Use the Precision Editor . 141

Edit Transitions . 142

Add a Title . 142

Add a title to just a portion of a clip 143

Specify a Location . 144

Add and Edit Photos . 145

Edit the Ken Burns Effect . 146

Disable the Ken Burns effect 147

Edit Audio . 148

Change a Clip's Volume Level 148

Add Background Music . 149

Add automatic theme music 149

Add a background music clip 149

Add a Sound Effect . 151

Move audio clips between
foreground and background 151

Add a Voiceover . 152

Share Projects . 153

Share to the Camera Roll . 154

Send the Project to a Device via AirDrop 154

Send the Project to a Device via iTunes 154

Export a project to iTunes . 154

Import the project into iMovie
on another iOS device . 155

CHAPTER 8 **Build an iPad Portfolio** **157**

5 Steps to Create a Great Portfolio 158
 iPad or iPad mini for Portfolios? *159*
Prepare Images for the Portfolio 160
 Adobe Photoshop Lightroom . 161
 Apple Aperture . 162
 Adobe Photoshop . 163
 Create an action .163
 Batch-process files .164
 Adobe Photoshop Elements . 165
 Apple iPhoto . 166
Create Your Portfolio. .167
 Using the Built-in Photos App. 167
 Create and Populate Galleries. 168
 Add Photos to a Gallery . 168
 Load from iPad media .169
 Load from iTunes .170
 Load from Dropbox or Box .171
 Edit a Gallery. 172
 Reorder images. .172
 Choose a gallery thumbnail.173
 Customize the Opening Screen. 174
Present Your Portfolio. .175
 Rate and Make Notes on Photos in Portfolio for iPad . . 175
 Present on the iPad . 176
 Present on an External Display 176
 Wired .176
 Wireless .179

CHAPTER 9 **Share Photos** **181**

Upload Images to Photo-Sharing Services 182
 Upload from Editing Apps. 182
 Upload from Snapseed .182

Upload from Photogene . 183
Share to the Web from Lightroom mobile. 184
To Watermark or Not? . 185
iCloud Photo Stream . 186
Upload Photos Using Services' Apps 187
Flickr. 187
Camera Awesome . 188
500px and PhotoStackr for 500px. 188

Email Photos . 189
Share a Single Photo . 189
Share Multiple Photos . 191

Share Photos Using Adobe Revel. 192
Import Photos to a Revel Library. 192
Rate and Edit Photos. 193
Collaborate with Others . 194

Print Photos from the iPad .195
Print from Nearly Any App . 196
Order Prints . 197

APPENDIX **App Reference** 199
Chapter 1: Capture Photos with the iPad 200
Chapter 3: The iPad on Location. 200
Chapter 4: The iPad in the Studio. 203
Chapter 5: Rate and Tag Photos 204
Chapter 6: Edit Photos on the iPad. 205
Chapter 7: Edit Video on the iPad 206
Chapter 8: Build an iPad Portfolio. 206
Chapter 9: Share Photos . 206

INDEX 209

Introduction

Photographers carry gear. It doesn't matter whether you're a pro with multiple camera bodies and lenses or a casual shooter with an ever-present point-and-shoot camera—there's always stuff to pack along. And if you're traveling or away from your office or studio, part of that gear typically includes a laptop for reviewing and backing up the photos you take. Too often I've heard friends who are about to go on vacation moan that they need to bring a bulky computer just to handle their digital photos.

The iPad is changing all that.

It's a fantastic device to take into the field. The iPad Air measures less than a quarter of an inch thick and weighs about 1 pound. The iPad mini is the same thickness and only three-quarters of a pound. (The iPad 2 and third- and fourth-generation iPads aren't much thicker or heavier.) With the addition of an inexpensive iPad camera adapter, you can import photos directly from a camera or memory card and view them on the iPad's high-resolution Retina color screen, revealing details that the relatively puny LCD on the back of your camera may obscure. More important, a rich array of photography apps and related products is adding to the list of things the iPad can do with those photos: rate and add keywords, perform color adjustments, retouch blemishes, and share the results online.

Oh, and don't forget everything else the iPad makes possible: browsing the Web, accessing your email, reading ebooks, playing movies and music, and, as they say, so much more.

Can You Really Leave the Laptop Behind?

Although the iPad can do a lot that you would have needed a laptop to do just a few years ago, there are still some important limitations that you should keep in mind when you decide whether a laptop stays at home.

If you're generating a significant amount of image data, storage becomes a problem. As this book goes to press, the current highest-capacity iPad holds 128 GB. You can free up some memory by removing apps, music, videos, and the like, but if you're filling multiple 16 GB or 32 GB cards

with photos, the iPad won't work as a repository of your shots. (But I detail several workarounds and workflows in Chapter 2.)

One solution is to buy a lot of memory cards and use them as you would film canisters. The originals stay on the cards, while the keepers remain on the iPad; you delete the ones you don't want as you cull through them. Fortunately, memory cards are inexpensive now. *Un*fortunately, they're small and easy to lose. Make sure you know where they are, label them accurately, and keep them protected. Most important, make sure you have some system of backing up your images; options include uploading them to online photo storage services or transferring them wirelessly to a Wi-Fi–enabled hard disk like the Seagate Wireless Plus.

If you capture raw-formatted images, you won't benefit from the same level of editing that a dedicated application on a desktop computer can offer. With a few exceptions, all image editing occurs on JPEG versions of the raw files, and exports as JPEG files (see Chapter 6 for more details).

So, to answer my question, in many circumstances yes, you can leave the laptop behind. If you're going to trek across Africa for four weeks, that's not ideal (but it is possible), but for most day trips or short vacations, the iPad makes a great companion.

Which iPad Should You Use?

If you don't already own an iPad, or you're looking to upgrade from an older model, here are some guidelines for choosing one that will be a worthwhile addition to your camera bag.

For the reasons mentioned, I recommend getting the highest-capacity iPad that's available (and that you can afford). That gives you plenty of room to store photos and apps; some image editors make a copy of a photo to work with, so you could easily fill a couple of gigabytes just editing. Plus, it's an iPad, not just an extra hard disk, so you'll want to store music, movies, books, and all sorts of other media. If you're on a budget, get at least a 32 GB capacity model—the 16 GB configureation, in my view, is now barely enough storage for general use, much less as a photo companion.

Size and weight are also extremely important factors. Until last year, you bought whatever iPad was available, because they were all mostly the same. But then Apple introduced the svelte and light iPad mini, which is really a great traveling size. The tradeoff is that the iPad mini's screen measures 7.9 inches (versus 9.7 inches for the regular iPad). The entry-level iPad mini doesn't have a high-resolution Retina display, so I'd say skip that and go for the Retina version. The size is definitely compelling, and it's fine for reviewing and editing images.

You also need to determine whether you want to buy a model that connects to the Internet via Wi-Fi only or that also connects via cellular networking. For photographic uses, cellular isn't as important, because you may burn up your data allotment quickly if you transfer images to sharing sites or to online backup sources like Dropbox. (And it's turning out that even when a cellular provider offers "unlimited" data plans, they're not really unlimited.) Depending on where you're shooting, though, cellular can be helpful for looking up locations, checking weather reports, and other on-the-spot uses. (Then again, you may already have an iPhone or other smartphone that can handle those tasks.) I find the cellular capability useful in general iPad use, but not necessarily for photo-related uses.

In terms of which iPad model to get if you don't own one yet, I'd argue for the latest model. As I write this, Apple sells the iPad Air and iPad mini with Retina displays, the iPad mini with a standard display, and the fourth-generation Retina iPad as the low-cost point of entry for the larger size.

The iPad 2, which was discontinued shortly before this book went to press, is a fine model for photographers (it's what I used to write the first edition of this book), but your investment will last longer if you buy a newer model. The original iPad will also work in some cases, but just barely—its older processor and small amount of working memory prevent it from running iOS 6, and many developers (at Apple's insistence) are starting to phase out support for older versions of the operating system.

What's New in the Third Edition

As more photographers and developers have adopted the iPad, more and better uses for it as a photo companion continue to appear. This third

edition of the book includes a host of new or changed material. Here are some highlights.

First of all, the biggest change to the iPad, apart from new hardware in the last year, has been the shift to iOS 7. All of the screenshots have been updated for apps that adopted the new iOS appearance, and I've edited the sequences dealing with Apple's Photos app, which changed in a few ways from the previous version.

When I talk to people at conferences and online, most of their questions are centered around workflow. The way the iPad handles raw files, in particular, creates interesting situations for processing photos in the field. So, I've broken the extensive workflow explanations and diagrams into their own chapter (Chapter 2).

The options for transferring photos wirelessly from the camera to the iPad continue to increase as camera manufacturers are finally starting to build wireless hardware into their products. Chapters 3 and 4 still focus on the Eyefi wireless SD cards and the CamRanger remote device, but now also include an example of controlling Wi-Fi cameras (in this case, a Fuji X-T1).

Chapter 5 still focuses on Photosmith and PhotosInfoPro for adding important metadata to photos, but I added an intriguing new app called PhotoScope, which lets you access Aperture and iPhoto libraries live when your iPad is on the same network.

The biggest addition to the book is Adobe Lightroom mobile, which I detail in Chapters 5 and 6. This app, which is free for people who subscribe to one of Adobe's Creative Cloud subscription plans, really is Lightroom on the iPad—albeit in a stripped-down, version 1.0 form. You won't find metadata tagging or rating (yet), but it does include all the Develop adjustments found in Lightroom's Basic panel. The best part is that photo collections you mark in Lightroom are synchronized automatically with Lightroom mobile: Edit a photo on the iPad and the changes are brought back to Lightroom within a a minute or so.

(The timing of Lightroom mobile inspired me to write a stand-alone ebook for Peachpit Press called *Adobe Lightroom mobile: Your Lightroom On the Go*. It's available from Peachpit directly; you can find it and my other books at http://jeffcarlson.com/my-books/.)

There are lots of little changes here and there that aren't worth calling out specifically, so in short I'll say: I'm proud that this is a meaty update to the first edition.

Notes About This Book

As you read, you'll run into examples where I've adopted general terms or phrases to avoid getting distracted by details. For example, I frequently refer to the "computer" or the "desktop" as shorthand for any traditional computer that isn't the iPad. Although the iPad is most certainly a computer, I'm making the distinction between it and other computing devices, such as laptops, towers, all-in-one machines, and other hardware that runs OS X or Windows. When those details are important to a task, I note specific applications or computers.

The same general rule applies to iPad models. The iPad mini, despite its size, is still a fully functional iPad, so when I refer to "iPad" in general it applies to the iPad mini as well as to the larger, flagship model.

I also assume you're familiar with the way an iPad works—using gestures such as taps and swipes, syncing with a computer, connecting to the Internet, charging the battery, and otherwise taking care of your tablet. If you're brand new to the iPad, allow me a shameless plug as I encourage you to buy my *iPad Pocket Guide* (also from Peachpit Press).

Don't be surprised when you frequently run across the phrase "As I write this." Both the iPad and the software useful to photographers are advancing rapidly, which makes this an exciting topic to cover.

I mention many apps throughout the book, so instead of cluttering up the text with Web addresses, you'll find links in the App Reference appendix at the end of the book.

To stay abreast of the changing field, be sure to visit the companion site for this book, www.ipadforphotographers.com, where I post updates and information related to the newest tool in your camera bag. I've also set up an iPad for Photographers community on Google+ for readers and others to share photos and conversation: https://plus.google.com/communities/111822708330207901957.

Lastly, please sign up for my low-volume newsletter, where I keep readers abreast of new projects and giveaways: http://eepurl.com/KYLFv.

Have fun shooting, and please feel free to contact me at the sites above with feedback!

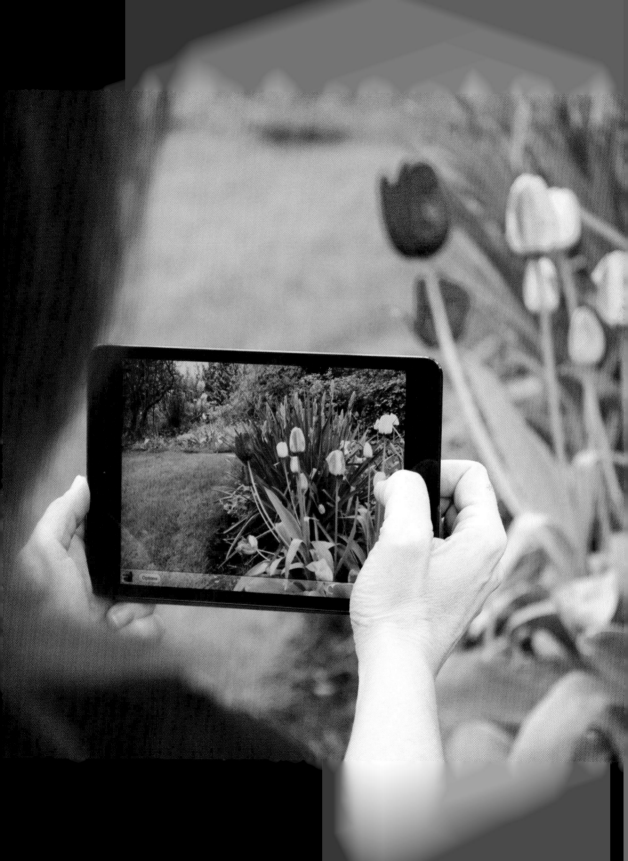

Capture Photos with the iPad

The iPad 2 was the first iPad to include cameras—one front-facing for FaceTime videoconferencing and one rear-facing—and boy were they terrible. The hardware was clearly added just to take advantage of FaceTime and because Apple's other iOS devices had cameras, not because Apple wanted to make the iPad a great photo-capture device.

In the first edition of this book, I recommended that readers ignore the photo capabilities. The results were just too painful. However, as the iPad's cameras have improved since then, I now regularly see people shooting photos or videos with their iPads. Although the form factor is awkward, I understand the appeal: Framing shots is easier when you have a large virtual viewfinder. The iPad mini seems like a better device for capturing photos, if only because it's not guaranteed to obscure the view of a person standing behind you.

Mostly, though, I think people shoot with an iPad because it's there. As the saying goes, "The best camera is the one you have with you." The built-in Camera app will get the job done, but I also want to highlight a few apps that will give you better results.

Shoot with the Camera App

When you're looking for something that quickly captures a shot, the iPad's Camera app gets the job done. It takes photos and saves them to the Camera Roll, where you can view, edit, or share them (see Chapter 5 for details). Although it is roughly the same app as on the iPhone, Camera on the iPad doesn't have the same features—you won't find a flash (there's no hardware for it) or the ability to make panorama images. Still, it's simple—which is the whole point.

1. Open the Camera app.

2. To toggle between the rear and front cameras, tap the Camera Switch button.

3. Frame your shot on the screen, in either landscape or portrait orientation.

4. The iPad attempts to focus on whatever is in the center of the frame. If you see one or more boxes appear, the app is identifying what it thinks is a person's face and using that as the focus point. You can focus on any other area by tapping once on the item on the screen (1.1).

 Tapping once also sets the overall exposure for the image. If you'd like to lock the focus and exposure, touch and hold an area for 2–3 seconds. You'll see an "AE/AF Lock" indicator at the top of the screen. Tapping anywhere removes the lock.

5. To capture a photo, tap the shutter button at the right edge of the screen or press one of the volume buttons on the side of the iPad. If you keep either button held, the iPad continues capturing photos (about 1.5 shots per second) until you release it.

 ▶ **TIP** To help you line up the photo, enable the camera's onscreen grid: go to Settings > Photos & Camera and turn on the Grid option.

Shooting a video follows the same approach: Slide the Video/Photo/Square option to Video and tap the record button to start capturing footage; tap it again to stop recording. (To switch modes easily, swipe anywhere on the screen, not just on the words near the shutter button.)

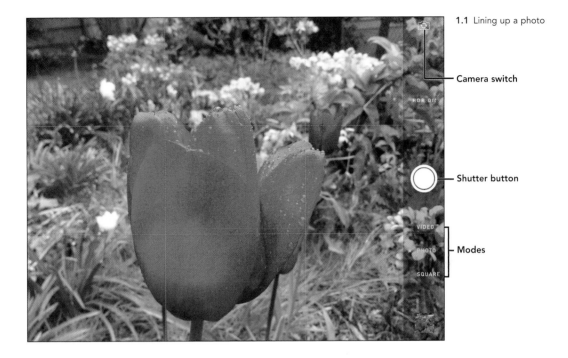

1.1 Lining up a photo

Camera switch

Shutter button

Modes

Shoot with Advanced Apps

As a photographer, you expect more control over how you capture images. Apple has made the iPad's camera a simple point-and-shoot operation, but the hardware is far more capable. That's where outside developers come in.

You'll find dozens of apps that go beyond basic picture-taking, from novelty apps that apply image filters to more complicated ones that fill in the gaps that Apple has left open. I couldn't hope to cover them all here—it would take away your fun of exploring, and selections are always changing. So instead, I'm going to focus on a few I've used that offer advanced features like separate focus and exposure control, timed shooting modes, and HDR (high dynamic range) imaging.

Set Focus and Exposure

It's convenient to set the focus and exposure based on a single area of a photo, but the two attributes aren't always tied together. The camera will try to achieve a perfectly exposed image overall, which can lead to, for example, subjects in the foreground appearing dark in order to prevent a bright background from blowing out to white. But sometimes you may want that—getting a well-lit shot of someone may be more important than having a properly balanced background.

Camera+ for iPad initially uses a single selector. Tap once to establish a focus point and then tap the attached (+) button to reveal separate Focus and Exposure selectors (1.2). Drag each one to set the focus point and exposure setting. (Focus is the primary control, so you can tap anywhere to redefine which area is sharp; you must drag the Exposure control.) Reframing the iPad will cause those settings to change, so if you want to lock one of them, tap the Lock button in the lower-left corner of the screen and choose which variable to lock.

1.2 Splitting the Focus and Exposure selectors in Camera+

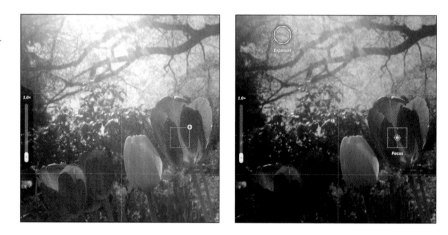

▶ **TIP** Many cameras and lenses offer image stabilization to minimize the effect of camera shake while you're shooting. Camera+ includes a Stabilizer mode that doesn't take the shot until the iPad has stopped moving. Tap the Mode button (the gear above the shutter button) and choose Stabilizer. If the iPad is moving too much, the shutter button turns red to remind you to stop moving; the app won't capture the shot until the iPad is relatively stable.

Time Your Shots

Some situations call for different shot timing than just one person pressing the shutter button. In Camera+, tap the Mode button above the shutter button to choose a mode:

- **Timer.** Selecting this option switches to a 5-second timer that counts down after you tap the shutter button. You can change the duration by tapping the Set Timer indicator in the middle of the screen—5, 15, or 30 seconds.

- **Burst.** When this feature is active, holding the shutter button down fires off multiple shots. The iPad doesn't need to shuttle images to a memory card, so unlike with most cameras you won't run into a lag as the images buffer to memory; I accidentally grabbed about 75 photos over a few seconds without realizing it. Burst mode comes at a cost, however: To achieve this performance, images are captured at a measly 640 by 480 pixels.

- **Long exposures.** Extremely low-light situations, or scenes where you want special effects such as star trails, require long shutter speeds.

The app Slow Shutter Cam includes modes for those types of shots as well as control over the duration the camera records photons (up to 60 seconds or "unlimited," which requires you to manually stop capturing). The app was designed for the iPhone and runs in emulation on the iPad, but that doesn't change the output of the photos.

Filters and Editing in Camera Apps

Many camera apps want you to stick with them from shot to share and include a bevy of editing features. If you like to experiment with looks as you're shooting, try Blux Camera for iPad, which applies effects to the live image before you capture the shot (1.3). I cover dedicated editing apps in Chapter 5.

1.3 Preview effects in Blux Camera for iPad.

Shoot HDR Photos

HDR (high dynamic range) is a technique for solving a common problem in photography: getting enough exposure in all areas of a scene without sections being plunged into darkness or blown out to white. HDR software combines two or more exposures—typically a dark one and a light one—into one balanced image. The iPad's HDR shooting mode in the Camera app is activated by tapping the HDR button. When it's on, the iPad snaps three photos and automatically combines them into one HDR image. A preference in Settings > Photos & Camera lets you decide whether to keep the shot that was normally exposed; otherwise, only the HDR shot is saved.

For more control, I like the TrueHDR app, which offers three capture modes as well as the ability to process photos you've already shot or imported. The Auto mode evaluates the scene and determines light and dark exposures for capturing two shots. The SemiAuto and Manual modes give you the opportunity to define your own light and dark areas. After merging the shots, you can adjust warmth, saturation, contrast, and brightness to tailor the result (1.4).

▶ **TIP** The app Snapseed includes a filter called HDR Scape that does a good job of pulling detail out of single images. It usually goes too far for my taste (leading to an overprocessed look), but you can dial it back for better results. I talk more about Snapseed in Chapter 6.

1.4 Fine-tuning a TrueHDR image

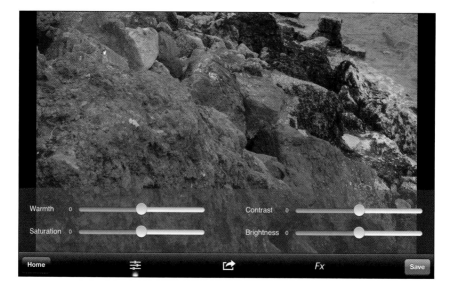

Create a Panorama

A snapshot is a specific slice of space and time, framed by the bounds of the camera's lens. But you can break out of that frame—or at least push its borders—by capturing a panorama. The iPad takes multiple photos as you pan across a scene, and then stitches them together to create one long image. (And yep, you guessed it: The Camera app on the iPhone includes a great panorama feature that isn't included on the iPad.)

You'll find plenty of panorama apps at the App Store, including AutoStitch Panorama for iPad. AutoStitch employs the iPad's accelerometer to help line up images as you shoot and offers a colored indicator to signal when areas overlap well (green) or poorly (yellow or red) (1.5). After capturing the shots, the app stitches them together and gives you the option to crop the result into a clean rectangular photo.

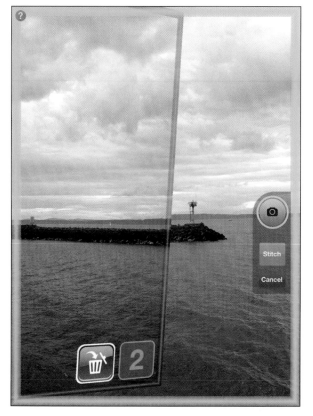

1.5 Overlap images to capture a good panorama.

CHAPTER 2

Build an iPad Photo Workflow

Before you start pressing your camera's shutter button, it's important to figure out which format you want to use to capture images that will end up on the iPad. The question of whether to shoot images in raw format or JPEG format initially seems irrelevant to the iPad—the device can import both types. But choosing one (or both) leads to considerations that ripple through the entire iPad workflow.

Keep in mind that workflows are always in flux due to changes in hardware and software. The ones I illustrate in this chapter apply to most situations, but not all. For example, Adobe Lightroom mobile doesn't import raw files, and it syncs photos automatically via cloud services; also, at the time of this writing, the app doesn't support metadata such as keywords or star ratings.

However, these workflows are great places to start and discover what works best for your situation. The table on the next page provides an overview of what to expect.

Raw vs. JPEG

Raw image files contain the unaltered information captured by the camera's image sensor, which provides much more data to work with when editing in a desktop program such as Photoshop, Lightroom, Photoshop Elements, or Apple's Aperture. In general, professional and intermediate cameras offer a raw capture option.

JPEG files, on the other hand, are processed within the camera before they're saved. Each image is color corrected, sharpened, compressed, and adjusted in other ways to create what the camera believes is the best image. All digital cameras can capture JPEG images; for some models, JPEG is the only choice.

When brought into an image editor on the desktop, a JPEG file doesn't offer as much image data and therefore can't be edited as thoroughly as a raw file. For example, you're more likely to successfully pull detail out of shadow areas with a raw file than with a JPEG.

The table below provides a quick overview of the discussion. Although I assume you want to shoot raw if you're able to—after all, the ultimate consideration is usually image quality—some situations may call for you to switch formats.

	Import to iPad	Rate & Tag Images	Edit Images	Sync to Computer
JPEG	Fast	Yes	Yes, but limited image information is available. Quality starts out compressed. Edited versions are saved as copies.	Easy import into desktop software or folder
Raw	Slower	Yes	Not directly in most apps. Edits apply to the JPEG preview. Lose the full advantage of editing raw files.	Raw files are imported into desktop software; any edited versions (JPEGs) are imported separately.
Raw+ JPEG	Slowest; uses the most disk space	Yes; treated as one image	JPEG portion is edited, while raw remains untouched. JPEG is often better quality than auto-generated preview.	Bring raw files and edited JPEGs into desktop software; delete other JPEGs (depending on software).

Shoot JPEG

If your camera doesn't shoot in raw format, JPEG is your only option. You might also choose to capture JPEGs when you're deliberately shooting snapshots that need to be processed or shared quickly, or when you want to employ the simplest workflow (2.1).

1. Capture photos in JPEG format on your camera.

2. Import the photos into the iPad (discussed in detail in Chapter 3).

3. Back up your images (also explained in Chapter 3).

4. Review the photos using the Photos app.

5. Optionally edit, rate, tag, or share pictures (using various apps, described elsewhere).

6. Synchronize the pictures to photo software on your computer when you're back at home or the office.

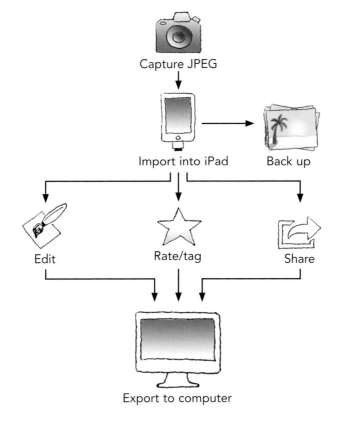

2.1 Workflow for shooting in JPEG format

Capture JPEG

Import into iPad Back up

Edit Rate/tag Share

Export to computer

The main advantage of the JPEG workflow is that it's largely friction free. Photos occupy less storage space on the iPad, making even the lowest-capacity model workable for holding pictures on location. You also deal with just one set of images, unlike with raw files (as you'll see shortly).

The primary disadvantage is that JPEG images are compressed and corrected within the camera, so you're not getting the fullest possible image data. Editing images, whether on the iPad or on the desktop, further reduces image quality, because the JPEG format applies *lossy* compression—image data is removed from the file whenever it's saved. If you edit the images on the iPad, many editing apps apply still more compression. When you bring the photos into the computer, you don't have as much latitude for editing them.

I don't mean to sound alarmist, as if shooting in JPEG is going to produce muddled images. JPEG compression is based on how the eye perceives images and is generally very good. It's just that, when compared to working with a raw file, JPEG files start you at a disadvantage.

Shoot Raw

Capturing photos in raw format adds some complexity to the iPad workflow (2.2). Although the iPad can import raw files, it can't edit them natively (with a few exceptions, explained in Chapter 6). Instead, any editing or sharing is done on JPEG previews supplied by the camera.

1. Capture photos in raw format on your camera.

2. Import the pictures into the iPad.

3. Back up your images.

4. If you edit or share photos on the iPad, the work is done on the JPEG previews (with a handful of exceptions, such as Photosmith, which can build JPEG files from the raw source images). Edited versions are saved as new JPEG files, and the raw files remain untouched.

5. If you rate and tag photos on the iPad, the metadata is retained when photos are exported from the iPad to the photo software on your computer (see Chapter 5).

6. Since any images you edited on the iPad are separate versions, they're added to your photo software. For images you didn't edit, the JPEG previews are ignored.

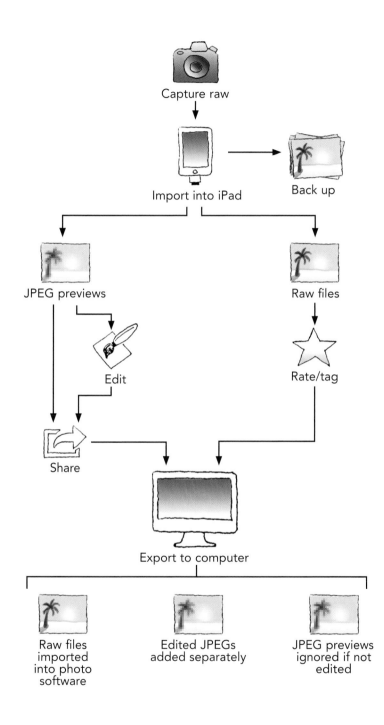

Capture raw

Import into iPad

Back up

JPEG previews

Raw files

Edit

Rate/tag

Share

Export to computer

Raw files imported into photo software

Edited JPEGs added separately

JPEG previews ignored if not edited

The advantage to the raw workflow is that you retain all of the image data for later editing, giving you the most flexibility with the photos on the desktop. Also, metadata that you add stays with the raw images, so you don't need to undertake another round of rating and keyword tagging on the computer.

> ▶ **TIP** One option is to consider editing on the iPad a temporary step: Edit images to share them quickly when you know you won't be back at the computer for a while, and then dump those edited versions when syncing to the computer, where you can edit the originals with better tools.

However, a main disadvantage is that raw files occupy much more storage space, which is an issue if you're shooting hundreds or thousands of photos. Most editing apps work only on JPEG previews, so you can't take full advantage of the raw image data unless you use a dedicated raw editing app. (Adobe Lightroom mobile doesn't import raw files on the iPad at all.) Also, you end up with separate JPEG versions that must also be imported (unless you dump the JPEG versions).

Shoot Raw+JPEG

For cameras that support it, a third option is to shoot in Raw+JPEG mode. In this case, the camera writes two files: the raw file, plus a JPEG file as specified by the camera settings instead of an automatically generated preview file. The workflow looks something like this (2.3):

1. Shoot photos using the camera's Raw+JPEG mode.

2. Import the photos into the iPad, which displays one thumbnail for each image, although each image is made up of a raw file and a JPEG file.

3. Back up the images.

4. Optionally edit and/or share photos, which applies to the JPEG counterpart for each photo. Edited images are saved as new JPEG files.

5. Rate and tag images. The Raw+JPEG pair is treated as a single image.

6. Export the photos to your computer. The Raw+JPEG pair is treated as one image, although you can choose to work on the versions separately; Aperture, for example, gives you the option to import just the raw file, to import just the JPEG, or to import both files and specify which is the "master" for the pair.

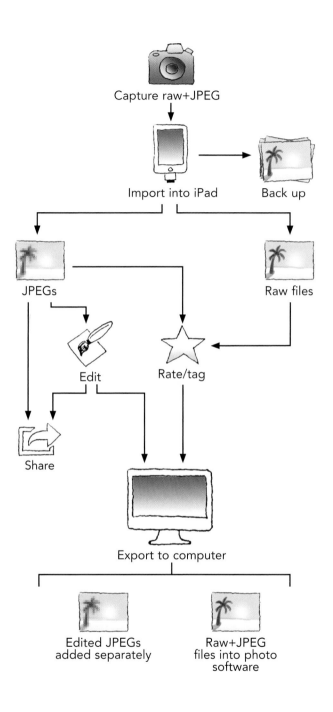

Capture raw+JPEG

Import into iPad Back up

JPEGs Raw files

Edit Rate/tag

Share

Export to computer

Edited JPEGs
added separately

Raw+JPEG
files into photo
software

On some high-end cameras that accept two simultaneous memory cards, you can specify that raw files be written to one card and JPEG files to the other. This implementation can be somewhat cleaner, treating the raw files as "digital negatives" that exist separately from the iPad (2.4):

1. Capture photos in Raw+JPEG format, specifying that raw files are written to one card and JPEG files are written to the other.

2. Import the JPEG images into the iPad. Leave the raw files on the card and store it in your camera bag.

3. Back up your images. That's not as easy in this workflow as in the others, because the raw files aren't on the iPad. You can get away with using the card as the backup, of course. If you were to lose the card, you'd still have the JPEGs on the iPad. But if you're paranoid (and there's a good case for paranoia—these are your original images, after all), you'll need a backup device that can copy the image files directly from the card. See "Back Up Your Photos," in Chapter 3.

4. Edit and/or share the JPEG files on the iPad.

5. Rate and tag images. Although you're applying metadata to the JPEGs, it's possible to transfer the data to the raw files on your computer via Photosmith's Lightroom sync feature or by exporting XML sidecar files created in PhotosInfoPro. (See Chapter 5 for details.)

6. Export edited versions of the JPEGs to the computer; delete the rest.

7. Export the raw files to your computer.

The primary advantage of shooting Raw+JPEG is that you have more control over the JPEG files that you import into the iPad. If your intent is to quickly preview and share photos from the iPad with a little editing here and there, and if you can save to separate cards, you can specify a smaller JPEG image size in your camera's settings. That speeds up import time and saves storage space on the iPad without affecting image quality much. Also, the raw originals are still available for editing on your computer.

The disadvantage is that Raw+JPEG when saved to a single card takes up more storage space. Recording to two cards helps in terms of storage but complicates the process in terms of backing up original raw files and syncing metadata in the computer.

Since I expect that I'll do at least some review and editing on the iPad, I now shoot Raw+JPEG most of the time so I can work with the higher-resolution images. This approach also works particularly well when transferring files

wirelessly; my main camera writes to just one card, but I use ShutterSnitch to transfer only the JPEG file to take advantage of the faster transfer speed afforded by the smaller file sizes (see Chapter 3). The raw files remain on the card until I import them into the computer.

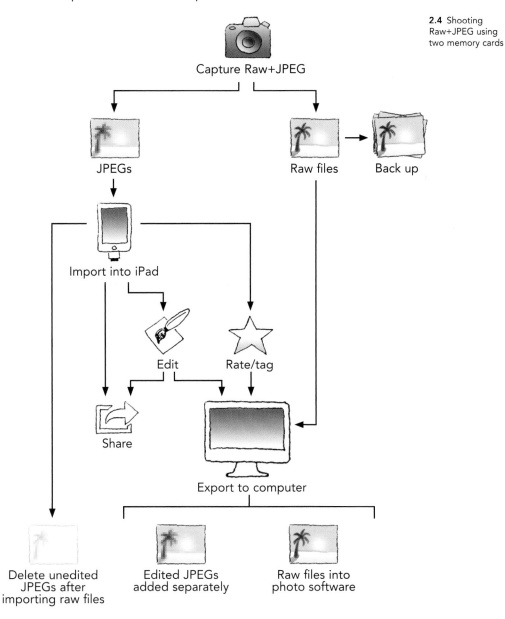

2.4 Shooting Raw+JPEG using two memory cards

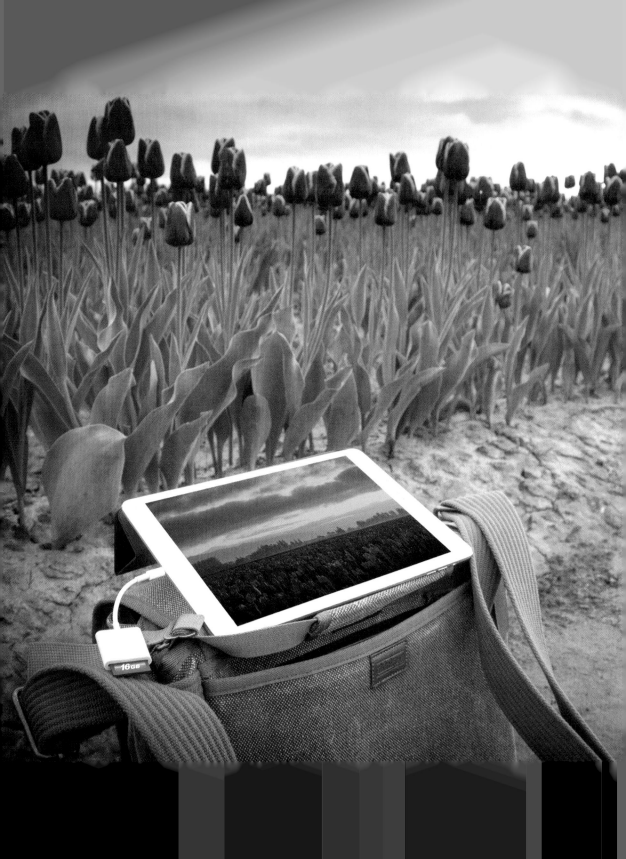

The iPad on Location

Through the years, I've hauled various laptops on vacations and business trips, and although the computers have gotten smaller and lighter over time, carrying one and its assorted peripherals still takes up a lot of space and weight. In contrast, the slim size and weight of the iPad (especially the iPad mini) makes it an ideal traveling companion. As a photographer, you probably already carry a fair amount of gear. Wouldn't you like to lighten your bag further?

Instead of squinting at the LCD panel on the back of the camera, view your shots on the iPad's brilliant 9.7-inch or 7.9-inch screen and pick out details in the middle of a shoot that you may miss through the viewfinder. You can also use the iPad as a remote photo studio. Sort, rate, and apply metadata to the images while you're traveling, or edit and share them to your favorite social networks. And then, when you're back at home or in your studio, bring the photos into your computer, ready for further editing in Lightroom or other software. Whether "on location" is somewhere truly remote or just your back yard, the iPad can be your new photographer's assistant.

Prepare for a Photo Shoot

Assembling your gear is only one part of preparing to make photographs. If you're headed to a specific picturesque spot, or even grabbing your camera for a day of exploring without direction, it helps to do a little work ahead of time to make the most of your shooting time. The iPad is a great source of location information and reference materials.

Find Photo Locations

Start by typing the name of a location in the address bar in Safari to perform a general Google search. That's a pretty wide net, so also consider searching photo sites such as Flickr (flickr.com) and 500px (500px.com) to see where other photographers have set their cameras. If location data exists for images, you can pinpoint the locations on a map. An app-specific approach is Stuck On Earth, which features locations of photos uploaded by other users of the app.

If you're capturing sunrises or sunsets, the app TPE (The Photographer's Ephemeris) identifies the position of the sun (and moon, if you choose) at any point during the day at a specific location (3.1).

Equally important when you're on location is to get a handle on what the weather will bring. You'll find dozens of weather apps in the App Store, but when I'm actually out on a shoot I frequently refer to Dark Sky on my iPad or iPhone (3.1). Using a clever algorithm and lots of source data, Dark Sky does a good job of predicting when you can expect raindrops to start falling.

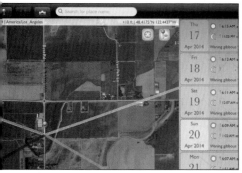

Heavy rain stopping in 30 min., starting again 8 min. later.

1 TPE (The Photographer's Ephemeris)

3.2 Dark Sky knows when the rain will start and stop. Really

Use GPS to Mark Locations to Revisit

My friend and photographer Rick LePage likes to get on his motorcycle and explore, and he often finds new potential photo spots. If he is unable to capture some photos at the time (usually due to weather or timing), he takes a snapshot with his iPhone and then later adds a "revisit" tag to it. The embedded GPS data marks the location so he can head back when conditions are more favorable. (Read more about this approach at www.135f2.com/2011/07/268-miles/.)

The apps Rego and Pin Drop (both designed for the iPhone, but they also work on cellular-enabled iPads) make it easy to mark a location, add a note about it, and attach a photo to jog your memory later (3.3). (I cover other utilities for tracking your location later in this chapter.)

Keep Reference Materials Ready

Instead of adding the weight of paper documentation to your bag, let the iPad carry them as weightless PDF files. That works for reference manuals (such as this book!) and anything else you can easily read in an app. I store most of my active documents in Dropbox, so the Dropbox app is a quick way to access them (mark a file as a favorite to store a copy on the iPad instead of fetching it each time you open it). For more flexibility, install GoodReader, which can transfer and read darn near anything.

Even more important, I keep a copy of the Easy Release app on the iPad so I can create and record model and location releases when necessary (3.4). The model signs right on the tablet and receives a copy via email.

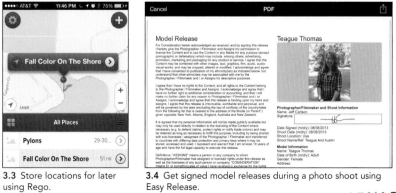

3.3 Store locations for later using Rego.

3.4 Get signed model releases during a photo shoot using Easy Release.

Review Photos in the Field

The shift from film to digital cameras brought an enhancement that fundamentally changed the way photographers shoot. It's second nature for us now, but the ability to take a shot and review it on the camera's LCD for feedback was a real revolution. You could tell right away if you needed to adjust the exposure, you could check whether everyone in the shot was looking at the camera, and you could otherwise see what was just recorded to the memory card.

And yet. Camera screens have improved over the years, in both resolution and size, but it's not always easy to spot details on a 3-inch display. The iPad's 9.7-inch screen—and even the iPad mini's 7.9-inch screen—reveals plenty of detail, without involving the bulk and inconvenience of a laptop.

Using an inexpensive adapter from Apple, you can import shots from a memory card or from a camera directly and get a better view of your photos—while you're shooting on location, not later at home when the shot is no longer available. It's also possible to transfer photos to the iPad wirelessly using Wi-Fi–equipped cameras, memory cards, or add-on devices.

In this section, I'm making the assumption that you've left the computer at home and have the iPad on location—whether far-flung or just out and about for a couple of hours. There may be times when you want to review photos on the iPad even with a laptop available; I cover such situations in the next chapter, "The iPad in the Studio."

Import Using the iPad Camera Adapters

Apple's iPad camera adapters rank among the few truly essential iPad accessories; without them, I wouldn't have been able to write this book! If you own a third-generation or earlier iPad (with a 30-pin dock), you want the $29 iPad Camera Connection Kit. It's made up of two pieces that attach to the iPad's dock connector: an adapter that accepts SD memory cards, and one that accepts a standard USB plug. If you own an iPad mini or fourth-generation or later iPad, you can buy the Lightning to SD Card Camera Reader or the Lightning to USB Camera Adapter, sold separately for $29 each (3.5). Or, if you already own the 30-pin adapters and have upgraded to a Lightning-equipped iPad, you can get away with the Lightning to 30-pin Adapter, which also costs $29.

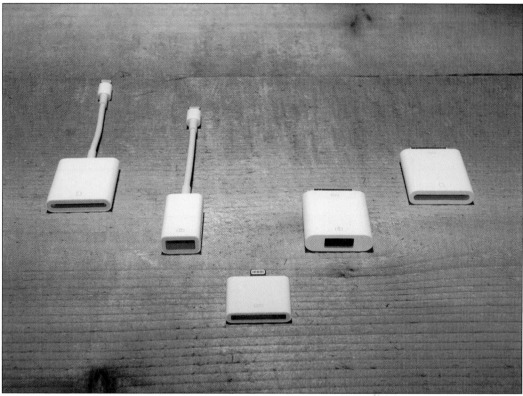

3.5 Camera adapters are available for whichever iPad you own.

Import from a memory card or camera

When you're ready to transfer the photos you shot, do the following:

1. Remove the SD card from your camera and insert it into the SD card adapter. Or, connect the USB cable that came with the camera (typically a USB-to-mini-USB cable) between the USB adapter and the camera's USB port.

2. Wake the iPad if it's not already on.

3. Insert the adapter into the iPad's dock connector. If you're connecting via USB, you may also need to power on the camera or switch it into its review or playback mode. The Photos app automatically launches and displays thumbnails of the memory card's contents (3.6, next page).

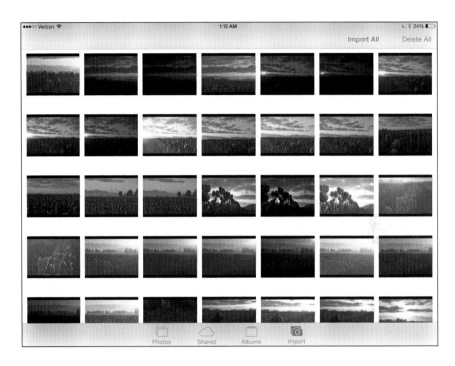

Note that when importing Raw+JPEG images, the format is not marked on their thumbnails in iOS 7, as it was in iOS 6. You can't choose whether to import JPEG or raw independently; the pairs arrive together.

4. If you wish to bring in all of the photos, tap the Import All button (and skip ahead to step 6). Otherwise, tap the thumbnails of just the photos you want; a blue checkmark icon indicates a photo is selected. Unfortunately, there's no option to view a larger version of the shots at this point. There's also no easy way to select a range of thumbnails other than tapping each one.

5. Tap the Import button (3.7). You still have the opportunity to ignore your selections and import everything by tapping the Import All button. Or, tap Import Selected to copy the ones you chose in the last step. The photos begin copying to the iPad's memory; a green checkmark icon tells you the photo has been imported.

▶ **TIP** It can take a while to import a full memory card, but you don't have to put the iPad down. Photos continue to copy in the background, even if you switch to another app.

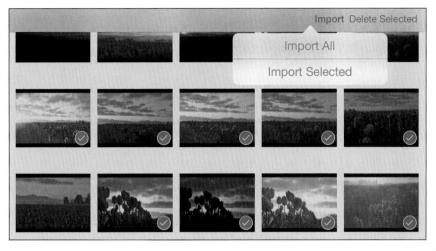

Import Delete Selected

Import All

Import Selected

3.7 Import just the images you want.

6. After the photos are copied, you're asked if you want to delete the imported files from the memory card. I recommend tapping the Keep button and then erasing the card using the camera's controls.

 The images appear in your Photo Library. In the Albums view, you can find them in three new, automatically created albums: Last Import, All Imported, and Imported Photos & Videos.

7. At this point, you can remove the adapter—no need to eject it, as you would on a computer.

When the Photos app scans an inserted memory card, it identifies shots you've already imported with a green checkmark. For example, suppose you're shooting with the same card that you used yesterday because there's still plenty of free space left on it. If you tap the Import All button, you're asked if you want to re-import all of the photos—in which case you end up with multiple copies—or to skip the duplicates.

▶ **TIP** The import process also gives you the option of deleting images from the memory card. This feature is great if you want to keep using a card for shooting but don't want to save obviously poor photos. For example, I don't need to retain dozens of test and setup shots while I'm trying to dial in the right settings and lighting positions. Tap to select the photos you wish to remove, and then tap the Delete Selected button.

The Secretly Versatile iPad USB Camera Adapter

The iPad USB camera adapters were designed to connect the iPad and digital cameras, but they work with other USB-based items, too. Need to type something lengthy but don't own a wireless keyboard? Plug in a USB one. Connect a wired USB headset and use the Skype app to talk to people via voice. Or, plug in a USB microphone, record to GarageBand or iMovie, and you have a portable podcasting studio (3.8). There is one catch, though. Since iOS imposes a 20 mA power limit on the USB connection, some accessories that draw more energy won't work. In that case, you need to connect the accessory to a powered USB hub. Be sure to test any accessory before you go on location.

3.8 The USB adapter works with accessories such as this external microphone.

What About Importing from CompactFlash (CF) Cards?

You can connect the USB adapter to your camera, but of course that ties up your camera while the photos are downloading. Instead, plug the card into a CompactFlash USB reader and connect that via the USB adapter. However, there's a catch: It doesn't work with all readers due to the iPad's power limit. If the card reader requires more, it won't work (unless the reader is connected to a powered hub, and the hub is connected to the iPad; but a powered hub won't help you if you're on location without an electricity source). I can't recommend any particular models, since the market changes frequently, but a search for CompactFlash adapters for iPad will reveal models that other photographers have used successfully.

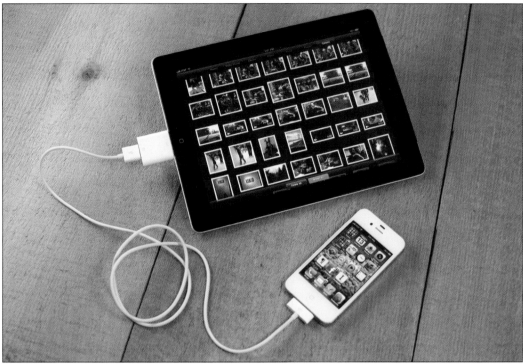
3.9 Importing photos from an iPhone into the iPad

Import from an iPhone

While I was having coffee with a friend, he asked, "So, are you going to get the cool new camera?" I must have looked puzzled, because he followed up with a grin and, "You know, the camera that also has some smartphone features." He meant the latest iPhone, which was then about to be released. He was far less interested in the specifications or new features of the device than in the substantial improvements made to its camera.

That camera is quite impressive, made more so by the fact that the iPhone is always with me. I can capture great shots without also carrying a separate camera all the time.

Getting photos from the iPhone into the iPad is as simple as importing from any other digital camera. Plug a regular iPhone sync cable into the iPad USB adapter, and then connect the iPhone and the iPad. Thumbnails appear in the Photos app, ready to be imported (3.9).

Import Wirelessly from the Camera

Wait a minute. We're in the second decade of the twenty-first century, viewing high-resolution digital photos on a tablet computer operated by touch. Do we need to shuttle files using adapters and cables as if we were using floppy disks? Isn't there another way, one that feels more like the future we live in?

How about taking a photo and having it appear on the iPad a few seconds later, using the camera you already own and without tethering it to the iPad via a cable? Using a wireless camera, memory card, or dedicated device, you can do exactly that. Eyefi, Toshiba, and Transcend each sell cards that look and work like regular SD memory cards, but also feature built-in radios that can connect to Wi-Fi networks or even create their own. Some cameras now include built-in Wi-Fi hardware or use manufacturer-specific adapters (like the Nikon WU-1b for some Nikon models). A handful of companies now also offer wireless devices that can control the camera from the iPad, such as the CamRanger (see Chapter 4 for more information).

When shooting on location, you can't guarantee that a Wi-Fi network will be available. Each card and device is capable of creating its own wireless network. After you connect the iPad to that network, photos you shoot can be transferred shortly after they're captured.

As I write this, the SD cards are available in capacities from 4 GB to 32 GB and range in price from $40 to $100. Be sure to check out the specifications for each device; the Eyefi Mobi cards are the easiest to set up, for example, but the Eyefi Pro X2 model is the only Eyefi card that can import raw files.

▶ **TIP** Many cameras now include built-in support for Eyefi cards. The Nikon D610, for instance, recognizes when one is inserted and provides controls for enabling or disabling the wireless feature.

Shoot and import wirelessly using ShutterSnitch

Each of these devices relies on its own iOS app for communicating with the iPad, but the implementation can be spotty. Instead, save yourself a headache and buy ShutterSnitch (check the hardware compatibility first, of course, but the app supports many cards and cameras).

I'm using Eyefi as the example, but the process is similar for other cards and wireless adapters. You'll first need to configure the card, using desktop software provided by the manufacturer to set up Direct Mode and any Wi-Fi networks it should recognize (like your home network). For these instructions, I'm assuming you're in the field, pith helmet and all, where Wi-Fi networks are scarce; if you're on a recognized home network, you can skip step 2.

1. Take a photo to activate the wireless card's Direct Mode. (It goes to sleep after a few minutes of inactivity to conserve power.)

2. On the iPad, go to Settings > Wi-Fi and select the Eyefi Card network (3.10).

3. Open ShutterSnitch and tap the New Collection (+) button.

4. Name the collection and tap Create, or just tap Create to use the current time as the name.

5. The test photo you just took automatically transfers to the iPad; any images on the card that had not yet been transferred are also copied.

6. Continue shooting. As you capture each shot, it's transferred to the iPad (3.11).

7. Tap a thumbnail to view the photo full-screen.

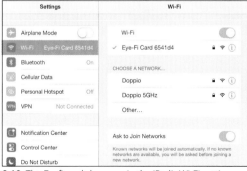

3.10 The Eyefi card shows up in the iPad's Wi-Fi settings.

3.11 Photos arrive in ShutterSnitch from the camera just after they're shot.

ShutterSnitch stores its photos within the app, so when you want to move them to your computer or make them accessible to editing apps, tap the Share button, select the images you want, and then choose an option from the Export button (the arrow pointing up); that can be the Camera Roll, Dropbox, email, or other apps.

ShutterSnitch as Photographer's Assistant

ShutterSnitch does more than just import photos. It displays pertinent metadata (ISO, aperture, shutter speed, and focal length) and can pop up warnings about that metadata that you specify. One of my annoying shooting traits is to forget to reset ISO, so too often I've started shooting at ISO 800 (or higher) even in well-lit situations. In ShutterSnitch, I created a warning that appears when any photo arrives with an ISO higher than 400 (**3.12**).

You can also set up action tasks to automate tasks within ShutterSnitch before exporting to another source. For example, you could rename a photo, add a watermark, and resize it for sharing.

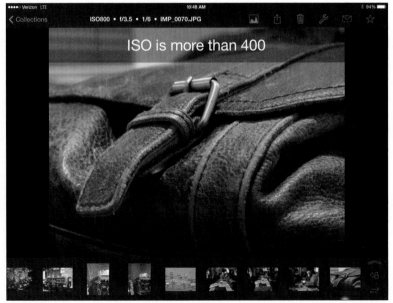

3.12 ShutterSnitch warns that my ISO is high.

▶ **TIP** Change the iPad's Auto-Lock setting to 15 minutes or Never when you're shooting with the Eyefi (go to Settings > General > Auto-Lock). If the iPad goes to sleep, it severs the connection to the Eyefi's network to conserve power. When you wake up the iPad, it may not automatically grab the network again (especially if you took a break in shooting, during which the Eyefi goes to sleep).

Import wirelessly from another iOS device

Another direct import route from iPhone to iPad (or between any two iOS devices) is to transfer the photos wirelessly using an app called PhotoSync. As long as both devices are connected to the same Wi-Fi network, they can bounce images back and forth, like so:

1. On the iPad, launch PhotoSync and tap the red Sync button.

2. Tap the Receive button.

3. On the iPhone, launch PhotoSync and tap the thumbnail of the image or images you want to transfer.

4. Tap the red Sync button.

5. Tap the Selected button.

6. In the next dialog, tap the Phone/Tablet button to specify where you want to transfer the image or images.

7. Tap the name of your iPad that appears. The photo or photos you selected copy from the iPhone to the iPad (3.13).

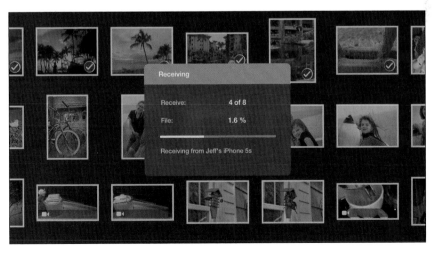

3.13 Receiving photos wirelessly from an iPhone

Record Location Information

Have you ever looked at a photo and wondered where it was taken? Was it one of your own photos? Thanks to the scientific marvel of GPS (Global Positioning System), you can add geolocation data to your photos and find their locations on a map.

Although GPS isn't a new technology, most cameras don't capture location data. A few cameras can be outfitted with GPS adapters that write the data directly to the photo files, and you can buy standalone GPS logging devices. However, you already own one: the iPad. Models that offer cellular networking include a GPS chip; Wi-Fi models can also perform some geolocation, but in a limited capacity because they need to know which Wi-Fi networks are nearby to determine location.

I'm going to highlight two iOS apps, both of which are designed for the iPhone but run fine on the iPad. Geotag Photos Pro records the data and then makes it available via the Web or Dropbox for you to import into a photo organizing application. GeoSnitch works with ShutterSnitch to apply the geolocation data to photos on the iPad itself.

Record Location Using Geotag Photos Pro

Geotag Photos Pro runs in the background on your iPad or iPhone, tracking your location. It then saves the data as a GPX (GPS eXchange format) file that can be read by many applications. I like it because the trip logs it creates can be automatically uploaded to my Dropbox folder, saving me the trouble of transferring the data to my computer later.

1. In Geotag Photos Pro, tap the New Trip button to name your recording session.

2. By default, the app logs your location every 2 minutes, but you can change that by tapping the Autolog button and specifying a time. The more frequently it records a location, the more battery it will consume.

▶ **TIP** Make sure the date and time listed matches the same information on your camera; it's possible to get the time back in sync after you shoot, but taking care of it now is easier. Tap the Settings button and then tap Setup Time on Camera.

3. To start recording, tap the Rec button, which then changes into a Stop button (3.14).

4. When you're done shooting photos, open Geotag Photos Pro and tap the Stop button.

5. Tap the Trips History button, locate your trip, and tap the Share button.

6. Choose to share via email, iTunes, or Dropbox (3.15). (If you set up automatic Dropbox syncing, the GPX file will automatically appear on your computer.)

7. Import the photos into your computer, and use an application (such as Lightroom, or HoudahGeo on the Mac) to associate the geolocation data with the images.

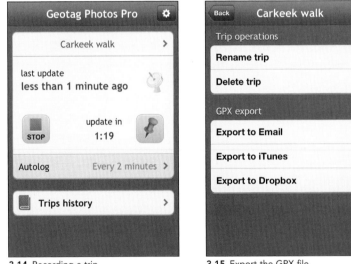

3.14 Recording a trip

3.15 Export the GPX file.

Record Location Using GeoSnitch

When you launch GeoSnitch, the app identifies your current location and presents a prominent red button. Tap the red button to begin tracking.

▶ **TIP** ShutterSnitch can't associate GeoSnitch's data with raw files, so geo-tagging works only with JPEGs.

GeoSnitch samples the location every second—you don't need to do anything. You can put the iPad or iPhone to sleep and it will still save location data until you tap the red button again to stop.

After you finish shooting, import the photos into ShutterSnitch on the iPad and then do the following:

1. Open GeoSnitch and tap the List button.

2. Choose the recording that matches your photo session.

3. Tap the Open In button and choose ShutterSnitch. The app opens and matches the photos with the time stamps.

4. Tap the Tag Selected button to apply the geolocation data.

Record Reference Photos Using the iPad

Having location capabilities built into the iPad (and iPhone) presents another geolocation option. Every photo you capture using the device automatically includes the location data. If you don't want to track every step or use third-party software, simply capture a shot using the iPad along with the photos you take with your camera. When you return to your computer, use desktop software to copy that GPS data and apply it to other shots taken at the same location. Aperture, for example, offers a nifty feature called Import GPS from iPhone Photos, which applies the iPhone's data to photos you select.

Back Up Your Photos

The main focus of this chapter is to move photos from your camera to the iPad, but getting them off the tablet in the form of backups is just as important. When you're shooting in the field with your iPad in hand, you don't have the luxury of transferring dozens of gigabytes onto your computer or to an external hard drive attached to it. That leaves you with a few options.

You can import photos into the iPad and use the memory cards you shot with as backups. It's like carrying film rolls all over again—although in this scenario, they occupy much less physical space. Fortunately, the price of memory cards has steadily dropped as capacities have increased, so you're not spending a lot of money to pick up several 8 GB, 16 GB, or 32 GB cards.

However, one problem with that approach is the relatively limited capacity of the iPad. The current high-end model, with 128 GB of memory, feels like an airy, open orchestra hall when you're just loading apps and documents. But the walls begin to push in if you're capturing several hundred shots during each outing (and that's assuming you've minimized the amount of music and video being synced in order to make room for photos).

So, if the iPad itself isn't big enough to hold one set of photos, you need to get them off the iPad and onto another medium. If I were talking about an average computer, this step would be trivial: just copy the files to a hard disk. Alas, the iPad doesn't work that way. Since iOS doesn't expose its file system to users, Apple opted not to offer the ability to push files around between devices without a computer in the middle.

If your iPad can connect to a speedy Wi-Fi Internet connection, you can upload images to a service such as Dropbox or to the Photo Stream feature of Apple's iCloud. I recognize that "speedy Wi-Fi Internet connection" can be a giant *if*. Maybe someday you'll be able to tap into a fast, high-capacity cellular network in a sheep pasture in Scotland, but chances are you'll be blissfully (or agonizingly) far from the rest of the world while you're shooting.

Or, after shooting for the day, you can return home or to a hotel room, or maybe park in a Wi-Fi–equipped coffee house for a few hours, and connect to a broadband Internet connection there (although even that possibility can be spotty, depending on location). But today's cellular networks are only starting to approach the speed and capacity required to upload dozens or hundreds of multi-megabyte files, and in most cases you pay a premium to do so. It's not impossible, though. I've uploaded large files while sipping in a Starbucks, and I've dribbled files over a flaky 3G cellular connection next to a tent and campfire in the mountains.

What's important is to have *some* type of backup. Everything I discuss in this book becomes useless if you somehow lose the photos you went to such trouble to capture in the first place.

iCloud Photo Stream

I signed up for Apple's free iCloud service primarily to share my calendars and contacts between various devices, but I also got an added bonus: Photo Stream.

Whenever you take a photo using an iPad, iPhone, or iPod touch, it's saved to the device's Camera Roll. With Photo Stream enabled, each of those photos is automatically uploaded to iCloud and copied to your other enabled devices when they're connected to a Wi-Fi network. A photo captured by my iPhone, for example, shows up on my iPad, on my Apple TV at home, and on my MacBook Pro.

More importantly for our discussion here, any photos imported into the iPad using a camera adapter are added to the Camera Roll, so they, too, appear in your Photo Stream (which you can find on the Albums screen of the Photos app) (3.16). The same applies to screenshots you capture on an iOS device, which often makes my personal Photo Stream quite the thrilling mix of photos, test images, and screenshots of those test images. Not quite the same emotional impact when playing slideshows for family.

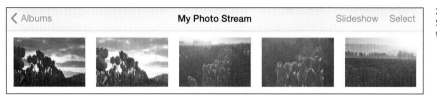

3.16 My Photo Stream, shown in the Photos app

Photo Stream is great because you don't have to do anything special other than enable the service. (In the iPad's Settings app, tap the iCloud button, tap Photos in the right column, and then flick the My Photo Stream switch to On.) As long as you're connected to the Internet via Wi-Fi, the photos copy automatically to Apple's servers.

Photo Stream stores just 1000 pictures on the iPad. After you reach that thousandth photo, the oldest images in the stream are removed in favor of new ones. On the iCloud servers, 30 days of photos are saved, giving you plenty of time to connect using your computer and download the pictures. The photos on your computer aren't deleted.

If you do want to make sure a few photos stick around on the device past the thousand mark, copy them from the Photo Stream to an album.

1. On the iPad, open the Photos app and tap the Albums button.

2. Tap the My Photo Stream album. (It's possible to create additional albums, called Shared Photo Streams; see Chapter 9.)

3. Tap the Select button.

4. Tap to select one or more photos you want to copy to an album.

5. Tap the Add To button (3.17).

6. Tap New Album, type a name for the album, and then tap Save. Or, tap an existing album. The photos are added to the album you created or chose.

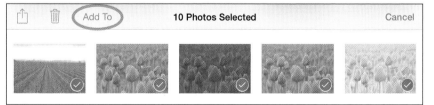

3.17 Tap the Add To button to keep a local copy of a Photo Stream photo.

Other Cloud Services

I started this discussion with iCloud because it's the photo service native to the iPad, but it certainly isn't the only offering. Over the past year, spurred by the amazing adoption of smartphones as cameras, companies of all sizes have jumped into the mobile photo space.

In fact, it's hard to keep track of them all. Shortly before this edition of the book went to press, Dropbox rolled out a new app and service called Carousel, and a week later purchased the promising upstart Loom. (Ironically, as I write this Carousel can't be installed on an iPad at all—it's coded solely for the iPhone and Android devices, so I can't recommend it as a possible iPad solution. I'm hoping Dropbox folds in Loom, which worked well on the iPad, in a smart way, but we likely won't see much integration for several months.)

Some services focus on backing up your photos so they'll be available on multiple computers or devices, while others store images and encourage you to share and publish them. For our purposes here, I'm going to focus on the backup aspect, since we want to make sure the photos are safe.

Automatic photo uploads

Just like iCloud, other services can automatically upload the contents of your Camera Roll. Examples include Picturelife, Google Plus, Flickr, Microsoft OneDrive, and Dropbox (which has offered this ability for a while, even without Carousel).

Storage limits and prices vary, but expect to get around 5 GB of photo storage for free and then pay a monthly subscription for more on top of that. Flickr is the outlier here: it offers 1 TB (yes, terabyte) of photo storage for free.

Each service will ask if you want to automatically upload photos, or you can set the preference manually. In Dropbox, here's how to enable the feature.

1. Open the Dropbox app and tap the Settings button.

2. Tap Camera Upload and flick the switch to On.

3. Choose whether you want to use cellular data to upload files or stick to Wi-Fi connections. Your photos begin to transfer.

▶ **TIP** Some of the services don't automatically treat the Last Imported album as part of the Camera Roll for updating, so you may have to manually upload the photos. The Google Plus app works this way, uploading only newly shot images. However, it also includes an option labeled "Back up all photos and videos" to grab items from the Camera Roll.

Manual photo uploads

If you don't want all photos automatically transferred (since services cap the amount of storage you can use before you need to upgrade to a paid tier), you can push images manually. Continuing with Dropbox as our example, here's how to do it.

1. Open the Dropbox app.

2. Navigate to the location in your Dropbox folder where you'd like the photos to appear.

3. Tap the ellipses (…) button.

4. Tap the Upload (+) button.

5. In the popover that appears, navigate to the folder in your Photo Library that contains the files you wish to upload.

6. Tap to select the photos (3.18).

7. Tap the Upload button to start transferring the files. When the copying finishes, the files are available at the Dropbox servers and on any of your computers that are connected to the Internet.

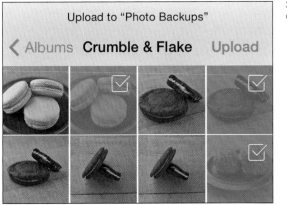

3.18 Choosing files to upload to Dropbox

Portable Storage

Working with gigabytes of photos begs for the capability to copy lots of files to a small, lightweight storage system. An external hard disk is almost a requirement for shooting on location with a laptop, so why not attach one to the iPad? Unfortunately, that would require a level of interaction with the file system that Apple intentionally obscures. In the company's view, when you're using an iPad, you're focused on tasks, not on shuffling files and figuring out where they're located. But a usage philosophy doesn't protect your photos.

I recommend two approaches, depending on the volume of photos you're working with: For a lot of photos or a long time away from the computer, copy photos from the camera's memory cards to a dedicated storage device that reads the card directly. For a modest number of photos or a short time before getting back to a computer, copy photos to the iPad and then make backups to a wireless storage device. In both situations, I recommend keeping your originals on the memory cards, if possible, as a secondary backup.

Dedicated media storage devices

The easiest, most straightforward way to back up your photos doesn't involve the iPad at all. Consider buying a dedicated storage device like the HyperDrive Colorspace UDMA 2. At its heart it's a hard drive, but one with slots for nearly every type of memory card and a color screen for previewing photos. It also includes built-in Wi-Fi so you can view photos on your iPad without copying them for quick review. It's not cheap, running about $300 for 120 GB of storage (and higher depending on capacity), but it will easily and quickly make a backup while you're on location.

Seagate Wireless Plus

Seagate's Wireless Plus is a $200 portable hard disk with 1 TB of capacity, a battery, and built-in Wi-Fi. Originally marketed as additional storage for the iPad (so you could carry your movie library without having to fill the iPad's internal memory—still a good idea if you are on a trip and don't want to consume your iPad's storage with entertainment), the Wireless Plus can also transfer files from the iPad using the Seagate Media app. (Seagate also sells a drive called the Wireless, but it only streams media from the drive to the iPad.)

After you've imported photos into the iPad, do the following to copy photos to the Wireless Plus:

1. In the iPad's Settings app, connect to the Wireless Plus's Wi-Fi network.

2. Open the Seagate Media app and make sure the location at the top of the screen says "On [name of your iPad]."

3. Locate the photos to transfer (in the Camera Roll or other album).

4. Tap the Select button (which looks like a checkmark in a circle, at the right edge of the toolbar).

5. Select the photos you want to back up.

6. Tap the Upload button (3.19). The files begin transferring.

Remember that you're transferring via Wi-Fi, so copying several hundred photos could take a while. This is a good activity to start before you go to dinner, making sure the Wireless Plus and the iPad are plugged into power and not just relying on battery.

▶ **TIP** Alas, the Wireless Plus has a potentially fatal flaw: Although you can copy raw files to the drive, you won't be able to review them from there later, because the app doesn't display raw files. So if you shoot exclusively in raw, you're limited to strictly copying files.

Upload button

3.19 Copy photos from the iPad to a Seagate Wireless Plus external drive.

Kingston MobileLite Wireless

In a similar vein, Kingston's MobileLite Wireless creates its own wireless network but saves photos to an SD or microSD card (which you provide). The device is much lighter and less expensive (about $40 online) than the Seagate drive, and its internal battery can nudge the iPad's or iPhone's battery in a pinch.

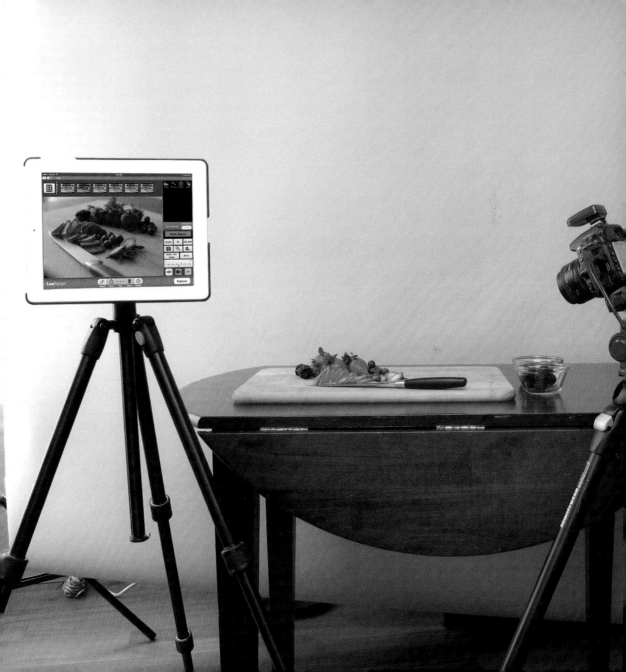

CHAPTER 4

The iPad in the Studio

An iPad is a great photographer's companion in the field, but it doesn't have to sit dormant when you're back at home or in a studio. The techniques covered in Chapter 3, such as importing photos using the iPad camera adapters or wireless devices, still apply when you're no longer on location. Other possibilities open up when you're not trying to minimize your equipment footprint.

The iPad can work alongside your camera, triggering the camera shutter, providing clients or visitors a window to a photo shoot (without them peeking directly over your shoulder), or even controlling a remote iPhone or iPod touch to capture photos or create stop-motion or time-lapse movies. And with a new crop of wireless accessories, you don't even need a computer (and its cables) in the room with you.

Control a Camera from the iPad

Often when you're working in a studio, the camera is tethered to a computer. This arrangement allows you to import photos directly into software such as Lightroom or Aperture, review shots as they come from the camera, and skip the separate import step entirely. So where does the iPad fit in this situation?

If you're shooting products, food, or other compositions that require the camera to remain locked down, you can trigger the shutter, change exposure settings, and more from the iPad without touching the camera. With wireless devices like the CamRanger and iUSBportCamera, or cameras with built-in Wi-Fi and an iOS app to control them, you won't trip on a tether cable as you move around.

An iPad also works well when clients or others want to see your output as the photo shoot progresses. If it's inconvenient to have them hovering over your shoulder, you can hand over the iPad and encourage them to relax on a couch situated a comfortable distance away from the camera.

Wireless Remote Control Devices

As I write this in April 2014, two devices on the market can control a DSLR from the iPad. The CamRanger ($299) and the iUSBportCamera ($199) attach to your Canon or Nikon DSLR's USB port. Both create their own wireless network, to which you connect using the iPad. You then control the camera using an app. By way of example, I focus on using the CamRanger in this chapter.

Tethered Shooting Using Capture Pilot HD

If you prefer to shoot tethered to a computer in the studio but want to incorporate the iPad, look to Capture Pilot HD, which works with Phase One's $299 Capture One software for Mac or Windows. Capture Pilot HD is free to use with Capture One, allowing you (or a client) to view, rate, and tag images as they're captured. A $14.99 in-app purchase unlocks the ability to control the camera and shoot from the iPad.

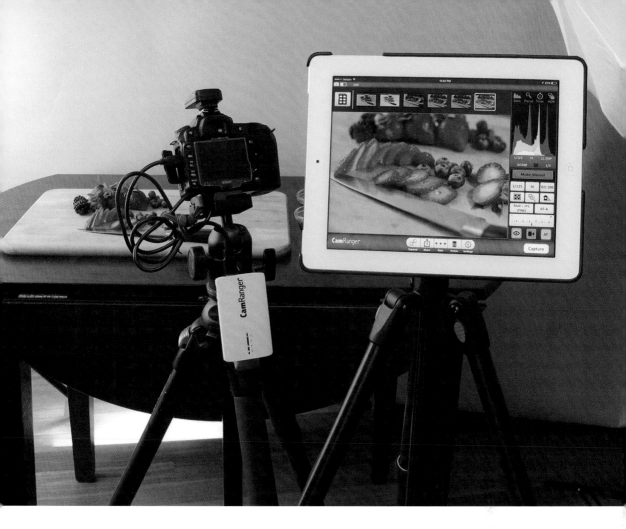

Compose and shoot

In many respects, your digital camera is already a computer, so why not use another computer to control the camera's settings and fire the shutter? In the device's app, use the following controls (4.1, on the next page).

Some items can't be adjusted, depending on the camera model. For example, some cameras don't let you change the exposure mode in software, because that setting is a physical knob on the camera. Also, as you would expect, the mode determines which settings are active—in Shutter Priority mode ("S" on Nikon models, "Tv" on Canon cameras), the aperture can't be set, because that's a value the camera calculates based on the desired shutter speed and ISO.

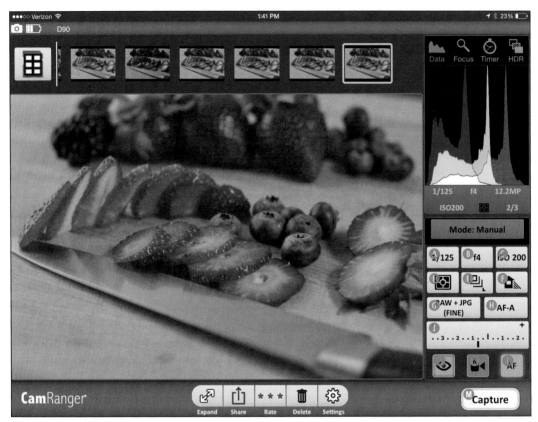

4.1 The CamRanger interface

A. Shutter Speed. Tap the Shutter Speed button to specify how long the shutter remains open.

B. Aperture. Tap the current Aperture setting to choose an f-stop from the list of possible values. The popover that appears shows only the settings that are available to the current lens.

C. ISO Speed. Tap this button to choose the level of light sensitivity.

D. Metering Mode. Tap to select how the camera calculates exposure.

E. Drive Mode. Tap to set how many shots are taken during a capture, including time delay and remote trigger options.

F. White Balance. Tap to select one of the color temperature presets.

G. Image Quality. Switch between available quality and format options.

H. Auto Focus Mode. Set how the camera determines where to focus.

I. Exposure Compensation. Choose from the range of positive and negative exposure adjustments.

J. Live View. See what the camera is seeing.

K. Movie Mode. Control video recording.

L. Movie Auto Focus. Tap to toggle between auto and manual focus in Movie mode.

M. Capture. Tap this button when you're ready to capture a shot.

▶ **TIP** The options that are enabled depend on whether the camera is in PC or Cam USB mode. Tap the Settings button, tap Connection/Network, and change the Connection Mode to PC; that lets you change settings like Mode despite what the camera's physical knobs are set to.

Use Live View

On supported cameras, tap the Live View button to get a live feed of what the camera's image sensor is seeing.

The CamRanger software can take advantage of the camera's auto-focus features: Tap the image preview to set the Auto Focus point, or tap the Focus button at the top of the screen for more specific focus control (Focus Nearer, Focus Farther, and Focus Stacking) (4.2).

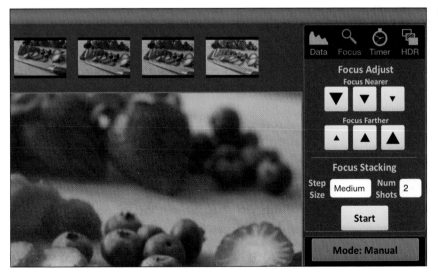

4.2 Focus controls in CamRanger

▶ **TIP** Since the image needs to travel across the wireless network from the camera to the iPad, expect a little lag when using Live View. It's not terrible, but it's not as smooth as looking through the camera's viewfinder. If the camera is locked down, that isn't a problem. Shooting handheld action proves to be more difficult.

▶ **TIP** The CamRanger doesn't automatically save photos on the iPad. Select a shot you've taken, and tap the Save button to copy it to the Camera Roll.

Use bracketing/HDR

The remote camera devices tap into your camera's ability to shoot a succession of three photos with different exposures (the current one, overexposed, and underexposed), a feature known as "bracketing." HDR (high dynamic range) images, for example, are created with three or more images at varying exposures. (However, the app doesn't merge the shots into a single HDR image; "HDR" is just shorthand for bracketing.)

1. Put the camera into its manual shooting mode.

2. In CamRanger, tap the HDR button to reveal the feature's options (4.3).

3. Set which variable is locked using the Property control: Aperture, Shutter Speed, or ISO Speed. If Aperture is selected, for instance, the camera will adjust the shutter speed and ISO to achieve the exposure change, leaving your chosen aperture constant.

4. Tap the Start Value button and choose a setting that establishes a decent exposure for the image, as if you were shooting just one shot.

4.3 Bracketing/HDR options

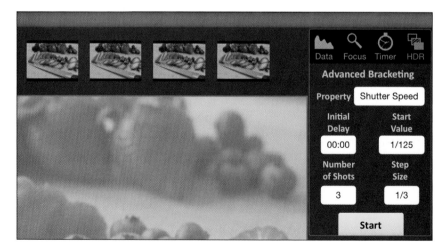

5. Choose how many exposures will fire using the Number of Shots button.

6. Drag the first slider to specify the variance in f-stops between each shot. For example, a setting of 1 would give you an image at the current exposure, one at +1, and one at –1. The higher the value, the broader the difference in exposure will be in the set of shots.

7. Tap the Start button to fire the shots.

Shoot at specified intervals

An intervalometer captures a series of shots at a specified interval. This automation lets you create a series of time-lapse shots.

1. Tap the Timer button (4.4).

2. To pause before the first capture, set a time using the Initial Delay control.

3. Tap the Number of Shots button, and enter a number in the text field to dictate how many captures are made during the session.

4. Tap the Shot Delay button, and choose the duration between shots in hours, minutes, and seconds (up to 59:59).

5. Tap the Start button to start the intervalometer.

▶ **TIP** The CamRanger stores the intervalometer settings on the device, so once you've started it, the iPad doesn't need to be on or even connected.

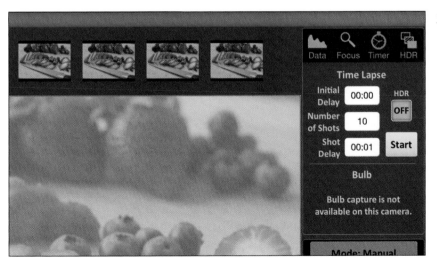

4.4 CamRanger's Timer controls

Triggertrap

If $200–$300 is too costly but you still want to control your DSLR from the iPad, the $30 Triggertrap is a great option. It doesn't give you a live view from the camera—in fact, you don't see any photos at all—but it does offer many methods of triggering the shutter. The Triggertrap app is free; the $30 is to purchase a dongle that's compatible with your camera.

Yes, you can remotely capture a shot of a specific duration, but that's just the start. Triggertrap uses the iPad (or iPhone) sensors to do things like fire the shutter when a loud noise (such as a clap, whistle, or tap) occurs (4.5), fire when you are driving and want a shot captured out the window every 20 kilometers, and fire when a person enters the picture (for cameras that do not offer built-in facial recognition).

4.5 Trigger the shutter based on noise level.

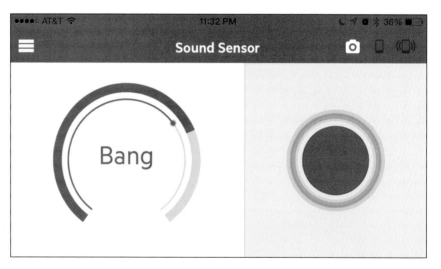

Triggertrap is also ideal if you want extreme control over time-lapse and long-exposure photography. The Wi-Fi Master mode works with another iOS device to control Triggertrap remotely (for example, when you want to capture starfields but would prefer to sit inside a cabin where it's warm).

▶ **TIP** For some creative shooting, check out the Triggertrap Flash Adapter, an add-on that lets you shoot high-speed photos (water droplets, glass breaking) using the strobes you likely already own.

Control a Wireless Camera

I believe that it won't be long before most cameras will incorporate some sort of wireless control. I'm happy to report that manufacturers have started building Wi-Fi connectivity into their cameras (4.6). The apps vary in their capabilities, but mostly they offer the same shooting features described earlier in this chapter. They also take advantage of the iPad's sensors, such as pulling location data and applying it to photos on the camera's memory card.

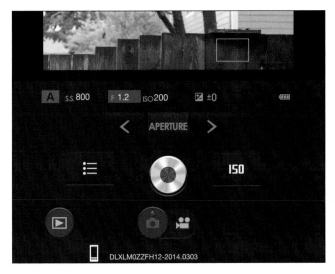

4.6 The FujiFilm Camera Remote app establishes a live link to the camera (a Fuji XT-1, in this case).

Control Another iOS Device

I've focused on controlling a DSLR so far in this chapter, but if you own an iPhone (or iPod touch, or another iPad), you already have a pretty good camera available. Blux Camera for iPad, which I mentioned in Chapter 1, has a companion app, called Blux Lens, that enables the iPhone to be a remote camera. As long as both devices are on the same Wi-Fi network, Blux Lens becomes the camera and the iPad acts as the controller.

Choose one to act as the camera and one to act as the remote, and you can then fire the shutter; lock focus, exposure, and white balance; and set a timer. And, of course, it offers a range of filters to change the look of the captured photo.

Make a Stop-Motion or Time-Lapse Video

Since a studio offers a controlled workspace, you don't have to deal with the whims of natural light or environment. Several apps feature an interval-ometer for firing off shots at specific intervals, which can then be combined into a time-lapse video later. But here I want to focus on a clever app that makes the process of creating time-lapse or stop-motion videos easy on the iPad. iStopMotion for iPad by Boinx Software ($9.99) can use the iPad's built-in camera or an iPhone (or iPod touch) with the help of the iStop-Motion Remote Camera app.

Create a Stop-Motion Video in iStopMotion

Although you could use the iPad or an iPhone to snap a bunch of photos and then stitch them together to make a stop-motion video, iStopMotion makes the process painless.

1. In iStopMotion, tap the New (+) button to create a new project.

2. Tap the Cameras button at the top right area of the toolbar and choose the front or back camera.

 If you're using another iOS device as a remote camera, first launch the free iStopMotion Remote Camera app there. Then, on the iPad, select the name of the camera device. Lastly, tap the Accept button on that device to establish the connection.

3. On the iPad or the other device, drag the Focus indicator to a spot where you want the focus to be locked (4.7). You can also tap the Expo-sure button at the top of the screen and identify an area on which to base the exposure level.

 ▶ **TIP** You'll want to shoot where the lighting is consistent, but also make sure you set the Exposure indicator to an area of the scene that's not likely to contain moving elements; they'll throw off the color in those frames.

4. Tap Done to exit the camera settings screen.

5. Tap the Clip Settings button (the gear icon) to set playback speed (frames per second) and how the editing environment appears. Tap the Show button and choose the middle option, which uses an "onion skin" mode to show the last frame and a ghosted rendition of the live video so you can see what the next frame will look like (4.8).

6. Set your scene, and then tap the Capture button to take a shot.

7. Reposition elements in the frame.

8. Tap the Capture button to grab the next frame.

9. Continue adjusting your elements and capturing photos until the scene is complete. Tap the Play button at any time to review what you've shot so far.

You can jump back to any frame to re-take it (make sure you line up your elements accurately), or you can delete a frame by selecting it, tapping the Actions button (the wrench icon), and then tapping the Delete Frame button.

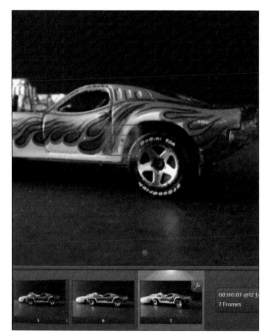

4.7 Lock focus in iStopMotion for iPad.

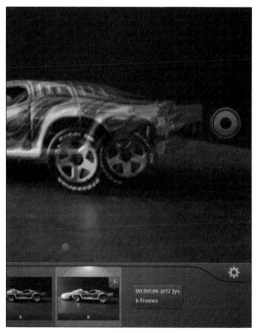

4.8 See the relative position of objects between shots.

Create a Time-Lapse Video in iStopMotion

Stop-motion animations require a lot of work and even more patience to do well. A time-lapse video, by contrast, needs just patience and an interesting place to point the camera. iStopMotion can automatically fire off a shot at an interval you choose, ranging from 0.1 second to 99.9 seconds.

1. Set up your iPad, iPhone, or iPod touch where you want to capture action over a period of time.

2. Choose a camera from the Cameras popover.

3. Tap the Time Lapse button to the right of the Cameras button.

4. Make sure Time Lapse is selected under Mode.

5. Drag the dials to select an interval, then tap outside the popover to dismiss it (4.9).

6. Tap the Capture button to start capturing the scene. The button doubles as a countdown timer while waiting for the next shot (4.10).

7. Tap the Capture button again to stop recording frames.

▶ **TIP** Tapping anywhere near the Capture button works, too—you don't have to hit the button perfectly centered.

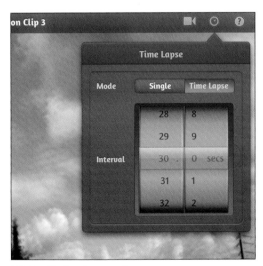

4.9 Specify Time Lapse settings.

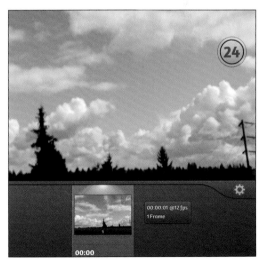

4.10 The Capture button counts the time to the next shot.

Mount the iPad

The iPad's portability can sometimes be a hindrance when you're shooting in the studio. Your hands are probably already full with camera gear—you don't want to set that down to pick up the iPad, or have to crane over a tabletop to view the screen without reflections from overhead lights. That's when mounting the iPad is useful.

Although there is no shortage of cases and stands for the iPad, I favor two options: a secure mount that was designed to integrate into a photographer's collection of stands and arms, and a simple desk mount that props up my iPad nearly all the time it's close to my computer. I encourage you to explore the market for options, which change often. For example, if you also dabble in music, a number of attachments designed for performance stands could also work to hold the iPad in place, to set it up as a teleprompter, to play relaxing music for clients or subjects, and for other uses.

Tether Tools Wallee System

The Wallee Connect system from Tether Tools consists of two parts: a case that connects to the back of the iPad (see the next page), and the Wallee Connect, a sturdy adapter that secures to the case and features holes and threads to connect it to tripods, heads, and lighting stands (4.11). The Connect Kit, which includes the case and the Connect, costs about $120.

4.11 Wallee Connect

Threads for tripods and light stands

Locking mechanism

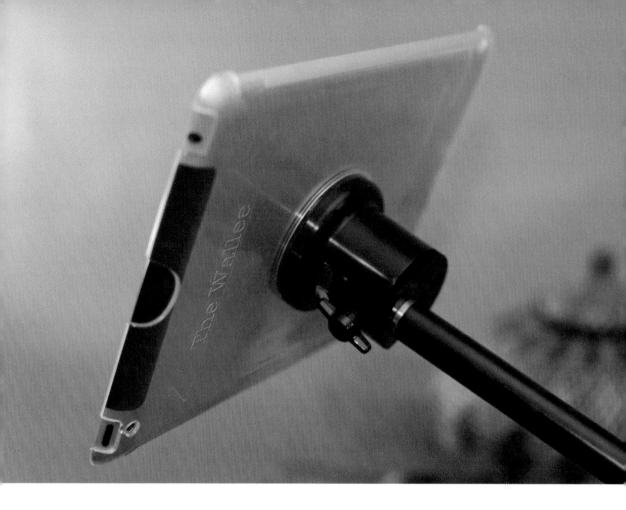

The Stump

Hundreds of iPad stands exist on the market now, ranging from simple plastic kickstands to large suction cups, but there's one that's proved invaluable to how I work. I often want to prop the iPad next to my computer or on a shelf or table near where I'm shooting. The Stump is a $25 angled piece of heavy material covered in rubber that puts the iPad into three positions, in either portrait or landscape orientation (4.12).

It sounds almost too simple, I'll grant you. I received one in a bag of goodies for speaking at a conference and figured I'd toss it fairly soon. However, it's currently lifting my iPad more often than the Smart Cover I bought. Whether it's for during a shoot or for working next to your computer later, the Stump is a great little addition.

4.12 The Stump is simple, portable, and quite useful.

Extend Your Computer Desktop with Air Display

Here's a neat way to take advantage of the iPad's screen real estate when you're back at your computer processing images: Set it up as a second display. Avatron's Air Display ($9.99) communicates between your computer and iPad via Wi-Fi to extend the computer's desktop **(4.13)**. Stash Photoshop panels on the iPad's screen to get them out of the way, or keep email and Twitter windows off to the side, leaving more space for working with your photos.

Speaking of Photoshop, the Adobe Nav app for the iPad can be helpful without invoking screen sharing. When running Photoshop CS5 or later on the computer, Adobe Nav ($1.99) accesses tools off to the side, offering more workspace on your computer.

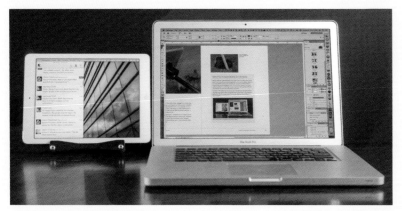

4.13 Use the iPad as an external monitor with Air Display.

CHAPTER 5

Rate and Tag Photos

Even if I were to do nothing else with photos on my iPad, I would want to perform my first round of rating and keyword tagging. I know that isn't the most thrilling way to pass the time, but doing that essential work on the iPad means less work later. I'd much rather spend time in front of my computer editing the photos than sorting them, especially since rating and tagging can be done with the iPad during downtime like waiting for a flight, chilling out in a coffee shop, or sitting on the couch in the evening.

Actually making that possible, however, is a difficult task, which explains why there are only a few apps capable of doing it. The ones I'm focusing on are Photosmith and PhotosInfoPro, which let you rate and assign keyword tags to imported photos, and then export them with the metadata intact to your computer (including direct sync with Adobe Photoshop Lightroom in the case of Photosmith). Several image editing apps also now offer tools for rating and tagging. Adobe Lightroom mobile doesn't currently include these features (though the company appears to be working on them), but it does let you flag photos as picks or rejects and easily synchronize the photos with the desktop version of Lightroom.

Rate and Tag Using Photosmith

Apple introduced the iPad Camera Connection Kit at the same time as the original iPad. In the years since, we've seen all kinds of software innovations with Apple's tablet, but surprisingly, being able to rate and tag photos hasn't quite succeeded until now. It seems like a reasonable request: Take the images you imported onto the iPad; assign star rankings to weed out the undesirable shots and elevate the good ones; add important metadata such as keywords; and, lastly, bring the photos and all that data into a master photo library on the computer.

Photosmith, in my opinion, finally delivers those capabilities. When you're shooting in the field, you can act on those photos instead of keeping them in cold storage. Back at the computer, that work flows smoothly into Photoshop Lightroom, so you don't have hours of sorting ahead of you.

Import Photos

After you import photos into the iPad using a camera adapter or wireless device (as described in Chapter 3), you next need to bring them into Photosmith. To pull images from the iPad's photo library, do the following:

1. Tap the Import button.

2. Choose an album from your library at left to view its photos (5.1).

3. Select the images you want to import. The checkbox above each group selects all shots in that group; you can drag the Smart Group slider to adjust the groups by their capture times. Or, tap the All, Invert, or None button to refine the selection.

4. Tap the Settings button to pick how the photos will be imported. The default setting is to copy files from the iOS library to Photosmith's library, which is what I recommend. It occupies more of the iPad's storage but is more stable than choosing the alternative, which is to link to the files. If the iPad is running short on free space, delete the images in the Photos app after you've copied them into Photosmith.

5. If you shot raw images, choose whether Photosmith should decode the raw files. The app can build full-resolution previews that are more accurate than the often-minimal JPEG previews the camera creates.

6. Also in the Settings screen, optionally assign the imported photos to a user collection.

7. Tap the Import button to copy the photos to Photosmith's library.

Photosmith can also import photos directly from an Eye-Fi card or from an FTP site. You'll find the configuration options in the Dashboard pane.

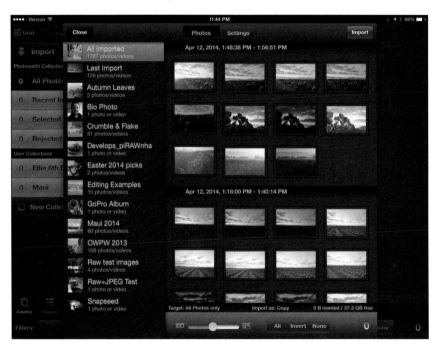

5.1 Importing photos into Photosmith

Importing from ShutterSnitch into Photosmith

As I mentioned in Chapter 3, I prefer to use ShutterSnitch to import photos wirelessly from Eye-Fi cards and other compatible adapters, but the app stores the images in its own database. That requires exporting shots to the Camera Roll, and then re-importing into Photosmith. However, the developers of both apps have come up with a grand solution (and even open-sourced the FileXchange method for sharing images between apps for other developers that want to implement it). In ShutterSnitch, export the photos using the PhotoCopy option. Choose Photosmith as the destination app, and the photos transfer over.

Rate Photos

As you'll learn in the pages ahead, Photosmith features several ways to organize and group your photos. But let's start with the most likely first action: reviewing and rating the images you imported. The app supports ratings (1–5 stars) and color labels that track with those features in Lightroom. You can also mark photos that don't make the cut as rejected.

To rate photos, do the following:

1. Double-tap a thumbnail to expand the photo in Loupe view. You can also tap the Fullscreen button to hide the sidebar and review each photo larger. Pinch to zoom in or out to view more or less detail.

2. Tap a star rating on the QuickTag bar to assign it to the photo (5.2). Or, if the shot isn't salvageable, tap the Reject (X) button to mark it as rejected. (The photo will still be transferred to Lightroom if you sync it, but it will arrive marked as rejected.)

3. If you use colors to label your shots, tap one of the color buttons.

5.2 Rating a photo in Loupe view

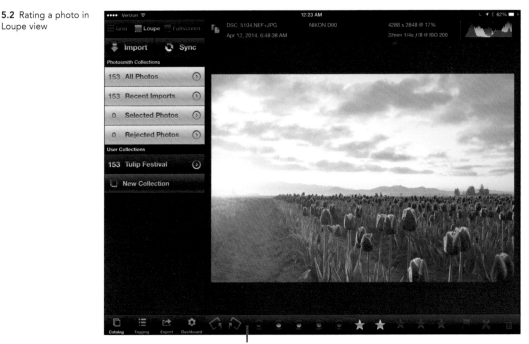

QuickTag bar

4. Use the Rotate buttons to turn photos that arrived with incorrect orientation in 90-degree increments.

5. Swipe left or right to switch to the next or previous photo.

6. Continue until you've rated all the photos you want.

 To return to Grid view, tap the Grid button; the photos are marked with stars to indicate their ratings (5.3).

The values of the stars are up to you. My approach is to rate anything that looks promising (which sometimes means, "Oh hey, that one's in focus after all!") as one star. Photos that strike me more creatively get two stars. On rare occasion I'll assign three stars at this stage, but usually I reserve stars three through five for after I've edited the photos in Lightroom.

Rate multiple photos simultaneously

For an even faster initial review pass, you don't need to enter the Loupe or Fullscreen views. Select the photos you want to rate or categorize in Grid view, and apply the information at once, like so:

1. In Grid view, tap once on a photo to select it. Tap to select others.

2. Tap the rating or color label in the QuickTag bar to apply it to each selected photo.

3. To let go of your selections, you can tap each one again, but there's a better way: Swipe up on the QuickTag bar and tap one of the selection buttons—All, Invert, or None (5.4).

5.3 Ratings and color assignments appear on thumbnails in Grid view.

5.4 The filter controls in the expanded QuickTab bar include buttons to select all thumbnails or none, or to invert the selection.

Assign Keywords

In the interests of speed and convenience when reviewing photos, one task that's often ignored is assigning keywords to the images. On the computer, it's a mundane but important task (especially if you've ever found yourself trying to find an old photo and ended up just scrolling through thousands of shots); on the iPad, it was darn near impossible to do until only recently.

Create or assign keywords

Bring up a photo in Loupe view or select one or more photos in Grid view, and then do the following:

1. Tap the Tagging button in the sidebar.

2. Tap the Keywords field to bring up the Keywords editor (5.5).

3. To create a new keyword, tap the Search field and begin typing. As you do so, in addition to listing matches to existing terms, the text also appears under a Create New Keyword heading. Tap the tag that appears to add it to the selected photo or photos and to the Keywords list.

4. To assign an existing keyword, locate it in the list on the left and tap its button. You can also choose from the lists of Recent and Popular keywords that appear to the right.

 To quickly locate a keyword, begin typing it in the Search field at the top of the screen.

5. Tap Done when you're finished.

5.5 The Keywords controls

Build keyword hierarchies

I prefer a single list of keyword tags, but you may be more comfortable with multiple levels of parent and children terms. Photosmith caters to both styles, letting you build keyword hierarchies that Lightroom understands, like so:

1. With the Keywords editor open, tap the Detail (>) button to the right of any tag to set that tag as the parent.

2. Type the name of the child keyword in the Search field. As the child keyword appears under the Create New Keyword section, Photosmith notes that it will belong to the parent tag.

3. Tap the new keyword to add it to the list and to the selected photo or photos.

▶ **TIP** When multiple photos are selected and some contain keywords that are missing from the others, an asterisk (*) appears on any term that isn't shared by all. To quickly add it to the rest of the group, touch and hold the keyword and choose Apply to All from the group of commands that appears.

Remove keywords

Suppose you mistype a keyword or apply it to a term by accident. To remove a keyword from those already applied to a photo, touch and hold it and then tap the Remove button (5.6). Or, to just remove a keyword from the hierarchy, swipe left to right over it and tap Delete.

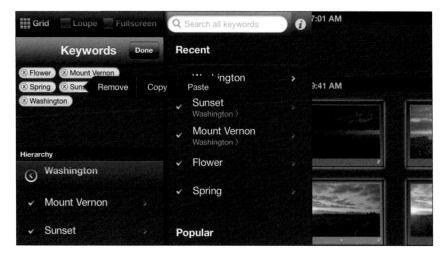

5.6 Removing a keyword from a photo

Edit Metadata

Keywords are essential for locating your images later and for assigning terms that can be found in photo-sharing services and commercial image catalogs, but you should also take advantage of other metadata while you're processing your photos in Photosmith.

With one or more photos selected in your library, go to the Tagging panel of the sidebar and tap any field to enter text (5.7). The Photo Title and Caption fields, for example, are used to identify images on Flickr and other sites. The IPTC fields are also important, because they embed your contact information, copyright statement, and job-specific metadata into the image file.

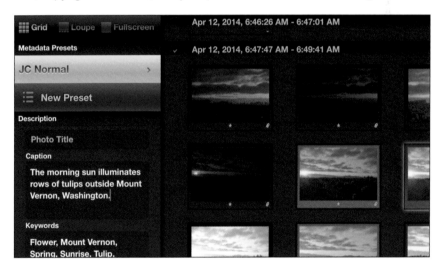

5.7 Add metadata to multiple selected photos.

Create metadata presets

Unless you are narcissistic and enjoy typing your name over and over, you don't want to re-enter the same metadata for each photo. Create metadata presets that include all your information, and then apply them to your photos in batches.

1. Select at least one photo in Grid view, or switch to Loupe view.

2. In the Tagging menu, tap the New Preset button.

3. In the drawer that appears, rename the preset at the top of the drawer, and fill in any other metadata fields you wish to save (5.8).

For example, you may want a generic preset that includes your contact and copyright information, and an additional one that applies to a specific location or project.

▶ **TIP** Unfortunately, you can't specify keywords in a metadata preset, which would be great for adding tags that you always apply (in my case, "jeffcarlson" and the camera I'm shooting with, like "D90" or "G12"). I'm hoping that capability arrives in a future update.

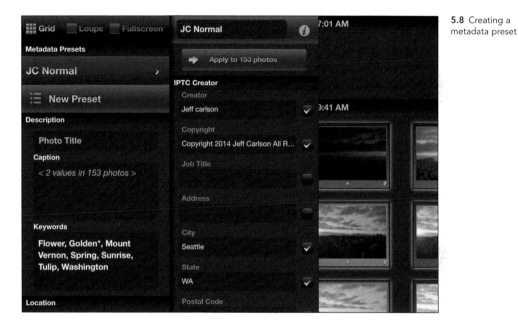

5.8 Creating a metadata preset

To apply that metadata, do the following:

1. In the Tagging menu, tap the name of the preset you created. The information appears in the drawer.

2. Any fields you filled out before are selected automatically; if you want to omit one, tap the checkbox to the right of the field to deselect it.

3. Tap the "Apply to [number of] photos" button to tag the selected shots.

If you want to choose a different preset without applying anything, tap the preset's name in the sidebar to hide its drawer.

You can edit a metadata preset at any time simply by updating the contents of the fields. However, the change isn't retroactive—earlier photos tagged with that preset don't gain the new information.

Filter Photos

Now that you've rated and tagged the photos and applied metadata to them, you can take advantage of Photosmith's filtering tools to customize which images appear based on all that information. Swipe up on the QuickTag bar to reveal the filtering options.

> ▶ **NOTE** Naturally, you don't need to apply every last bit of metadata before you can start filtering your library. Particularly when I want to share something online quickly, I'll do a pass of reviewing and rating my imported photos and then filter that group to view just my two-star picks. But for the purpose of explaining how the features work, it made sense to cover it all before talking about how to filter against it.

Filter by metadata

Here's where that rating and tagging pays off on the iPad. To display photos that match certain criteria, do the following in Grid view:

1. Swipe up on the QuickTag bar to reveal the filter options.

2. Tap the Set Filters button to reveal more specific filter controls.

3. Tap the criteria you wish to filter against (5.9). Selecting a star rating, for example, displays only images matching that rating. You can also filter by color labels and rejected status.

4. Tap Done to apply the filters.

5. To toggle filtering on and off, tap the checkbox to the left of the Set Filters button.

5.9 Using filters to view only photos marked with two or three stars

Change the sort order and criteria

Normally, photos appear in Grid view based on their capture date, with the newest additions at the bottom of the list. To change the order in which they appear, or to list them by import date, star rating, or color label, do the following:

1. Swipe up on the QuickTag bar to reveal the filter options.

2. To toggle the sort order between descending and ascending, tap the arrow at the left of the Sort button (5.10).

3. Tap the Sort button itself to reveal more sorting options.

4. Tap the button for the sorting criterion you wish to use (5.11).

5. Tap Done to go back to the filter options.

5.10 Swipe up on the QuickTag bar to reveal the filter options, including this button for changing the sort order.

5.11 Tapping the Sort button reveals more sorting options.

Filter using Smart Groups

Here's an issue I run into often when importing photos into Lightroom. The pictures on my memory cards tend to span several events, or even days if I haven't been shooting regularly. Lightroom sees the photos as one big collection, regardless of their contents. If I want to split them out into groups—and more importantly, apply accurate metadata during import— I need to bring them over from the camera in several batches.

Photosmith's Smart Groups feature enables you to view those photos in separate batches, adjusted on the fly using a simple slider control. Even if the photos cover one larger event, it's likely they represent distinct experiences. For example, when I'm on vacation I don't usually sit around and shoot in one place. I could be fly-fishing in the morning, sightseeing in

town in the early afternoon, hiking later in the day, and waiting for the sunset at a scenic overlook in the evening. (Now I want to go on vacation!)

A better and faster workflow instead works like this:

1. Import all the photos into the iPad.

2. Import the photos into Photosmith. (This step also lets me cull the obviously poor shots.)

3. Swipe up on the QuickTag bar to view the Smart Groups slider (5.12).

4. Drag the slider to the left to break the library down into finer events. Or, to group more photos together, drag to the right.

This grouping gives you the opportunity to select ranges of photos by tapping the button to the left of the date stamps. Then you can apply ratings and keywords in batches that better match the grouping of real-life events.

▶ **TIP** The Smart Groups slider doesn't have to be tied to capture dates. It takes its cues from the Sort criteria that are to the left of the slider.

5.12 Selecting a finer Smart Groups setting (drag to the left) breaks the shoot into groups.

Smart Groups slider Finer setting

Group Photos into Collections

For some people, having metadata in place is good enough to locate photos using filters and searches. Other people prefer to store images in albums, folders, or other types of digital shoeboxes. Photosmith's collections scratch that itch, giving photos an address within the app where they can be easily found. (Collections also play an important part in syncing between the iPad and Lightroom, as I'll discuss shortly.)

Follow these steps to add photos to a collection:

1. Select the photos in your library that you want to include in a collection.

2. If you need to create a collection from scratch, tap the New Collection button and give the collection a name.

3. To add the selected photos to the collection, take one of two actions:

 - Drag one of the photos onto the collection's name in the sidebar; all selected photos will accompany it.

 - Tap the collection's Detail (>) button to view its options in the sidebar drawer, and then tap the Add Selected Photos button (5.13).

▶ **TIP** A faster method of creating a collection is to select the photos you want and then drag them as a group to the New Collection button. Photosmith prompts you to name the collection and then you're done.

Deleting photos from a collection is just as easy: Select the photos you wish to remove, tap the collection's Detail (>) button, and tap the Remove Selected Photos button. You can also delete a collection by tapping Delete User Collection in the Detail options pane; the photos in the collection are not deleted from your library.

5.13 Adding selected photos to a collection using the sidebar drawer

Detail button

Sync with Photoshop Lightroom

And now we get to the whole point of using an app like Photosmith. Rating and tagging is helpful, but if you can't transfer that metadata with your photos to Lightroom, all the work you put into it ends up being futile. Photosmith offers two methods to synchronize your images and data.

Set up the Photosmith publish service

Lightroom's Publish Services panel lets you sync photos to your libraries on Flickr, Facebook, and others. Photosmith takes advantage of this conduit, enabling two-way synchronization between the iPad and the desktop. Download the free Photosmith plug-in at www.photosmithapp.com, and install it in Lightroom using the Plug-in Manager.

Any collections you create in Photosmith show up in Lightroom as well, and the photos and metadata remain in sync when you click the Publish button in Lightroom (5.14).

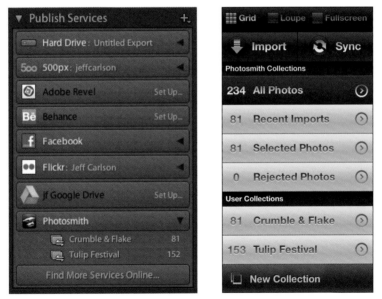

5.14 Collections appear in Lightroom (left) and in Photosmith (right).

Sync photos

To synchronize photos in Photosmith's catalog, do the following:

1. Make sure Photosmith is running on the iPad, Lightroom is running on your computer, and both devices are on the same network.

2. In Photosmith, tap the Sync button.

3. Select the collections you want to sync (5.15).

4. Tap the Sync [number] Collection(s) button to sync the catalog. The photos transfer to Lightroom, and any collections you've made are kept intact.

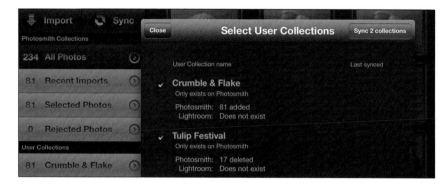

5.15 Sync selected collections.

▶ **TIP** Before you sync, I recommend adjusting the Local Destination setting in Lightroom for where the Photosmith plug-in stores the files. In my case, Photosmith put everything from my first sync into the Pictures folder on my Mac—a logical assumption. However, Lightroom stores imported photos in subfolders named according to the images' capture dates. In Lightroom, double-click the Photosmith publish service in the Publish Services pane to reveal its settings. Then, go to the Photosmith –> Lightroom Image Options area and specify where the files will end up in the Local Destination fields. If your Lightroom catalog already sorts by chronological folders, choose By Date from the Organize pop-up menu and then select a style from the Date Format pop-up menu.

Apply Develop settings

Does your camera tend to capture everything with a slight color cast? Or perhaps you've hit upon a favorite combination of edits that reflect your photographic style. If you've saved those values as Develop module presets, you can apply them (or any of the built-in Lightroom ones) during the sync process. Since Lightroom is performing the edits, they're non-destructive, so you can change or remove them within Lightroom at any point. Double-click the Photosmith publish service to bring up the Lightroom Publishing Manager, and expand the Photosmith -> Lightroom Image Options section. Then select the Develop Settings checkbox and choose the setting you want (5.16).

Apply a metadata preset

Earlier, I bemoaned the fact that Photosmith can't save keyword tags in a metadata preset. With help from Lightroom, you can overcome that limitation by applying one of Lightroom's metadata presets at import. If you've already created metadata presets in Lightroom, go to the Lightroom Publishing Manager, select the Metadata Preset checkbox, and then choose the preset you want. In the Action pop-up menu that appears, set how the data will be applied: Photosmith first, Lightroom first, just Photosmith, or just Lightroom.

Sync keywords

In addition to transferring the image files, Photosmith keeps Lightroom's library of keywords up to date every time you sync. This option, also in the Lightroom Publishing Manager, gives you the option of syncing just the keywords applied to the current set of photos or syncing all keywords in the catalog (which happens more slowly).

► **TIP** Want to speed up Lightroom import? Of course you do! Here's a clever way to copy your photos faster. When you get to your computer, connect the iPad via USB (even if you normally synchronize over Wi-Fi), and use Lightroom's standard import process to pull the photos from the Photo Library; transferring files over USB is much faster than over Wi-Fi. Next, use the Photosmith publish service in Lightroom to sync it with Photosmith (or initiate a sync from Photosmith). The sync copies only the metadata between iPad and computer; it doesn't re-copy the image files.

Sync photos from Lightroom to Photosmith

Consider this alternate scenario: You didn't get a chance to review your photos in Photosmith while you were out in the field, and you imported them into Lightroom directly from the camera. However, you'd still like to use Photosmith to review the shots, rather than accomplish the task while chained to your computer. The Photosmith plug-in can transfer JPEG versions of your photos (optimized for the iPad's screen if you want, cutting down on storage space and transfer time). Rate and tag them there, and then sync the metadata back to Lightroom when you're ready.

1. In Lightroom, right-click the Photosmith publish service and choose Create User Collection.

2. Enter a custom name for the collection in the dialog that appears.

3. Click the Create button. If Photosmith is running, an empty collection automatically appears.

4. Add the photos you want to sync to the collection.

5. With the collection selected, click the Publish button. Or, in Photosmith, sync the catalog or just the collection. The images copy to the iPad.

► **TIP** When you transfer photos from Lightroom to Photosmith, you don't need to send over the original high-resolution files—the goal is to review the photos, rate and tag them, and then sync just that metadata back. That's especially true if you're shooting with massive files created by cameras like the Nikon D800. The Photosmith plug-in transfers only JPEG-formatted files, at a size of your choice. Go to the Lightroom Publishing Manager (double-click the publish service) and, under Lightroom -> Photosmith Image Options, choose an image size: Full Screen, which matches the resolution of the original iPad 2 and the original iPad mini; Full Screen (Retina), the size for the third-generation and later iPads; or Full Resolution, which matches the original photo's dimensions.

After you mark the photos on the iPad, sync the collection or your entire library to update the changes in Lightroom. The same applies if you update a synced photo's metadata in Lightroom: When you sync again, the last-updated version is retained on both devices.

▶ **TIP** Do you rely on smart collections in Lightroom that update themselves based on criteria you feed them? Photosmith doesn't yet support smart collections (although the developers say they're working on the feature), but you can achieve similar functionality. In Lightroom, select all photos in a smart collection, and then drag them to a Photosmith Publish collection. You'll need to do this again the next time the smart collection is updated, but duplicates aren't transferred.

Export to Photosmith

If those aren't enough options, you can also set up Photosmith as an export target. In Lightroom, choose File > Export and then specify Photosmith from the Export To menu. You can specify the image format and size, and you can choose whether to sync keywords for the entire library (slower) or just the keywords in use by photos (faster). The export settings can also be set up as a preset for easier export later.

Export to Other Destinations

As you'd expect, you can share photos to Flickr and Facebook or attach them to outgoing email messages. And you can also copy photos to albums within the iOS photo library, which makes them accessible to other apps on the iPad. You'll find these options in the Export menu.

However, I want to draw attention to three other export options that broaden the usefulness of Photosmith. Although the app was designed to work with Lightroom, you can still export tagged photos to your computer for later processing in other software.

Dropbox

If you're on a robust Internet connection, copy images from Photosmith to Dropbox, which makes them automatically appear on any computer on which you're running the online service.

1. Select the photos you want to transfer.

2. Tap the Export button at the bottom of the sidebar.

3. Tap the Dropbox button to reveal the Export to Dropbox drawer (5.17).

4. At the top of the drawer, choose which photos to send (such as "Send 5 selected photos").

5.17 Send photos to your Dropbox account.

5. Tap one of the upload size buttons (Med JPG, Large JPG, or Orig) if you want to resize the photos.

6. If you want metadata saved in separate files alongside the image files, select the Create XMP Sidecar checkbox (see below).

7. Tap the Send Photos button to start copying.

XMP Export

When you're working with JPEG images, additional metadata is written to the image file. But raw images are treated as sacred originals in Photosmith and not changed in any way. To associate metadata with the file, you can export an additional XMP (Extensible Media Platform) file that contains the information and rides alongside the image. So, a raw file named DSC_1234.NEF would have a sidecar file named DSC_1234.XMP that includes the metadata. When imported into most photo management software, the data is combined with the image.

Photosmith's Dropbox option is capable of adding the XMP files during export. If you don't use Dropbox, you can still access the metadata files by tapping the XMP Export button, exporting selected files, and then copying them from within iTunes or via FTP.

PhotoCopy

The PhotoCopy option lets you export photos and their metadata to other iOS apps that support the FileXchange method of sharing images between apps. With images selected, tap the Export Photos button and then choose the app to receive them.

Delete Photos

You're bound to hit the ceiling of how many photos your iPad can store (even if you sprang for the 128 GB model), so you'll want to delete photos from Photosmith. After you've processed your photos and transferred them to your computer, do the following to remove them:

1. Select the photos to delete.

2. Tap the Delete button (the trash can) in the QuickTag bar to bring up the Delete Photos window. Photosmith notes whether the images have been synced to Lightroom or not (to make sure you don't accidentally delete images), and gives you the option of deselecting any shots you want to keep.

3. Tap the Delete button to remove the images. If you copied them originally from the iOS photo library, those originals still remain on the iPad. If you imported them into Photosmith as links, the links are removed.

The Proxy JPEG Workflow

What if, as I describe in Chapter 2, you're recording photos as Raw+JPEG to two memory cards in your camera—one for raw and one for JPEG files? Using a "proxy JPEG workflow," you can import only the JPEG images into the iPad, work with them in Photosmith, and then marry them with their raw counterparts in Lightroom. See http://support.photosmithapp.com/knowledgebase/articles/66161-proxy-jpg-workflow-v2- for more information.

Rate and Tag Using PhotosInfoPro

Unlike Photosmith, which focuses on syncing photos to Photoshop Lightroom, PhotosInfoPro takes a streamlined approach that exports metadata in XMP files to be imported into any software that supports the sidecar files.

Import Photos

PhotosInfoPro reads images in the iOS photo library, so the first step is to choose which album you want to work with. Assuming you've just imported a card's worth of images into the iPad, tap the Library button and choose either the Last Import or All Imported album.

Rate a Photo

PhotosInfoPro makes it easy to scan your photos and apply ratings.

1. Tap a photo thumbnail to view it larger and to see the metadata your camera applied (5.18).

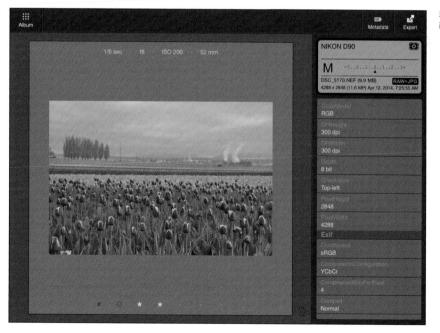

5.18 Rating a photo in PhotosInfoPro

2. Tap the rating dots below the photo to assign zero to five stars or to mark the image as rejected.

3. Flick right-to-left to view and rate the next image.

I find the default review size to be too small to get a good idea of the image's quality. Tap once anywhere to expand the size (hiding the toolbar at the top) and put the photo against a black background. You can also view the image full screen by tapping the double guillemet (») symbol to hide the sidebar. Pinch-to-zoom works in this view, but the picture snaps back to the screen edges when you lift your fingers.

However, the full-screen view obscures the ratings, so you'll need to tap once on the photo again to reveal them (making the photo smaller again).

Add Metadata to a Photo

To assign IPTC metadata to a single photo, tap it and then do the following:

1. Tap the Metadata button.

2. Tap the Keywords button (which sports a key icon).

3. Type a keyword in the Search field to locate a tag you've used previously, or tap Return on the keyboard to create a new one (5.19).

 You can remove a keyword you applied by tapping the Delete (–) button to the right of the word. To delete a keyword from the app's database, swipe left-to-right on it in the Vocabulary list and then tap the Delete button.

4. Tap the tab for another metadata category to edit its information: Headline, Creator, Copyright, Title, or Location.

5. To define a location, type a name in the Search field. Or, navigate the map using your fingers and tap the Drop Pin button in the upper-left corner to set the location in the middle of the map (5.20).

6. To exit, tap the Done button.

▶ **TIP** While you're editing metadata, swipe left or right on the photo to switch between images.

▶ **TIP** When you switch to another image in the Location tab, the map position remains the same. Tap the Drop Pin button to assign the same location as the previous photo.

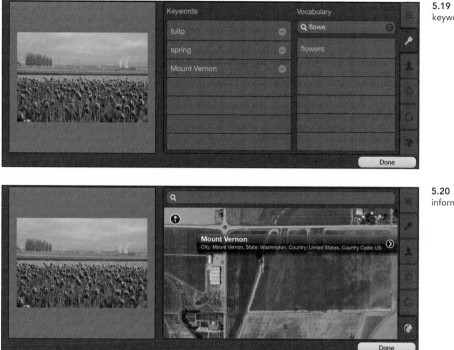

5.19 Adding keywords

5.20 Set geolocation information.

Add Metadata to Multiple Photos

Of course, you don't want to apply metadata to every photo individually if you're working on a large batch of similar shots. Here's how to tag multiple photos in one swift stroke.

1. In the Album view, tap the Metadata button.

2. Tap to select the photos you want to work with, or tap the Select All button.

3. Tap the Done button to finish making selections.

4. Enter the metadata in the respective tabs.

5. To exit, tap the Done button.

Export Metadata

PhotosInfoPro exports the metadata you apply in three ways.

- **Master + XMP.** This option sends the original image file plus an XMP sidecar file that contains the metadata.

- **XMP.** Just the XMP files are sent, saving considerable time (especially if you're in an area that does not offer robust Internet access). For example, you could upload the XMP files to Dropbox and then, when you're back on your computer, import the images from your memory cards. You'd then import the XMP files and match them with the photos.

- **JPEG.** The JPEG option writes the metadata into the JPEG file, bypassing the need to deal with XMP sidecar files. However, note that the JPEG route applies an additional level of compression to your images, reducing their quality. Even if the photos were shot on JPEG originally, you'll end up with higher-quality photos by using Master + XMP.

To export photos and metadata, do the following:

1. Choose one image or multiple images; for the latter, tap the Export button in the Album view, select the photos you want, and then tap Done. The Export window appears (5.21).

2. Choose an export option and tap the method you'd like to use, such as the iTunes shared folder, Dropbox, or FTP.

3. In the photo organizing software on your computer, import the image files and XMP pairs.

5.21 Exporting multiple photos and their metadata

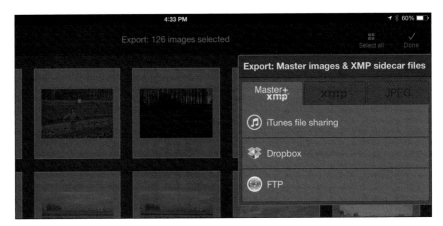

Rate and Tag Using Editing Apps

I've spent this chapter focused on Photosmith and PhotosInfoPro because they both work with many photos at once. The way I prefer to work, I first review and rate my photos, find the ones that are worth spending more time on, and then bring them into an editing program (on the iPad or on the computer) later. Sometimes it feels as if I can fire off 200 shots just watching dust migrate, so sorting images one at a time just isn't practical.

However, if you're under the gun to process a few shots and share them with a client, editor, or friends online, running them through Photosmith is overkill. That's why some editing apps now offer the ability to edit various metadata and save that information to the exported image file. By way of example, I'm using the image editor Photogene, which I cover in more detail in the next chapter.

Rate Photos

Photogene offers two methods for assigning star ratings:

* While you're viewing photos in their albums, touch and hold a photo until an options bar appears, and then choose View Metadata.

* Open and edit a photo in Photogene's editing environment, and tap the Metadata button.

Tap the General heading in the popover that appears, and then select a star rating (5.22).

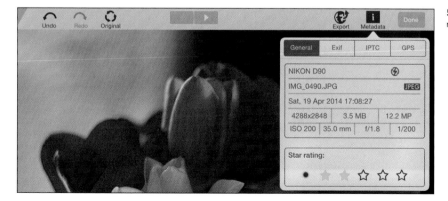

5.22 Assign a star rating in Photogene.

Add IPTC Information

Much of the IPTC information that gets embedded with the photo is specific to the shot. In the Metadata popover, tap to edit any of the text fields (5.23).

However, the core data about *you* presumably stays the same, in which case you'll want to create IPTC defaults and sets that you can easily copy and paste to new photos.

Create and use IPTC sets

The advantage to creating sets is that you might want most of the same information (such as contact info) but need something about it tailored for specific uses. In my case, I shoot with two cameras: a Nikon D90 and a Canon PowerShot G12. So, I've set up separate IPTC sets that are nearly identical except for the camera-specific information.

1. In the Metadata popover, tap the IPTC heading and then tap the IPTC Sets button.

2. Tap the plus (+) button to create a new set. Tap the name of the new set to reveal its information fields.

3. Enter the relevant information in the IPTC fields. When you're done, tap the IPTC Sets button in the popover's menu bar.

The next time you need to quickly add metadata from one of your sets to a photo, tap the Metadata button, tap IPTC Sets, and then tap the Use Set button belonging to the set you created.

▶ **TIP** You can also apply IPTC sets to several photos in a batch. After you fill in the values in one photo, scroll to the bottom of the Metadata window and tap the Copy button. Then, when viewing your library, tap the Select\ Collage button. Tap to choose one or more images, and lastly, tap the Paste IPTC button.

Export IPTC Information

When you're ready to export the photo, make sure the IPTC data goes along with it. Tap the Export button and set the Preserve IPTC switch to On (5.24). The information is written into the file that gets exported.

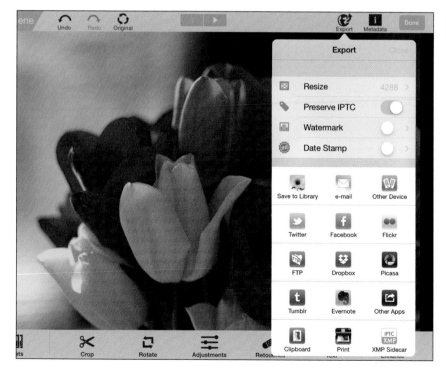

5.24 Make sure Preserve IPTC is turned on.

Sync and Flag Photos in Adobe Lightroom mobile

I'm accustomed to having my entire photo library available in Lightroom on my computer, so of course that's what I expected at first from Lightroom mobile. But I quickly realized that's absurd: When you travel, do you bring your entire wardrobe? No, you take what you think you'll need (at least, I hope you do!). In this case, you sync collections between Lightroom and Lightroom mobile that you intend to review or edit on the iPad. You can also build collections on the iPad, edit the photos there, and sync them with the desktop version of Lightroom.

Create and Sync Collections

Lightroom offers a few methods of creating a collection, but here's how I do it:

1. In your library, select the photos you want to put into the collection. These can be shots from the All Photographs list (which you choose in the Catalog panel within the left sidebar), for example; I often choose Previous Import in the same panel after I've imported a card's worth of images.

2. Click the menu button in the Collections panel and choose Create Collection.

3. In the dialog that appears, give the new collection a name and make sure both "Include selected photos" and "Sync with Lightroom mobile" are selected.

 You can, of course, make a new empty collection and then populate it after it's created, but selecting the images first minimizes the amount of dragging you have to do later. You can always add more photos to a collection once it exists.

4. Click the Create button.

The new collection appears in the Collections panel, and Lightroom begins syncing its photos; the sync button that appears to the left of a collection name indicates which collections are set up for syncing (5.25).

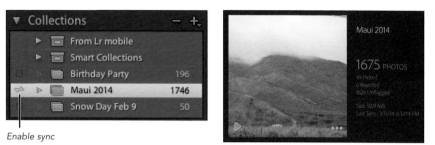

Enable sync

5.25 Sync collections from the desktop version of Lightroom.

Any collection (except for smart collections) in your library can be synced to Lightroom mobile. Click the sync button to the left of the collection name to enable it.

If you decide you no longer wish to sync a collection, click the button to disable syncing. Keep in mind that the collection's photos are removed from Lightroom mobile and the Adobe servers that connect to it. Re-enabling a collection triggers the desktop version of Lightroom to re-upload all the photos.

Not every collection begins on the desktop. You can create one in Lightroom mobile and then import images from the iPad's Camera Roll and sync them with the desktop version of Lightroom. The collection appears in the Collections panel under the "From Lr mobile" collection set.

▶ **TIP** Throughout Lightroom mobile, tap with two fingers to change which metadata is displayed. For example, doing so in Loupe view shows or hides the information about the photo and the histogram. In Grid view, the two-finger tap reveals badges to indicate edit status and rating, as well as basic image metadata **(5.26)**.

Badge indicates photo is flagged as a pick.

Capture metadata

5.26 Tap with two fingers to reveal image metadata.

Add photos to a collection

The advantage of syncing collections is that you're not just pushing pixels from the computer to the tablet. Adding photos you've imported into (or captured using) the iPad can be done manually or automatically. In Lightroom mobile, tap the button in the lower-right corner of a collection's thumbnail (which looks like ellipsis points: "...") to reveal options that include these two import actions:

- **Add From Camera Roll** is the same action you take when creating a new collection within Lightroom mobile. Tap to select photos to add, and then tap the Apply button (the checkmark) (5.27).

- **Enable Auto Import** sets that collection as the target to automatically bring in any new photos added to the Camera Roll since you last used Lightroom mobile. This option is an easy way to ensure that all of your images end up in Lightroom.

▶ **NOTE** Importing photos from the Camera Roll has one significant downside: Lightroom mobile doesn't import raw files. So this approach won't work for adding raw images to Lightroom. If you shoot Raw+JPEG format, the JPEG versions will be imported and synced, but you'll still have to import the raw files into Lightroom on the computer later.

5.27 Add photos from the Camera Roll.

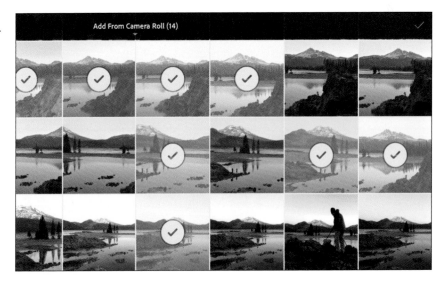

Remove photos from a collection

I'm the type of person who has difficulty deleting photos from my library. (That blurry sunrise might turn out to be art someday!) But I have no qualms about removing images from my Lightroom mobile collections. Getting rid of them on the iPad frees up space for more photos. More important, the originals are still locked safe in Lightroom desktop.

Tap a collection to view its contents in Grid mode, and locate a photo you want to remove. Touch and hold the image to display a pop-up menu, and then choose Remove (5.28). In the Loupe, tap the Share button and choose Remove.

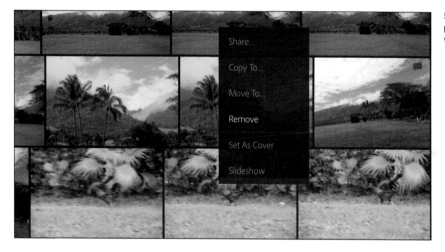

5.28 Remove the bad photos (you know which ones).

Remove a Collection from Lightroom mobile

When you are done with a collection, or just want to free up some space on your device, tap the ellipsis button (...) in the collection's thumbnail and then tap Remove Collection. Deleting a collection erases its photos from the iPad but does not affect the collection in Lightroom on your computer.

▶ **TIP** When you have hundreds of photos in a collection, swiping to view more becomes tiresome quickly. Instead, swipe vertically once to reveal a scroll bar at the right edge of the screen. During the second it's available, drag the bar's position indicator to swiftly navigate the photos.

Flag Photos as Picks or Rejects

Lightroom mobile doesn't support star ratings, but you can set the flag of a photo as a pick or a reject (or leave it unflagged). In the desktop version of Lightroom, I've long used ratings to identify the good images from the bad, so I'm a little disappointed that only flags appear in the mobile incarnation.

However, I've found that it's also an advantage: I now use flags to mark photos that I want to revisit in Lightroom desktop. When I'm looking at the shots in Lightroom mobile, I don't have to expend any extra attention deciding star ratings or color labels, making for a faster review pass. And when I'm perusing the Grid, I filter by Picked to hide rejected and unflagged shots.

▶ **TIP** Adobe has hinted that it's working on adding deeper metadata support to Lightroom mobile. At the time of this writing, however, the app is focused on synchronizing collections and editing images (see Chapter 6).

A flag button appears in the lower-left corner of the screen, but consider that to be just a visual indicator, even though you can tap to toggle the flag status. The better way to flag an image is to swipe with one finger up or down to pick, reject, or unflag the photo (5.29).

5.29 Adobe Lightroom mobile supports flagging photos as picks or rejects.

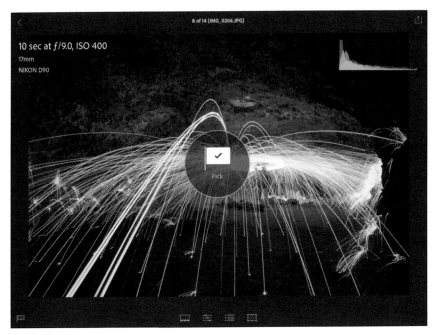

Review and Rate in PhotoScope

If you use Apple's Aperture or iPhoto to manage your photo library, Photo-Scope is another option for reviewing your photos on the iPad. The app reads photo thumbnails from a Mac that's running a PhotoScope Helper application, providing a near-live interaction with the library. The catch is that it works only on the same network as the computer hosting the library. You can't use it while you're in the field, but it does remove the tether keeping you in front of the computer so you can review and rate photos on the couch.

PhotoScope can display full-size previews for review, and you can rate, reject, and flag photos (5.30). It doesn't offer the ability to edit or apply additional metadata.

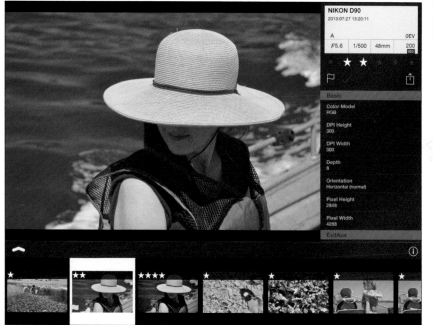

5.30 PhotoScope accesses Aperture and iPhoto libraries on the local network.

CHAPTER 6

Edit Photos on the iPad

So far, I've focused mostly on moving photos around—importing them into the iPad, organizing them, and getting them onto your computer. And if the iPad were nothing more than a glorified picture frame, that would be fine. But, of course, it's a powerful image editor, too. A rich array of apps can manipulate pixels in all sorts of ways: apply premade filters to simulate other cameras or eras, correct color and tone, retouch to fix blemishes and other oddities, and much more. Image editing tools on the iPad are especially helpful when you want to share photos soon after importing them, before you're back at a desktop computer.

In this chapter, I focus on common photo adjustments using a handful of representative apps. In practice, I use iPhoto, Snapseed, and Photogene interchangeably, depending on how I want an image to appear, so I walk through making edits in those apps. And because I organize my photos in Lightroom, I'm using Lightroom mobile more often, too. If you already have a favorite alternative, you'll find similar controls for accomplishing the tasks I mention. I also include a few specialized apps, such as piRAWnha for editing raw files directly and Handy Photo for removing blemishes or objects from a scene.

Make Photo Adjustments

In an ideal world, every photo I capture would be perfect in-camera, but that's just not the case. (It's a worthy goal to strive for, however—the less work you have to do to an image later, the better.) Most pictures can benefit from a little tinkering in a few areas. Here are the typical areas I focus on when I want to edit an image. Some of these won't apply in all cases, or may not be needed at all, depending on the image.

- **Recompose.** I'm pulling a few concepts under this heading because they each change the boundary of a photo. Cropping is often done to exclude distracting elements at the edges of the frame or to "zoom in" on a subject, but it's also often used to move a subject away from the center of the image for better visual interest.

- **Adjust tone.** Several tools affect a photo's tone: exposure, brightness, contrast, levels, curves, and more, depending on the software. Adjusting tone can usually restore detail to underexposed areas or add definition to a photo that's overly bright.

- **Adjust color.** Color usually gets edited when adjusting tone, but color-specific adjustments exist that can help photos. Changing the white balance (color temperature) can remove color casts or bring warmth to cloudy scenes, while saturation controls boost or reduce overall color intensity. Some apps also offer a vibrance control, which affects saturation but preserves skin tones (no sense kicking up the saturation if the people in your photo end up looking like Oompa Loompas).

- **Make specific fixes.** Some photos need isolated adjustments: fixing red-eye, spot-retouching, sharpening, and the like.

- **Apply creative presets.** Most adjustment apps include preset filters that approximate the looks of other cameras, add borders or "grunge" effects, or evoke aged film stock.

▶ **NOTE** Keep in mind that when you edit a raw photo on the iPad, you're making adjustments to a JPEG preview (or, if you originally shot Raw+JPEG format, the higher-quality JPEG version of the photo). That means you won't get the full advantage of manipulating the raw file, which usually yields better recovery in underexposed or overexposed areas. The exception is if you use an app, such as piRAWnha, that edits the raw file directly (explained later in this chapter).

Edit Photos in the Photos App

I highlight working in third-party apps because they offer more features, but Apple's built-in Photos app also includes a few basic editing tools. Tap a photo to view it full-screen, and then tap the Edit button to reveal the following controls:

- **Crop.** Tap the Crop button to enter the Crop and Straighten editor, and then do the following:

 1. Drag the corner handles or the edges of the overlay to redefine the visible area of the photo.

 2. Drag the middle of the photo to reposition the image within the crop area.

 3. If you want to crop the image to a specific aspect ratio, tap the Aspect Ratio button and choose an option in the popover that appears. Further adjustments to the overlay don't adhere to that constraint, though; you need to crop and then constrain again if you want to tweak the border.

 4. To straighten the image, press two fingers against the screen and rotate them left or right, like you're turning a radio dial. (You may need to zoom in first, to provide enough padding for the image to fully fill the crop area.) A faint yellow grid appears to help you align objects in the scene (6.1).

6.1 Grid lines help straighten the photo.

- **Rotate.** If a photo was imported sideways or upside down, tap the Rotate button to turn the entire image 90 degrees counterclockwise.

- **Enhance.** Tap the Enhance button to let the Photos app automatically apply tone and color correction.

- **Filters.** Tap the Filters button to view the app's small library of photo effects.

- **Red-Eye.** If people or animals have an evil glare about them, tap the Red-Eye button and then tap the affected red eyes to correct them. It's helpful to first zoom in (pinch outward), but the app does a good job of identifying eyes even if you don't tap right in the middle of them.

When you're finished making edits, tap the Save button. Or, tap Cancel to discard the changes. Even after you've saved the picture, you can always resurrect the original version by tapping the Revert to Original button, followed by the Save button (the latter because you need to save the fact that you removed the edits).

An Important Note About Color Management

You obviously want your photos to look the best they can, but digital photos are always at the mercy of the screen on which they're viewed. On your computer, you can color-manage the monitor or laptop screen to varying degrees in order to be confident that the photos' colors are displaying accurately. (If you don't color-manage your monitor, I highly recommend it—especially if you also print your own photos.)

When you take your photos to another device, however, you lose that control. And in the case of the iPad, you get what you get: it doesn't incorporate any type of color profiling or adjustment other than brightness. For some photographers this is a deal-breaker, because they want to be sure they're looking at the same color values of a photo on any device. As it currently stands, you can't expect true color fidelity on the iPad.

I suspect this isn't a problem for most photographers, no matter where they land on the professional spectrum. If the nature of your work demands a higher level of quality (usually in the form of printing photos or delivering them to clients who will probably print them), then you'll want to bring it back to the desktop and fine-tune from there.

Edit Photos in Snapseed

Snapseed differentiates itself from others in this field with an innovative interface that often makes me turn to it just because it's great to use. Conceived for touchscreen interaction, Snapseed doesn't try to be Photoshop in its approach to editing photos. Instead, it uses immediately familiar swiping gestures for choosing which edits to apply and for controlling their intensities.

To get started in Snapseed, launch the app, tap the Open button, select the image source (like your Photo Library), and choose the photo you want to edit. Once the image is loaded, tap one of the correction modules.

Recompose

To change the visible area of the photo, tap the Crop module and then do the following:

1. Drag the corner handles or edges of the selection rectangle to define the image borders.

2. Tap the Ratio button to constrain alterations to a set aspect ratio. Unlike the Photos app, the Ratio control locks the shape, enabling you to refine the borders at that aspect ratio.

 To switch between landscape and portrait orientation for the selection area, tap the Rotate button.

3. Tap the Apply button to accept the cropped area and return to the app's main screen.

If you need to straighten or rotate the image, tap the Straighten & Rotate module and do this:

1. Tap the Rotate Left or Rotate Right button to turn the image in 90-degree increments.

2. Drag left or right on the image to adjust the rotation angle, up to 10 degrees in either direction. (Dragging up or down also works.) Positioning your finger farther away from the center of the image affords more granular adjustments.

3. Tap the Apply button.

Adjust Tone and Color

The Crop and Straighten & Rotate modules use controls similar to other apps for their edits, but most of the other tools work in a central "cross" configuration: Drag up and down to select the type of adjustment you want to make, and then drag left or right to increase or decrease the amount of the adjustment. For example:

1. Tap the Tune Image module.

2. Drag vertically to display the available adjustments and select one, such as Saturation (6.2).

3. Drag horizontally anywhere on the image to increase or decrease the amount, indicated at the bottom of the screen (6.3).

4. Repeat steps 2 and 3 to choose other adjustments.

5. Tap Apply to save the edits.

▶ **TIP** In any of the Snapseed modules, tap the Cancel button to return to the app's main screen without applying any adjustments. Or, while you're working, tap the Preview button to see how the edits will look once applied; in some tools, a Compare button appears instead, so you can toggle quickly back to the version that existed before your edits.

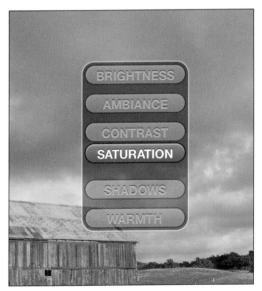

6.2 Choose an adjustment type.

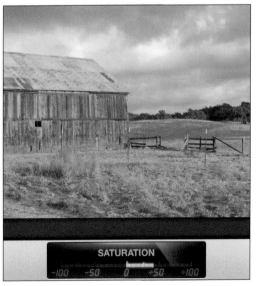

6.3 Drag left or right to specify the amount.

Adjust Specific Areas

Most of Snapseed's tools apply edits to the entire image. When you need to punch up just one area, use the Selective Adjust module. Although it doesn't offer the ability to make precise selections, such as highlighting a certain object in an image, the tool lets you define a feathered, circular area to apply brightness, contrast, and saturation.

1. With an image loaded, tap the Selective Adjust module to open it.

2. Tap the Add button to create an edit point.

3. Tap a location on your image to specify the center of the adjustment.

4. Pinch inward or outward from the point to define the affected area, which shows up as a temporary red mask while you pinch.

5. Drag up or down to choose an adjustment, which is represented on the point by its first letter: B for brightness, C for contrast, and S for saturation.

6. Drag left or right to set the intensity of the adjustment; in addition to the display at the bottom of the screen, the edit point also displays a green border to represent a positive value, or a red border for a negative value, according to the amount (6.4).

7. Repeat as needed to get the look you want, then tap Apply.

▶ **TIP** To ensure you're getting an accurate view of the adjustments you make, turn up the iPad's Brightness setting. Swipe up from the bottom of the screen to view the Control Center. Drag the Brightness slider to the right to increase brightness, and then swipe down or press the Home button to hide the controls.

6.4 To highlight the barn in this photo, I've increased brightness and saturation around the edit point at left (with the light gray radius line indicating the affected area). The edit point at right reduces brightness and increases contrast.

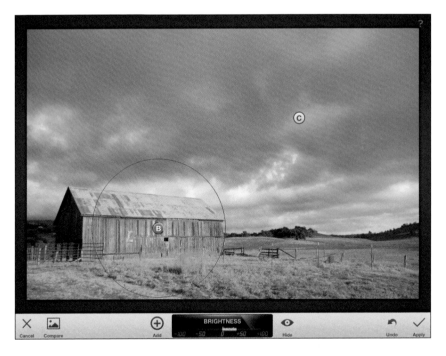

Apply Creative Presets

Half of Snapseed's modules are dedicated to applying creative effects, which follow the same approach as the correction tools. Choose Black & White, Vintage Films, Drama, HDR Scape, Grunge, Center Focus, Tilt-Shift, or Retrolux to take a photo in a new direction from the original (the image above was styled with the Drama 2 preset).

▶ **TIP** Most of the presets include a fixed number of styles, but they offer much more variation than you might expect. In Vintage Films, for instance, tap the Texture button, tap one of the textures, and then tap the texture again to randomly apply variations. Or, in the Grunge module, just drag from left to right to view hundreds of variations in color.

Edit Photos in Photogene

You may already be adept at pushing pixels in Photoshop or Photoshop Elements, in which case you'll find Mobile Pond's Photogene for iPad to be a familiar editing environment. It includes traditional tools such as levels and curves and lets you work with layers and masks.

To get started, browse your Photo Library and tap an image to open it in Photogene's editor. As you work, you can tap the Undo button to step back among your edits; or, at any point, tap the Original button to discard all changes.

Recompose

To recompose a photo using the Crop tool, do the following:

1. Tap the Crop tool to reveal the selection area and a side pane where you can constrain the aspect ratio.

2. Drag the selection handles to define the visible area. You can reposition the selection over the image by dragging the area from the middle using one finger.

3. Tap the Crop button in the pane to apply the crop.

4. To dismiss the Crop interface, tap the Crop button in the toolbar.

For images that are a bit (or a lot) askew, follow these steps:

1. Tap the Rotate button in the toolbar.

2. In the Rotate panel that appears, drag the Angle slider to straighten the image (6.5). Photogene applies the change as soon as you let go of the slider.

You can also rotate the image by quarter turns or flip the image horizontally or vertically.

▶ **TIP** To reset any adjustment slider's value to its default, double-tap it.

▶ **TIP** If you shoot in raw format, Photogene can directly read the raw file and create an editable version, versus relying on the JPEG preview the camera supplied.

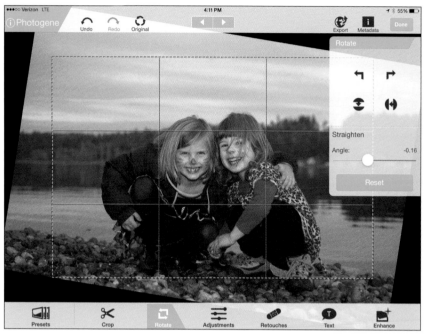

6.5 Some photos require more straightening than others.

Adjust Tone and Color

Photogene includes several tools for adjusting brightness, contrast, and color, each of which has its own strengths. The Brightness controls, for example, can brighten or darken an image or pull detail out of shadows and highlights. Or, you may prefer to adjust white and black levels using the histogram, or adjust curves to manipulate separate red, green, or blue channels.

Adjust brightness and contrast

I often shoot with exposure compensation set to –1 (or maybe a third of a stop) because it results in slightly more saturated colors and, more importantly, reduces the chance that portions of my image will end up blown out to all white. Camera sensors, especially when shooting in raw mode, capture a lot of detail in shadows that might not immediately be apparent. Pixels that are blown out, however, rarely offer any usable image data.

The easiest method is to manipulate the sliders in the Brightness section of the Adjustments panel:

1. Tap the Adjustments button to reveal the panel.

2. Drag the Exposure slider to increase or decrease the photo's overall brightness (6.6).

3. Drag the Contrast or Clarity sliders to enhance the distinction between light and dark pixels.

4. To illuminate pockets of darkness, drag the Lighten Shadows slider; this control also affects the full image, but not to the extreme that the Exposure slider does. Similarly, use the Darken Highlights slider to try to recover overly bright areas.

▶ **TIP** While you're editing, touch and hold the A/B icon to the right of the side panel's title to view the uncorrected version of the image.

▶ **TIP** I almost always tap the Auto button to see what the software suggests for a fix. And just as often, I follow that by either tweaking the sliders or tapping Reset and starting over. But viewing the automatic settings helps me determine which areas of the image need work.

6.6 Adjusting exposure in Photogene's Brightness panel

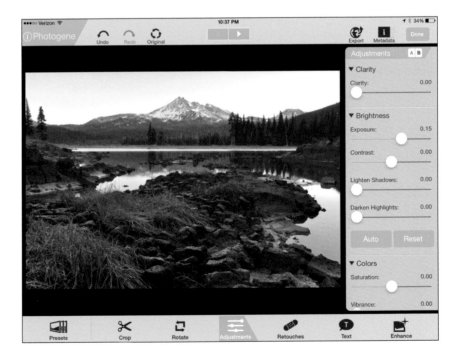

If you're more familiar with adjusting levels in desktop software, scroll down to the Histogram section, where you can drag the left vertical bar to set the clipping point of black pixels (making the image darker) or drag the right bar to specify highlight clipping (making the image brighter). The triangle in the middle darkens or brightens the image's midtones.

▶ **TIP** Tap once on the image to hide all of Photogene's panels and controls for an uncluttered view of the photo. Tap again to make the controls visible.

Some people prefer to adjust exposure using curves, a feature available in the pro version of Photogene.

1. In the Adjustments panel, tap the Show button in the Curves section. The interface appears over the top of the image (6.7).

2. To increase brightness, tap the control point in the middle of the grid and drag it up and to the left. Dragging it toward the lower-right area of the grid decreases the exposure.

3. Tap anywhere on the curve to add a new control point, which you can use to further adjust the tones. For example, adding another point toward the lower area of the curve lets me apply contrast (by compressing the dark values) while retaining the increase in exposure I applied in the previous step (6.8).

4. Tap the Hide button in the Adjustments panel when you're done.

6.7 The Curves interface

6.8 Adding a control point

Adjust color cast

Does your photo look a little green? The adjustment tools can compensate for color shifts as well as exposure values:

- In the Adjustments panel, drag the RGB sliders to increase or decrease the red, green, or blue offsets.

- If you've purchased the pro version of Photogene, bring up the Curves editor and then tap one of the colored tabs to the left to edit just those channels.

> **TIP** Touch and hold anywhere on the image to bring up a Copy Edits command, which notes the adjustments you've made. Then, in another image, touch and hold to view a bar of options, and choose Paste Edits to apply them to that image.

Adjust white balance

If your camera misinterpreted the existing light as being too cool or warm, you can specify a new value for white balance (also called color temperature). Living in Seattle, I often do this to add warmth to photos taken under gray skies, but cameras can be thrown off by fluorescent or incandescent light bulbs as well.

1. Tap the Adjustments button, and scroll down to the Colors section of the Adjustments panel.

2. Drag the Color Temperature slider left (cooler) or right (warmer).

In Photogene's pro version, you can set the white balance by identifying an area that is white, black, or neutral:

1. Scroll down to the Colors section of the Adjustments panel and tap the eyedropper icon.

2. Touch and hold on your image to bring up a zoomed-in loupe, and then drag to locate a neutral color (6.9).

3. Lift your finger; Photogene picks a Color Temperature value based on your selection.

Adjust saturation and vibrance

To boost or pull back the color in your image, drag the Saturation slider. However, to retain skin tone, the Vibrance slider might give better results.

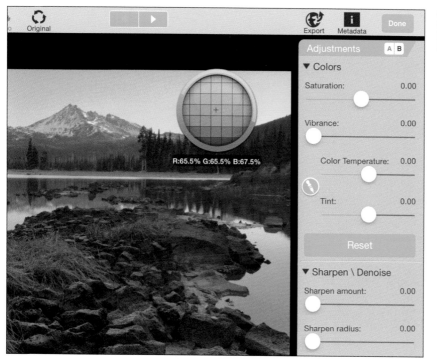

6.9 Use Photogene's Color Temperature loupe to set white balance.

Apply Selective Edits

You won't always want to apply adjustments to the entire image. Photogene's Retouches category of tools includes a healing brush but also masking overlays that let you paint areas to be adjusted. For example, use the Dodge tool to brighten an area, or enhance the depth of a photo by applying the Blur tool to its background. The pro version of the software lets you adjust exposure, saturation, contrast, color temperature, and RGB offset values in areas you paint.

1. Tap the Retouches button in the toolbar.

2. Tap one of the Masking Overlays tools.

3. Set the diameter of the brush by tapping the Brush button and specifying Radius and Feather amounts using the sliders provided. Tap the button again to dismiss the popover.

4. Begin painting the edit onto the photo by dragging (6.10). To erase an area you've painted, tap the Erase button; or, easier, tap once on the photo to switch between the Paint and Erase tools.

 Normally, you see the effect that painting produces as you work. However, you can also tap the Contour button to view the edit area in translucent red.

5. Tap the Done button at the bottom of the panel when you're finished.

6.10 Apply edits to selective areas. In this case I've inverted the Grayscale tool so I can erase the balloon and reveal its color.

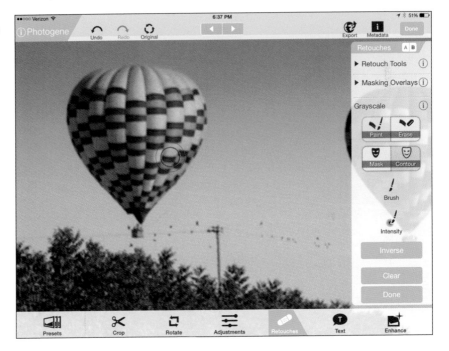

Apply Creative Presets

Photogene offers dozens of presets: Tap the Presets button and choose among several categories (Colors, B&W, Vintage, Frames, and Fun). Then, tap a preset to apply it.

What's more interesting is the ability to save your own presets. For example, if you find yourself applying the same amount of vibrance and sharpening to your images, create a preset. After setting those options on a photo, tap the Presets button, tap My Presets, and then tap Save.

Edit Photos in iPhoto

iPhoto shares a name with Apple's photo software for the Mac, but they're really completely different applications. iPhoto for iOS is optimized for a touch interface and includes features not found on the Mac.

Tap a photo to start editing it; the editing tools appear at the bottom of the screen. While in editing mode, you can also tap another photo to begin editing it without exiting the mode.

As you work, compare the edits you've made by tapping the Show Original button in the upper-right corner of the screen. Tap it again to return to the edited view. Tapping Undo removes the last edit (or touch and hold to reveal an option to redo), but if you want to start over from scratch, tap the ellipses (…) button in the lower-right corner and choose Revert.

▶ **TIP** Tap the Show or Hide Thumbnail Grid button to make more room for the photo you're editing. If you don't mind thumbnails along the side, drag the edge of the grid in the top toolbar left or right. That lets you choose between one and four columns of thumbnails. And here's a nice touch, especially if you're left-handed: Drag the top of the grid to move the whole thing to the other side of the screen. That also repositions the tool buttons.

Recompose

I'll be honest, various editors take several approaches to cropping and straightening photos, but I like iPhoto's implementation the best: Select a photo and, in the Editing mode, tap the Crop & Straighten tool.

Straighten the image

If iPhoto detects a possible horizon, it draws a line along it and attaches a rotate button to the right edge (6.11). Tap the button to accept the suggestion and straighten the image. Or, to manually straighten the photo, drag the dial at the bottom of the screen, or touch the screen with two fingers and turn them, to rotate and zoom the image as necessary.

6.11 iPhoto suggests straightening if it detects a horizon line.

► **TIP** Here's a feature that's fun but almost useless in practice. Tap once on the Straighten tool at the bottom of the screen to highlight it. Now, instead of dragging it to adjust rotation, turn the entire iPad itself clockwise or counterclockwise and use the device's gyroscope. Tap the control again to disengage the gyro.

Crop the frame

To redefine the visible area of the photo, do any (or all) of the following:

- Drag a corner or edge of the image's border to resize the area freely.

- Drag the middle of the image to reposition it within the frame.

- Pinch with two fingers to zoom in or out of the image.

- Tap the Lock Aspect Ratio button (next to the ellipses button) to keep the ratio of the current frame.

- Tap the ellipses button to choose from several standard aspect ratios, such as 4 x 3 or 16 x 9. This is often the quickest way to switch between landscape and portrait orientations (6.12).

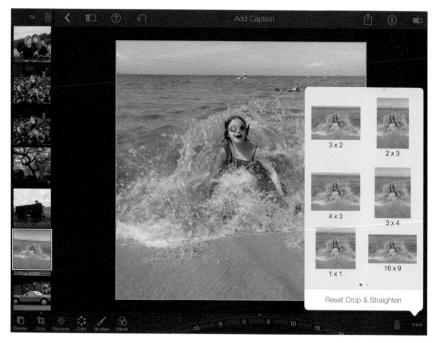

6.12 Choose from standard aspect ratios.

Adjust Exposure and Color

iPhoto's controls for improving exposure and color include sliders for adjusting brightness, contrast, saturation, and the like, as you might expect. But those are secondary to dragging directly on the photo and applying corrections based on where you touch.

Brightness and contrast

To adjust a photo's tone, tap the Exposure button in the toolbar and do the following:

1. Touch and hold anywhere in the image to reveal the onscreen brightness and contrast controls (6.13).

2. Drag up to increase or down to decrease brightness. (Or, drag the Brightness control in the slider.)

3. Drag left to decrease contrast, or drag right to increase it. (Or, drag one of the Contrast controls in the slider.)

6.13 Exposure controls in iPhoto

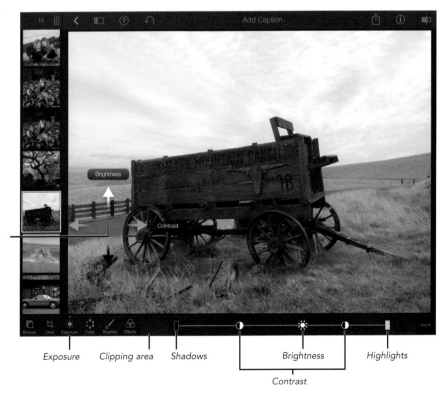

Touch and then drag to edit anywhere

Exposure Clipping area Shadows Brightness Highlights

Contrast

4. To brighten shadows specifically, touch a dark area of the photo to reveal a Shadows control. Or, drag the left-most control on the slider at the bottom of the screen. Extending it left beyond the hairline border clips the black pixels in the image (the area behind the control turns red to indicates clipping).

5. Similarly, to adjust highlights, touch a bright area of the photo to reveal a Highlights control. Or, drag the right-most slider control, optionally blowing out the lightest values to white.

Color

The color controls focus on five key areas: saturation, blues, greens, warmth, and white balance. The sliders with the descriptive icons at the bottom of the screen control the intensity of these attributes, but you can drag corresponding areas of the photo to adjust those values.

For example, dragging from a green area displays the Greenery control (even if you're not editing grass) that affects all greens in the image (6.14).

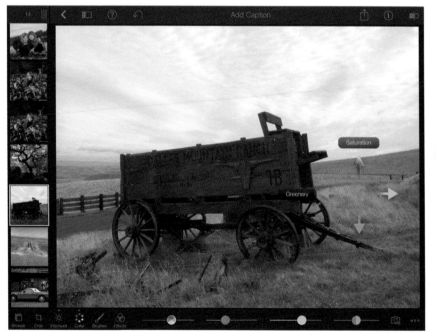

6.14 Apply color adjustments based on the area sampled in your image.

To change the photo's color temperature, tap the White Balance button to the right of the Warmth slider and choose one of the white balance presets. For more granularity, tap the Face Balance or Custom buttons and pinpoint an area of the image to sample. (As the name implies, Face Balance is intended to better preserve skin tones when setting color temperature.)

▶ **TIP** Once you've made tonal or color changes to an image, it's easy to apply them to related photos. Tap the ellipses (…) button and choose Copy Exposure or Copy Color (depending on the tool), switch to a different photo, and then tap Paste Exposure/Color from the same menu. In fact, you can use this technique to apply adjustments to several photos at once. After copying settings from one, touch and hold to select multiple photos (or double-tap an image to select visually similar ones), tap the ellipses button, and choose the Paste Exposure, Color and Effect button.

Adjust Specific Areas

Some photos need just a touch of detail adjusted here and there. Using the Brushes tools, paint adjustments just where you want them.

1. Tap the Brushes button to reveal the available tools.

2. Tap a brush to select it.

3. Zoom or pan the image using two fingers. When painting areas, it's often easiest to zoom in.

4. Drag your finger on areas to apply the adjustment (6.15). If you paint an area by accident, switch to the Erase tool. Or, tap the Detect Edges button (next to the Erase tool) to help you scribble inside the lines. Sometimes it can be difficult to tell where you've painted. In that case, tap the ellipses button and enable the Show Strokes option (6.16).

The tool settings popover also includes a slider for setting the intensity of the stroked areas you've painted. You can also apply a brush's effect to the full image (instead of painting) by tapping the [Effect] Entire Image button; this isn't as useful for a brush such as Lighten (since you could achieve similar effects using the Exposure tools), but is helpful if you select the Sharpen tool to make the entire photo more crisp.

6.15 Painting the berries brightens them.

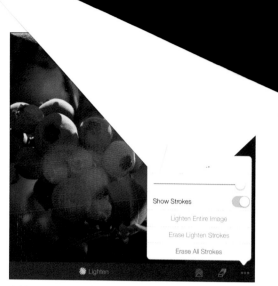

Show Strokes

Lighten Entire Image

Erase Lighten Strokes

Erase All Strokes

6.16 View your strokes as a red overlay.

> **NOTE** The results of the Brushes and Effects tools are applied to a virtual overlay of your image. If you add an effect and then decide to adjust the tone or color of the photo, switching to another tool temporarily disables the effect (it's pulled up like a plastic film). The edits reappear when you finish the adjustment.

Apply Creative Effects

You won't find the largest selection of preset effects in iPhoto, but for my money, that's fine. The effects are restrained, not thrown in to see how many levels of visual complexity can be piled onto a photo.

1. Tap the Effects button in the toolbar to reveal the effect categories.

2. Tap a category to select it and explore its effects.

3. For the Vintage and Artistic categories, tap a thumbnail, such as Sixties or Muted, to apply that effect. (It's helpful to tap the Help button—the question mark—to see an overlay that labels each one.)

4. For the other categories, drag along the thumbnail strip until you find a hue or look that appeals to you.

5. If the category includes other options, they appear to the right of the thumbnails. Add Vignette is most common: Tap it to create the dark halo surrounding the photo, and then pinch with two fingers to specify the size and center of the vignette (6.17). The Black & White effects also include the options of adding film grain and a sepia tone.

▶ **TIP** I almost can't believe I'm suggesting this, but make sure your iPad's audio isn't muted when you edit in iPhoto. Many actions have sound effects—like a *ziiip* as the loupe appears or disappears—that are well done.

▶ **TIP** Despite the improved camera in the latest iPads, I'm far more inclined to take photos using my iPhone. The iPad, however, is a much better editing environment. Since iPhoto runs on both devices, it's a cinch to transfer photos from one to the other. On the iPhone, select a photo and tap the Share button. Make sure the iPad is also running iPhoto, and tap the Beam button on the iPhone. Specify which photo to beam (the selected one, or others that may be flagged or favorited), and choose the name of the iPad.

6.17 Changing a vignette in an effect

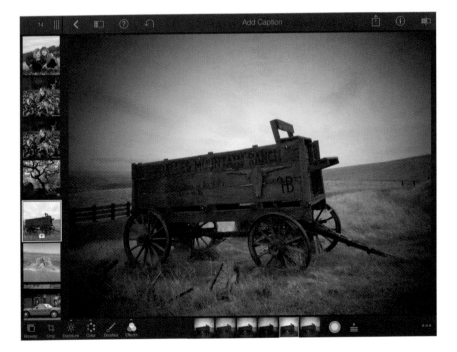

Edit Photos in Adobe Lightroom mobile

Although I, too, would love a full version of Lightroom running on my tablet, that's not yet possible with the technology at hand. Lightroom mobile is designed to be your remote link to your Lightroom library, enabling you to sync collections with the desktop version to review and edit photos on the tablet. For editing, it offers many (but not all) of the adjustments found in Lightroom's Develop module, including many filters and presets.

▶ **TIP** There's more to Lightroom mobile than the editing controls, which is why I wrote a separate 53-page ebook devoted to it: *Adobe Lightroom mobile: Your Lightroom on the Go* expands on the information here and is available for just $8 from Peachpit Press.

Recompose

Reframing a photo can involve a slight adjustment to straighten a horizon or a major crop to emphasize something that was originally smaller in the scene. The Crop tool handles both.

1. In the Loupe view (editing a photo), tap the Crop button.

2. If you want to use a preset aspect ratio, such as 16 x 9, tap one of the options at the bottom of the screen. Tapping the same option again changes the orientation of the frame (from wide to tall, for example).

3. Drag an edge or corner of the frame to resize the visible area of the photo (**6.18, on the next page**). When the padlock icon at the right appears locked, the aspect ratio won't change as you drag. To resize without a fixed aspect, tap the padlock icon to unlock the restriction.

4. To reposition the image within the frame, drag with one finger.

5. To straighten the image, drag outside the frame.

6. If the photo needs to be rotated in 90-degree increments, tap the Rotate button below the padlock icon.

7. Tap the Crop button to apply the changes.

▶ **TIP** Double-tap the crop area to reset the visible portion of the image.

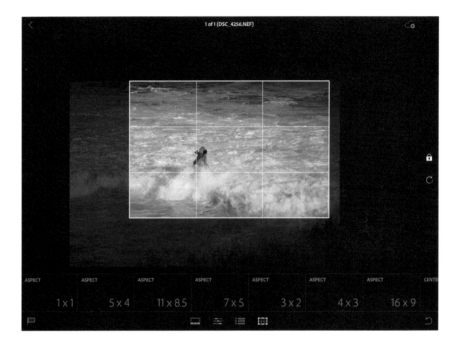

How Lightroom mobile Syncing Works

To synchronize photos between Lightroom and Lightroom mobile, the desktop application does two things: creates Smart Previews of your photos (which retain enough data to be editable but aren't as large as the original image files) and uploads them to a cloud server. On the iPad, Lightroom mobile then downloads thumbnails of the images for display in Grid view. When you open an image to view or edit it, the app loads the higher-resolution Smart Preview version.

Applying edits happens locally. But as soon as you finish editing (by returning to Grid view or swiping to the next or previous image), a small XML text file describing the edits is sent to Lightroom desktop by way of the cloud. After you make an edit, the changes should appear in both places within a minute.

Syncing works over any Internet connection, so if you own an iPad with cellular networking, the activity could eat into your cellular data quota. However, you can override this in Lightroom mobile: Tap your name in the upper-left corner to view the app's settings, and turn on the Sync Only Over WiFi option. When Wi-Fi isn't available, a "paused cloud" icon appears at the upper-right corner of the screen.

Adjust Tone and Color

Lightroom mobile includes many tone and color tools found in the desktop version, more than enough to make a good photo or serve as the starting point for editing later on the computer. They appear in two guises: sliders, such as Exposure, which let you drag to set positive and negative values; and pop-up presets, such as White Balance, which let you choose from a selection of settings. And don't forget the all-important Undo button in the lower-right corner for when you want to back up a step (or more).

White Balance, Temperature, and Tint

These three settings affect the overall color of a photo, adjusting for the quality of the existing light by, for example, warming up overcast scenes or counteracting the color cast created by fluorescent bulbs. Often the easiest correction is to choose a White Balance preset.

1. Tap the Develop button (second from left at the bottom of the screen) to reveal the controls.

2. Tap the White Balance button to view the presets (6.19).

3. Choose a preset to apply the change.

 One of the options is Pick, which presents a loupe for you to identify a neutral tone on which to base the photo's white point (6.20).

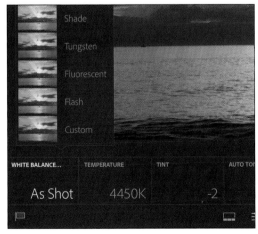

6.19 Choosing a White Balance preset

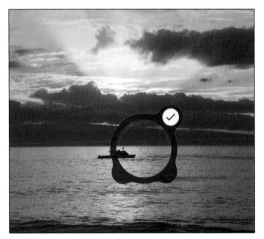

6.20 Setting white balance using tones in the image

As you drag, the color at the center of the reticle appears around the inside of the loupe; when you let go, you'll see a preview of the changed white balance. Tap the Apply button (the checkmark) to set the white point.

The Temperature and Tint sliders offer finer control over the white balance setting; tap one of the buttons and drag the slider that appears to adjust the setting.

▶ **TIP** This is the tip that you will probably use the most when editing your images: Touch and hold with three fingers to view the original, "before" version of the image. Lift your fingers to return to the "after" version. Note that this feature is limited to alterations you make within Lightroom mobile. If you worked on the image in Lightroom desktop before you synced it, that edited version is treated as the "before" in Lightroom mobile.

Exposure

Light dictates all photography, but sometimes the light in my photos doesn't represent the light I saw when I was shooting. (And sometimes I underexpose without realizing just how much.) This is where the exposure controls come in, shaping light as much as possible within the boundaries of the available image data:

- Exposure. To edit the overall brightness of the image, tap the Exposure button and drag the adjustment slider left (to darken the scene) or right (to brighten the scene) (6.21).

- Highlights. When the overall exposure is fine but you have some hot (bright) areas, tap the Highlights button and drag the slider to the left. Or, if the highlights are muted, you can increase the value without increasing the photo's overall exposure.

- Shadows. Turn to the Shadows control to bring up the brightness just in an image's midtones, boosting the light without blowing out the highlights.

- Whites and Blacks. These controls push or pull back the white and black values in the scene, introducing intentional clipping without manipulating every pixel.

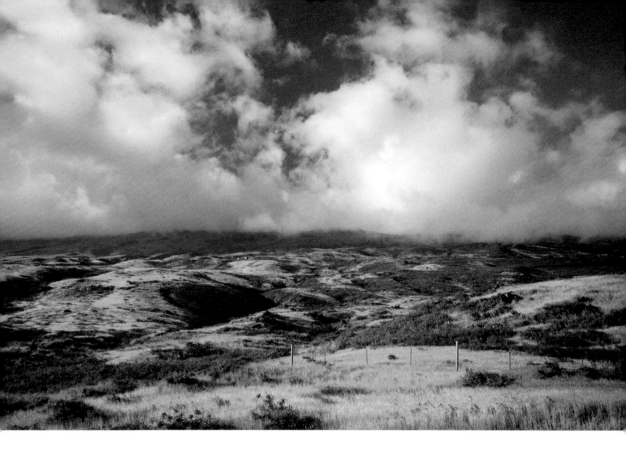

Contrast and Clarity

These two adjustments aim to take the muddling fog out of photos that lack definition. Both Contrast and Clarity target an image's midtones, darkening middle-to-dark areas and brightening middle-to-light areas. The difference is that Contrast works on the entire image, whereas Clarity applies its effect with more smarts to local areas within a photo.

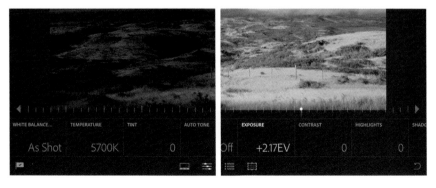

6.21 Adjusting the exposure from dark (left) to bright (right)

Saturation and Vibrance

Saturation and Vibrance can add richness and pop to images that appear a little drab, but be careful not to overdo them. It's easy to step over the line from great to garish. As with Contrast and Clarity, these two adjustments differ primarily in their approach. Saturation affects the intensity of all colors in a photo, whereas Vibrance works on muted colors to prevent clipping of already-saturated colors. One of the biggest advantages of Vibrance becomes obvious when you're working with a photo that has people in it, as it does a good job of preserving skin tones.

▶ **TIP** In any of the Develop controls, tap the control again to turn off its adjustment. Or, double-tap its button to return to the original image's settings.

The Helpful Histogram

Exposure is where the histogram can be quite helpful. (Tap the screen with two fingers until it appears if it's not visible.) If you're not familiar with a histogram, the left edge represents black pixels and the right edge represents white ones. A "good" histogram (setting aside artistic taste) should have a nice even bump in the middle. If the graph is skewed up against either side, the photo is being clipped—too many pixels are appearing as absolute black or white. Adobe added a helpful feature to identify where clipping occurs: drag an adjustment slider with two fingers instead of one **(6.22)**. The clipped areas appear as a solid color, while the rest of the image is black. This feature works in any slider control.

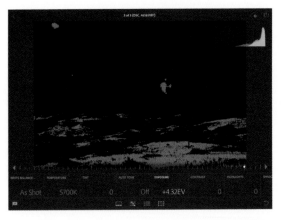

6.22 Identify clipped areas to balance the tones (and the histogram).

Apply Presets

All those sliders are well and good, but sometimes you want one-button style adjustments. Lightroom mobile includes several presets that you'll recognize from Lightroom on the desktop. Tap the Presets button (the third from the left at the bottom of the screen) to access them.

Here you can choose from many black and white options, including filtering for specific colors, as well as apply color processing to achieve looks that aren't realistic (like cross-processing or sepia tones). Alas, user-created presets are not supported, but we can always hope they might be in future versions of the app.

▶ **TIP** If a pop-up menu covers an important area of your photo, you can move it out of the way. Drag the menu left or right with one finger.

The Presets controls are also where you'll find abbreviated versions of some features you may use regularly in Lightroom on the desktop. Although there's no detailed sharpening control in the app, the General button includes two sharpen presets. Creating a vignette is the same: under Effect, you can choose between Vignette 1 (mild) and Vignette 2 (heavy).

Apply Previous Edits

The desktop version of Lightroom offers the ability to copy Develop settings from one photo and apply it to others. Lightroom mobile includes a pared-down version of the same feature, limited to applying the settings from the previous image you viewed. Here's how to do it:

1. In Loupe view, bring up a photo with the Develop settings to copy.

2. If the photo you wish to edit is adjacent to the visible one, swipe to view it. If not, tap the first button at the bottom of the screen to view the thumbnail strip of images, and then tap the one you want to edit.

3. Tap the Develop button or the Presets button (second or third from the left at the bottom).

4. Tap the Previous button and choose whether to apply just the basic tones or everything from the previous photo.

5. Tap the Previous button again to dismiss the pop-up menu.

Reset Adjustments

The Develop controls in Lightroom mobile are a great playground for experimentation, but you might decide to scrap your edits and start over:

1. Tap the Develop button or the Presets button.

2. Tap the Reset button.

3. Choose which state to revert the image to: All goes back to the original image; Basic Tones resets adjustments made using the Develop controls. If you made edits in Lightroom desktop first and then worked in Lightroom mobile, choosing To Import removes the edits you made in Lightroom mobile.

Lightroom mobile's Offline Editing Mode

The point of having a mobile version of Lightroom is to work on your photos anywhere, but the app isn't completely independent. It needs an Internet connection to communicate with Adobe's servers and download the higher-resolution files as you open and edit them. I can't believe I'm typing this, but Lightroom mobile turns out to be tethered to the most ephemeral infrastructure the world has ever known.

It is possible to cut the invisible cord and work without an Internet connection using the offline editing mode. The key is to enable it before you'll be offline, since it takes time to download the editable photos. You're out of luck if you realize when you arrive that your vacation cabin has no Internet access.

Tap the ellipsis button (...) for a collection, and then tap Enable Offline Editing. Lightroom mobile indicates how much space is required to store the files, as well as how much free space is available on your device, Tap the Download button.

Lightroom mobile syncs your changes the next time you're connected to the Internet and you launch the app. You can then choose Disable Offline Editing from the collection's settings to recover some storage space.

(Behind the scenes, Lightroom mobile downloads the Smart Previews that Lightroom desktop created for a collection's images, giving you high-quality, editable versions that are still small enough to not overwhelm your iPad's storage.)

Edit Raw Files Directly

For most of this book, I've referred to this section as an interesting asterisk. In general, the iPad ignores raw files: You can import them, but editing and sharing occurs on their JPEG previews or on the JPEGs that were recorded if you shot Raw+JPEG originals. iOS accepts raw files, but it doesn't support the myriad translators that are required to work with them directly.

However, working with raw files is really just a computational hurdle. Two apps, piRAWnha and PhotoRaw (and the free but limited PhotoRaw Lite), act as preprocessors for a photo—similar to the way the Adobe Camera Raw plug-in works in Photoshop on the desktop. If you're working with a dark image, for example, running it through piRAWnha first may tease out detail that another editor might overlook. Then, after exporting the file (as a JPEG), use Snapseed, iPhoto, or another editor to perform additional adjustments.

To be up front, editing raw files on the iPad isn't yet ideal. Expect editing to take a while, even just to make what would be a trivial adjustment on a computer—although the iPad's processor has lots of oomph, the amount of working memory limits how much data can be processed at a time.

I prefer the interface of piRAWnha, so that's what I'll use as the example:

1. After you open the app, locate the photo you want to edit from the albums in your Photo Library.

2. Use the sliders at right for each control to edit the photo's attributes. As you drag, a preview appears at the lower-right corner (6.23).

3. Tap the Export Photo button to process the image and save it as a JPEG file in the Camera Roll.

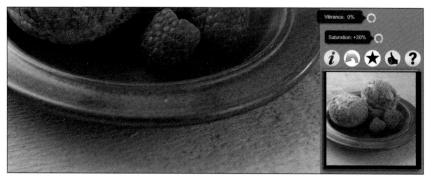

6.23 piRAWnha's editing interface

Retouch Photos

Photo retouching is an area where desktop titans like Photoshop still rule from on high, but some adjustments are possible on the iPad. Although you're not likely to touch up a portfolio of fashion shots using the iPad alone, it's possible you'll want to fix minor blemishes in photos that you plan to share directly from the iPad.

Photogene

Photogene's Heal tool fixes errors by cloning related areas of a photo. I recommend zooming the image to make it easier to control how the edits are applied.

1. Tap the Retouches button to view the Retouches panel.

2. Tap the Heal button.

3. Double-tap the area you'd like to fix (6.24). Photogene adds a pair of retouch circles: One covers the area you selected (and is marked with a gray X), and the other copies a nearby area.

4. Drag the blue anchor points to resize the retouch circle.

5. Drag the center of either retouch circle to reposition it (6.25).

6. Tap the Done button in the Retouches panel to finish.

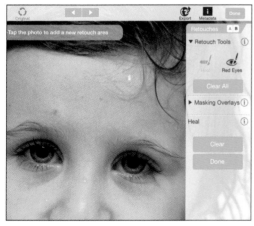

6.24 Identify an area to fix (the scratch above her eye).

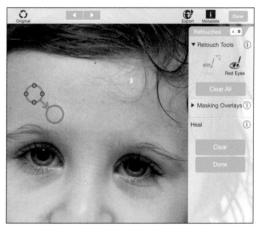

6.25 Clone pixels from a nearby area to retouch the spot.

Handy Photo

Photogene (and other approaches) samples nearby pixels to apply fixes. Another way to tackle the problem is to make software fill in pixels computationally based on the surrounding area. In Photoshop CS5 and later, Adobe calls this "content-aware" healing.

In the app Handy Photo, Adva Soft uses this type of technology to achieve similar results. It can be especially useful when you need to remove unwanted people or objects from a scene. Tap the Gallery button to open a photo you'd like to edit, and then do the following:

1. Tap the Handy Photo button in the upper-right corner and choose the Retouch tool.

2. Pinch outward to zoom to 100%, which makes it easier to define the area to be edited.

3. Mark an object to remove by selecting the Lasso tool and drawing around it or by selecting the Brush tool and painting over it (6.26). Use the Eraser tool to refine the edges. You don't need to be too specific about defining the area accurately.

4. Tap the highlighted area. The object you selected disappears.

5. If the result isn't quite to your liking, try painting over the area again.

6. Tap the Handy Photo button and then the Save/Share button to save a copy of the photo to your Photo Library, to attach it to an outgoing email, or to share it via Facebook or Twitter.

6.26 As you paint an area to be fixed (in this case, a toy in the background), a preview window appears so you can see the area (which is often obscured by your finger).

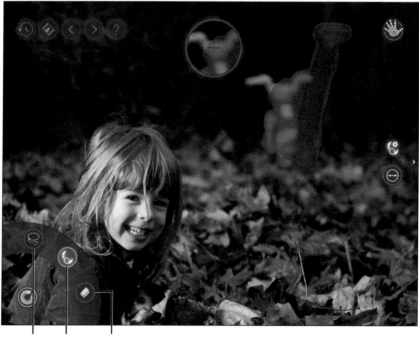

Lasso Brush Eraser

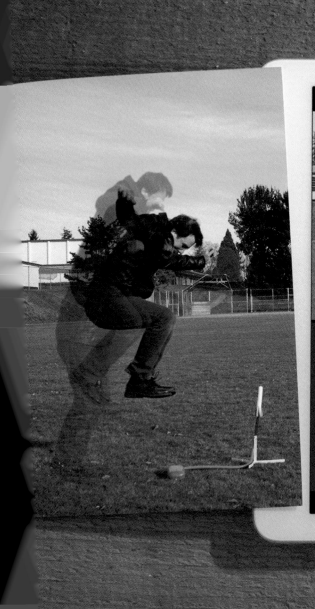
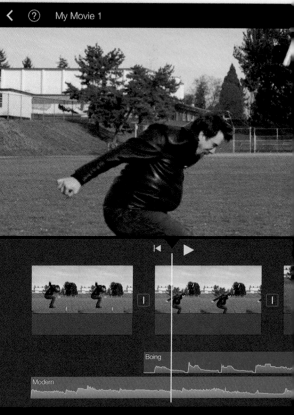

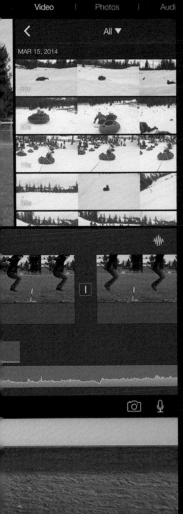

CHAPTER 7

Edit Video
on the iPad

I look at the title of this chapter and am a little amazed at its implications. Editing video was once something you could do only with a massively expensive infrastructure of equipment. Even as computing power increased (and the cost of software decreased), one still expected to need a high-powered desktop or laptop computer to edit video.

And now here we are, editing high-definition video in real time on a tablet computer. Oh, and using iMovie for iOS, an app that costs just $4.99. iMovie doesn't give you all the features of a desktop video editor, but still: *editing HD video on a tablet*.

The future is fun.

Work with Projects in iMovie for iOS

To get started in iMovie, create a new project in which you'll assemble and edit your video and audio clips.

1. Tap the Projects button to open the Projects browser.

2. Tap the Create Project (+) button and choose Movie (instead of Trailer) as the project type.

3. Choose a theme (tap the triangular Play button to preview its appearance) and then tap the Create Movie button.

 Every movie must have a theme, even if you don't plan to use theme elements. You won't see evidence of them unless you specifically choose a themed transition or add a title to a clip. You can change a project's theme at any time. Any themed assets in the movie automatically switch to the chosen theme (which means you can't mix and match elements from different themes in the same project).

4. iMovie takes you to the editing environment (7.1), which works in either the horizontal or portrait orientation.

Open an Existing Project

iMovie keeps track of your saved projects on the opening screen, like you're choosing a video at a stylish multiplex.

1. Tap the Back button (<) in the upper-left corner twice to go to the information about your current project.

2. Tap the button again to return to the Projects browser.

3. Tap a project icon to open the project.

4. Tap the preview at left to enter the editing environment.

 ▶ **NOTE** Although I'm focusing on iMovie in this chapter, it's not the only video editor available for the iPad. Another option to check out is Pinnacle Studio, which is a more advanced video editor.

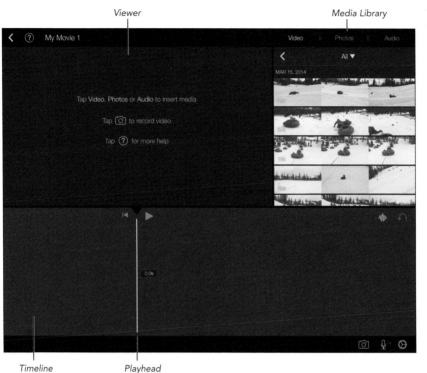

Viewer Media Library

Timeline Playhead

7.1 The iMovie editing environment in landscape orientation. When viewed in portrait orientation, the Media Library is hidden and accessible as a popover window.

Apply a Fade In or Fade Out to the Movie

Instead of starting with the first frame of the first clip, you may want to begin your movie with a fade in from black. The Project Settings window includes single-switch options for adding fades to the start and end of a project.

1. Tap the Project Settings button (the gear) to open the Project Settings window.

2. Tap the switch next to "Fade in from black" or "Fade out to black" (or both) to change the setting from Off to On.

3. Tap outside the window to apply the setting.

▶ **TIP** If you create a project and then immediately return to the opening screen, iMovie discards the new project because it has no content.

Add Video to a Project

iMovie for iOS is picky about the video it uses. Basically, if the video came from an iPad, iPhone, or iPod touch, you're golden. However, I've also had success with footage from a few other cameras. If iMovie balks at the video produced by your camera model, you will need to first convert it on your computer. That said, there are several ways to get video into iMovie.

Add Clips from the Media Library

With a library of clips to work from, it's easy to add clips to the timeline.

1. Scroll to the position in the timeline where you want the clip to appear. (This doesn't apply if no clips are in the timeline yet.)

2. If you're holding the iPad in its portrait orientation, tap the Media Library button. (If you're editing on the iPad in landscape orientation, the Media Library appears in the upper-right corner.)

3. To preview the contents of a clip, touch and hold briefly and then drag your finger across it.

4. Tap once on a clip to reveal its selection handles.

5. Drag the handles to define the portion of the clip you want to add (7.2). You can also tap the gray Play button to review just the selected range.

6. Tap the Add button (the arrow) to add the clip to the timeline.

▶ **TIP** iMovie 2.0, available at the time of this writing, offers the ability to add clips so they overlap existing footage, appear as a picture-in-picture effect, and appear as a split-screen effect.

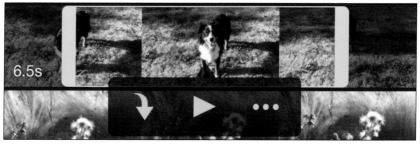

7.2 Select a portion of a video clip to add.

> ▶ **TIP** No more reviewing small footage! iMovie's Video browser (accessible via the main screen) provides large-sized previews of the clips in your library. You can also speed up or slow down playback (just while previewing), or mark sections as favorites by tapping the heart-shaped button. Tap the Favorites button as the clip is playing to mark 4-second increments.

Capture Video Directly

Using the cameras on the iPad, you can record video directly into your iMovie timeline. With a project open, do the following:

1. Tap the Camera button.

2. Set the mode switch to video.

3. Tap the Record button to begin capturing the footage.

4. Tap the Record button again to stop recording.

5. Press the Play button to review your footage. If the clip is acceptable, tap the Use Video button; the clip appears in the Video browser and at the point in your movie where the playhead was positioned. If the clip isn't what you want, tap the Retake button and shoot again.

It's important to detail this approach, because iMovie treats video differently depending on whether it was captured or imported: Video shot in iMovie stays within iMovie; it isn't automatically added to the Camera Roll, which is where iOS stores photos and videos that were shot by the Camera app or imported using the iPad camera adapters. If you create a new project, that clip you shot in a previous project won't appear at all.

However, there is a workaround: Tap the disclosure triangle at the top of the Media Library and choose "Manage local media." Next, select the clip recorded in iMovie and tap the Save to Camera Roll button.

Import from an iPhone or iPod touch

I'm far more likely to shoot video using my iPhone than my iPad, but I prefer to edit on the iPad's larger screen. Follow the same procedure for importing photos described in Chapter 3, import media into the iPad's Camera Roll from an iPhone or iPod touch using the Lightning to USB Camera Connector or the iPad Camera Connection Kit. Or, use AirDrop between compatible devices to transfer movies wirelessly.

Edit Video

Editing video in iMovie requires just a few core concepts, which you'll quickly adopt as second nature.

Play and Skim Video

The timeline in iMovie for iOS runs left to right across the bottom of the screen. Tap the Play button to preview the movie in real time in the Viewer.

To skim the timeline, swipe left or right. Or, tap the Reverse button to the left of the Play button to jump back to previous edit marks. The playhead remains stationary, so instead of positioning the playhead on the video, you're actually moving the video clips under the playhead (7.3).

▶ **TIP** When the movie expands beyond the edges of the screen, touch and hold the upper-left edge of the timeline to quickly jump to the beginning of the movie. Hold the upper-right edge to jump to the end.

7.3 The Viewer shows the current frame under the playhead.

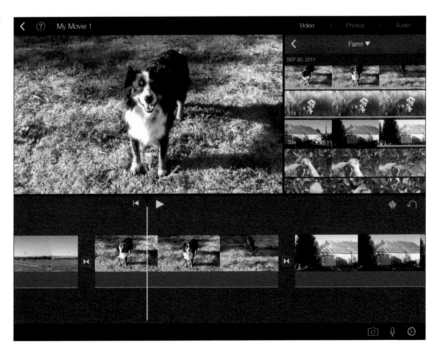

Edit Clips

After adding footage to the timeline, you'll find yourself moving, trimming, splitting, and deleting clips to cut out unwanted sections and create good timing.

Move a clip on the timeline

1. Touch and hold the clip you want to move. It lifts out of the timeline as a small thumbnail (7.4).

2. Without lifting your finger from the screen, drag the clip to a new location in the timeline.

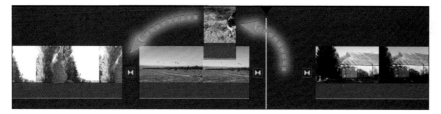

7.4 Move a clip in the timeline.

Trim a clip

1. Tap a clip once to reveal its selection handles (the yellow edges).

2. Drag a handle to shorten or lengthen a clip (7.5).

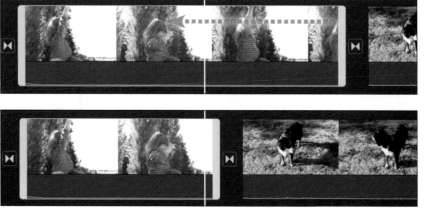

7.5 Trim a clip.

Split a clip

A clip can be added only before or after an existing clip; you can't insert a new clip in the middle of an existing clip. To do that, you must first split the clip in the timeline.

1. Position the clip so the playhead is at the point where you want to split it.

2. Tap the clip to select it.

3. Tap the Split button at the bottom of the screen. Or, slide one finger down the playhead from the top of the clip to the bottom (7.6). The clip is split into two, with a transition added between them. (The transition, however, is set to None, so there's no break between clips when you play the video. See "Edit Transitions," later in the chapter.)

7.6 Split a clip.

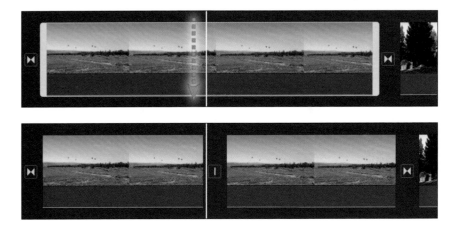

Delete a clip

Drag a clip from the timeline to the Viewer until you see a small cloud icon appear (7.7). When you lift your finger from the screen, the clip disappears in a puff of smoke. Or, select a clip and tap the Trash button at the bottom of the screen.

▶ **TIP** To view more thumbnails in the timeline, pinch outward horizontally with two fingers to expand the clips; pinch inward to compress the sizes of the clips.

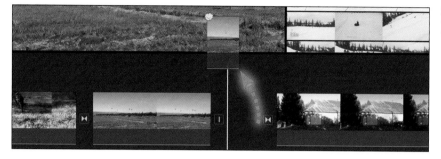

7.7 Give a clip the Keyser Söze treatment.

Use the Precision Editor

1. Tap a transition icon to select it, and then tap the double-triangle icon to display the Precision Editor (7.8). Or, pinch outward vertically on a transition.

2. Do any of the following to adjust the edit point:

 • Drag the transition itself to reposition the edit point without changing the duration of the surrounding clips.

 • Drag the top handle to change the end point of the previous clip without adjusting the next clip.

 • Drag the bottom handle to change the start point of the next clip without adjusting the previous clip.

3. Tap the triangle icons, or pinch two fingers together, to close the Precision Editor.

▶ **NOTE** It's possible to adjust the duration of the transition from within the Precision Editor. Tap the duration amount at the bottom of the screen.

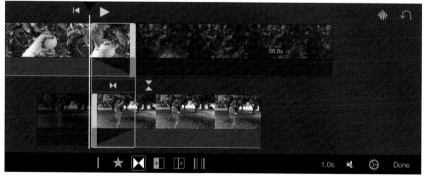

7.8 Use the Precision Editor to more accurately set where adjoining clips begin and end.

Edit Transitions

iMovie automatically adds transitions between every clip. Now, before your imagination fills with endless cross dissolves, note that it's possible to have a transition that doesn't do anything at all—it's there so you can tap it and change its settings.

1. Select a transition icon to reveal the Transition settings at the bottom of the screen (7.9).

2. Tap to choose the type of transition: None (creating an abrupt jump cut between the clips on either side), Theme, Cross Dissolve, Wipe, Push, or Fade to Black (or White).

 The appearance of the Theme transition depends on which theme you chose for your project. To change the theme, tap the Project Settings button and tap a new one, as described earlier in the chapter.

 When you tap the Wipe and Push transitions, choose a direction for the effect. The Fade to Black transition offers a Fade to White option.

3. Tap the duration in the Transition settings to choose an amount.

4. To apply the changes, tap outside the transition.

7.9 Choose a transition style and duration.

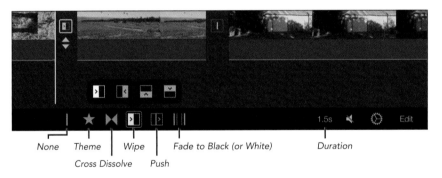

None Theme Wipe Fade to Black (or White) Duration

Cross Dissolve Push

Add a Title

Any clip can have a title, which is an attribute of the clip, not something added separately.

1. Select a clip to view the Clip settings at the bottom of the screen.

2. Tap the Title button; the default style is None.

3. Choose a title style: Opening, Middle, or Ending. The styles depend on the project's theme and are designed for common spots in your movie. For example, Opening is good for titles at the start of a movie and can occupy the entire screen, while Middle typically runs a title at the bottom of the screen without obscuring your video. Of course, you can choose whichever style you want at any point in your movie.

4. Tap the text field in the Viewer, and enter your title text (7.10).

5. Tap Done in the virtual keyboard to stop editing the title.

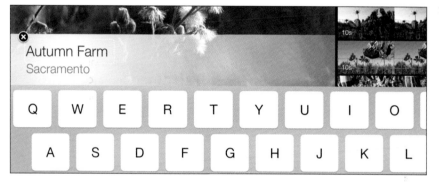

7.10 Entering text in a theme title

Add a title to just a portion of a clip

A title spans the entire length of a clip—even if the clip is several minutes long. If you want the title to appear on just a portion, such as the first few seconds, do the following:

1. Position the playhead in the clip where you want the title to end.

2. Split the clip.

3. Select the portion you want, and add a title to it (7.11).

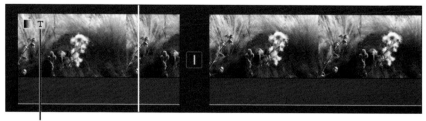

Title applied

7.11 Split a clip to display a title over just a portion of it.

Specify a Location

The iPad 2 (and later), iPhone, and iPod touch can all embed location data in the photos and video they capture, thanks to their built-in assisted-GPS technologies. iMovie reads that data, too, and gives you the option of using it in titles and, creatively, a few themes.

1. Select a clip to view the Video settings at the bottom of the screen.

2. Tap the Title button and choose a title.

3. Tap the Location button (which looks like a pin).

4. If location information was saved with the clip, it appears in the Location window (7.12). To change the location, do one of the following:

 • To use your current location, tap the arrow button.

 • To find a location, tap the Search button to search iMovie's database of locations. Tap the closest match to use it.

5. You can also change the label to something more specific, like a neighborhood or restaurant name. Tap the label and enter new text; it won't change the underlying location data. For example, the Travel theme adds a location marker to a map in its Opening title; the marker stays in place, but its label changes (7.13).

6. Tap outside the clip to deselect it and exit the Title settings.

7.12 Location settings

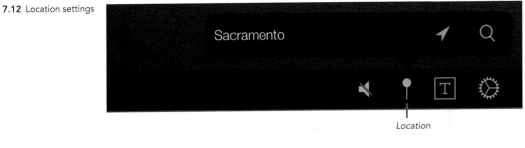

Location

7.13 A custom label applied to the location data

> ▶ **TIP** In most themes, the location appears as a subhead below the title. If you don't want to announce the location, why not put that text to good use? In the Location window, enter any text you wish to display, even if it has nothing to do with location (7.14).

> ▶ **TIP** As you're working on editing your movie, you can tap the Undo button to reverse the last action. But what if you tap Undo a few too many times? Touch and hold the Undo button, which reveals a Redo option.

Add and Edit Photos

iMovie for iOS can import photos as well as video, and even manages to apply the Ken Burns effect to them. In fact, every photo gets the Ken Burns treatment, without an easy way to keep an imported photo from moving.

Photos you've shot using the device or that were synced from your computer can be brought into your iMovie project. As with video, if you captured photos from within iMovie, those images are restricted to the project that was active when you did the shooting.

7.15 Photos in the Media Library

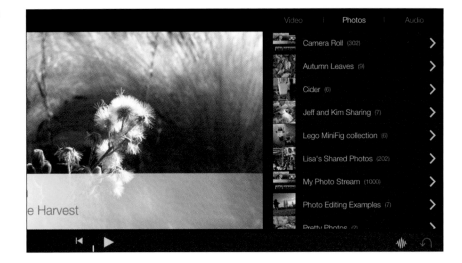

To add photos to your project, do the following:

1. Position the playhead in the timeline where you want a new photo to appear.

2. Go to the Media Library and tap the Photos button to view available photo albums.

3. Tap an album name to view its photos (7.15).

4. To preview a photo, touch and hold its thumbnail. On the iPad in landscape orientation, the preview appears in the Viewer.

5. Tap the photo thumbnail once to add it to the timeline.

Edit the Ken Burns Effect

The Ken Burns effect is based on the position of the frame at the beginning and end of the clip. iMovie determines how best to make the camera move from one state to the other.

1. In the timeline, tap a photo you've imported to select it.

2. Tap the Start button in the Viewer to move the playhead to the first frame of the clip, if it's not already positioned there (7.16).

3. Position the starting frame the way you wish: Pinch inward or outward to zoom in or out on the frame.

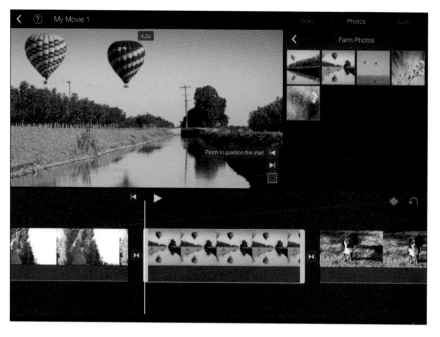

7.16 Editing the Ken Burns effect

4. Tap the End button to move the playhead to the last frame of the clip.

5. Adjust the image to the way you want it to appear at the end of the sequence.

6. Deselect the clip. iMovie builds the animation between the Start and End frames automatically as the movie plays.

Disable the Ken Burns effect

Unfortunately, there's no easy control to turn off the Ken Burns effect and just display a static photo. However, a(n imperfect) workaround is possible.

1. Tap the Start button.

2. Pinch the image onscreen so you can see all of its edges (zoomed out), and then release it—iMovie snaps it back into place with a minimal amount of zoom applied.

3. Tap the End button and repeat step 2 to let iMovie snap it into place.

4. Tap Done to stop editing the photo.

Edit Audio

One area where iMovie for iOS sacrifices features for mobility is in editing audio. You can adjust the volume level for an entire clip, but not specific levels within the clip; it's also not possible to detach audio from a video clip. Still, that leaves plenty of functionality, especially now that you can add multiple background music clips, include up to three additional sound effects at a time, and record voiceovers. Viewing audio waveforms on tracks is extremely helpful. Tap the Audio Waveforms button to make them visible.

Change a Clip's Volume Level

So that you don't have multiple audio sources fighting for attention, you can adjust the volume level for any clip or mute it entirely.

1. Select a clip in the timeline to display the Clip settings.

2. Tap the Audio button.

3. Drag the volume slider to increase or decrease the overall level (7.17). To mute, tap the speaker icon, which sets the audio to zero.

▶ **NOTE** Whenever a video clip with audio appears over a background song, the song is automatically ducked (made softer). Unfortunately, iMovie offers no controls for specifying the amount of ducking to apply.

Audio Waveforms button

7.17 Change a clip's volume in the Clip Settings window.

Volume slider

Add Background Music

iMovie can include background music, designed for the current theme, that loops in the background. Or, you can add your own audio tracks (with a few limitations). What's unique about iMovie's approach (and this is mirrored in iMovie on the Mac) is that a background music track is a separate type of audio track that operates a bit differently than iMovie's other audio tracks and sound effects. A background song always starts at the beginning of the movie; it can't be pinned to a specific location in the movie.

Add automatic theme music

1. Tap the Project Settings button.

2. Tap the Theme Music switch so it's set to On.

3. Tap outside the Project Settings window to apply the setting.

Add a background music clip

1. Go to the Media Library and tap the Audio button.

2. Choose an audio source (7.18). In addition to iMovie's theme music selections, the Audio window gives you access to your iTunes music library, sorted by playlists, albums, artists, or songs.

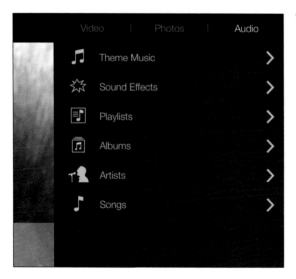

7.18 Audio window

3. Tap the name of a song to add it to your project. It appears as a green track under the video clips in the timeline (7.19).

▶ **TIP** Music written for each theme is available to add to any project, not just to movies with those themes. In the Audio window, tap Theme Music and choose any song you wish.

7.19 A background song added to the timeline

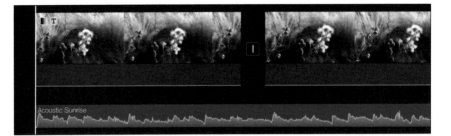

▶ **NOTE** iMovie does not import any music encumbered with Apple's Fair-Play DRM scheme; those tracks appear in the song list, but in gray with "(Protected)" before their names. Apple abandoned DRM for music tracks a while ago, but you may still have tracks in your iTunes library from before the switch. Apple's iTunes Match service (which costs $24.99 a year) enables you to re-download non-DRM versions of your music (which are often better-quality copies at higher bitrates). If you do subscribe to iTunes Match, your music is synced via iCloud instead of through iTunes on your computer, so you'll need to download any songs you wish to use in your projects from within the Music app.

Aside from the fact that a background song can't be repositioned in the timeline, you can edit it like most clips. Tap to select it, and then adjust its duration using the selection handles; then adjust the clip's overall volume. To fade the audio at the start or end, tap the Fade button and drag the fade marker that appears (7.20).

7.20 Applying a fade to the background song

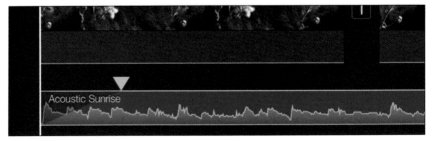

Add a Sound Effect

When you want to add a little punch to your audio, consider throwing in a sound effect. Up to three sound effect clips can appear in a section.

1. Position the playhead at the section where you want a sound effect to start.

2. In the Media Library, tap the Audio button.

3. Tap the Sound Effects button to view a list of available effects.

4. Tap the effect you want to use to add it to the timeline (7.21).

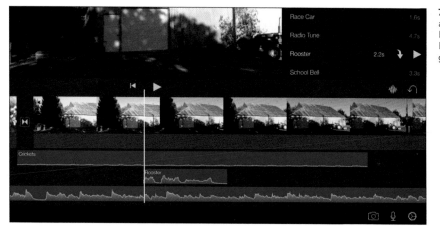

7.21 Sound effects appear on tracks below the video but above the background song.

Move audio clips between foreground and background

Any song you add that's longer than one minute is deemed a background song. However, you can move tracks between the background and the foreground (where sound effects reside).

1. Select an audio track you want to move.

2. Tap the ellipses (...) button.

3. Choose Move to Foreground or Move to Background.

Add a Voiceover

Most of the time, your videos can speak for themselves. On occasion, though, you may want to provide narration or a commentary track that plays over the footage. iMovie's audio import feature lets you record your voice (or any sound, for that matter) into the timeline.

1. Position the playhead in your movie where you want to begin recording audio.

2. Tap the Record button to bring up the Ready to Record window.

3. When you're ready to start capturing audio, tap the Record button in the window. iMovie counts down from 3 to 1 and begins recording (7.22).

4. Tap the Stop button to end recording. The recorded clip appears as a purple audio clip below the video in the timeline.

5. Choose what to do with the recorded clip: Tap Review to listen to it; tap Retake to record again; tap Cancel to delete the recording; or tap Accept to keep it in your project.

Feel free to record multiple takes, but keep in mind that you can have only three audio tracks in one spot at a time. Also, mute the other takes before you record a new one.

▶ **TIP** To capture better-quality audio, consider using a microphone instead of relying on the device's built-in mic. That can be the microphone on the earbuds that come with the iPhone or even, when connected to the iPad using the Lightning to USB Camera Adapter or iPad Camera Connection Kit, a professional microphone or USB headset.

7.22 Recording a voiceover

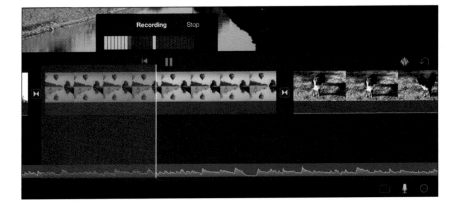

Share Projects

iMovie for iOS is designed to easily turn footage into a movie, but it's also intended to take your video and share it with the world. That could mean saving the finished movie to the Camera Roll for later viewing, importing it into iTunes on your computer, or adding it to iMovie Theater to view it on other devices including the Apple TV. You can also post it directly to YouTube, Facebook, Vimeo, or CNN iReport (but those options are straightforward, so I don't cover them here).

But first, we need to take care of a pesky detail: iMovie doesn't give you the opportunity to rename your project until you exit the project. So, before you share, do the following:

1. Tap the Back button (<) in the upper-left corner to view information about your project.

2. Tap the title to make it editable.

3. Enter a new title, and then tap the Done button on the virtual keyboard. The project is renamed (**7.23**).

7.23 The renamed project, along with playback and sharing options

▶ **TIP** The project information screen also includes a button for playing the selected movie full-screen, without having to open the project. If you own an Apple TV, you can send the video via AirPlay to broadcast on an HD television.

Share to the Camera Roll

When you share your project to the Camera Roll, a final version of the movie is created and made available for you to not only watch, but also access from other apps that can read your photo and video library. If you want to send the finished movie to someone, you need to save the video to the Camera Roll first.

1. In the project's information screen, tap the Share button.

2. Tap the Save Video button.

3. In the dialog that appears, choose a resolution to export: Medium - 360p, Large - 540p, HD - 720p, or HD - 1080p. iMovie creates the finished movie and saves it to the Camera Roll.

4. To view the movie there, open the Photos app, locate the movie at the bottom of the Photos list, and tap the Play button.

Send the Project to a Device via AirDrop

iOS devices that support AirDrop can transfer iMovie projects wirelessly. Make sure both devices are on and that AirDrop is enabled. At the project information screen, tap the Share button and choose the other device that appears in the AirDrop field. After a few minutes (depending on the size of the project and its media), the project exists on both devices.

Send the Project to a Device via iTunes

This method of sharing an iMovie project is, quite frankly, a weird work-around, but it has its uses. You can export the project itself—not just a rendered version of the movie—for backing up to your Mac or sending to another iOS device for editing. It is, however, a fairly counterintuitive procedure.

Export a project to iTunes

1. At the project information screen, tap the Share button.

2. Tap the iTunes button. iMovie packages all the data and resources (including video clips and audio files) and then informs you when the export is complete.

3. Connect your iPad to your computer.

4. Open iTunes and select the device in the sidebar.

5. Click the Apps button at the top of the screen and scroll down to the File Sharing section.

6. Select iMovie in the Apps column.

7. Select the project you exported (7.24) and click the Save To button. Specify a location, such as the Desktop.

7.24 The exported project in iTunes

Music	Movies	TV Shows	Podcasts	iTunes U	Books	Photos	On This iPad	2 Devices	Done

iMovie Documents

Autumn Farm.iMovieMobile	Today 4:30 PM	216.4 MB
Blue Harvest.iMovieMobile	6/8/12, 2:39 PM	95.6 MB
Carkeek Afternoon New.iMovieMobile	4/13/11, 1:14 PM	376.6 MB
Carkeek Afternoon.iMovieMobile	4/3/11, 10:18 PM	169.2 MB
Ellie Recital 2012.iMovieMobile	12/5/12, 2:18 PM	504 MB
Herkimer 2011.iMovieMobile	4/3/11, 10:31 PM	245.2 MB
iPad 2 Video vs iPhone 4.iMovieMobile	4/3/11, 10:18 PM	72.4 MB

Import the project into iMovie on another iOS device

1. Connect the other device to iTunes and select it in the sidebar.

2. Go to the Apps screen, scroll down to the File Sharing section, and select iMovie in the Apps column.

3. Click the Add button and locate the project file you exported in the previous exercise. Or, drag the project from the Finder to the iMovie Documents column. (You don't need to sync the device to copy the file; it's added directly.)

4. Open iMovie on the device.

5. Although the project now exists on the device, iMovie doesn't yet know about it. Go to the Projects screen and tap the Import button.

6. In the dialog that appears, tap the name of the project to import it. It appears among your other projects.

See? Only 13 steps to move a project from one device to another!

Build an iPad Portfolio

The desire to showcase your photos may have been your impetus to buy an iPad in the first place. The benefits are compelling: You can show off your work on the large screen, where the backlight makes the photos pop. You don't need to create a printed portfolio, which can involve considerable cost and requires lugging it around whenever you're meeting with a prospective client. And you or your client can zoom in to examine photos in detail.

An iPad portfolio also extends your reach beyond an initial meeting. Email a photo to a client directly from the iPad so they have something more than a business card or a print to remember you by. And since you're likely to have your iPad with you at other times, impromptu portfolio viewings are possible wherever you are—airplanes, lunches, or even just around the coffee table with family members.

5 Steps to Create a Great Portfolio

Before getting into the nuts and bolts (or more accurately, taps and swipes) of building a portfolio, let's look at what makes a portfolio successful. It's easy to throw all your photos onto the iPad and use the Photos app to play a slideshow. What makes a good portfolio stand out is how well it's edited. I doubt there's such a thing as a portfolio that's too small, but many portfolios end up being much too large.

1. **Include only your best work.** I know this should seem obvious, but I find that when I'm picking photos for my portfolio, I often consider one because it's a favorite, not necessarily because it's great. That's an important difference. Always think about how best to impress the person viewing your portfolio.

2. **Demonstrate your range.** Choose photos that show a variety of skills and styles, to better help the client imagine what you're capable of, not just what you've done before.

3. **Tell a story.** Even if your photos are pulled from a variety of situations and styles, your portfolio shouldn't come across as if it had been just thrown together. Start and finish with your best images, and give purpose to everything in between. That can be as literal as starting with images that were shot early in the day and ending with those set at night (8.1), or working through the various stages of a wedding (preparation, ceremony, reception). Or consider working through the color spectrum—black and white images first, building to full-color, high-saturation closing shots.

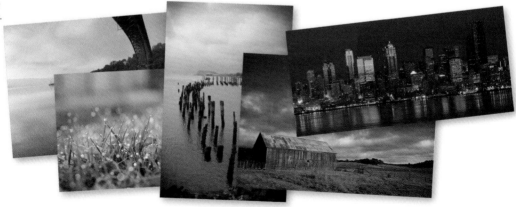

8.1 Tell a story in the portfolio.

4. **Build multiple portfolios.** If you work in several areas, create portfolios for each, such as for weddings, for landscapes, for portraits, and so on **(8.2)**.

5. **Update the portfolio as needed.** A digital portfolio isn't limited by paper. As you create more great shots, add them to your portfolio to keep it fresh. If necessary, rotate out old images to prevent the portfolio from getting bloated or looking dated.

▶ **TIP** Make sure your iPad portfolio reflects your online portfolio. Potential clients will search for your work online on their own time. Make sure your talents are equally represented there.

iPad or iPad mini for Portfolios?

Since both iPad models run the same software, I've treated them equally throughout the book. But for portfolios, I think the larger iPad is the better option. If you're showing off your work to potential clients, the iPad's larger screen offers a better viewing experience. I won't discount the Retina iPad mini—it's still a good choice for presenting your photos—but the iPad has the edge here.

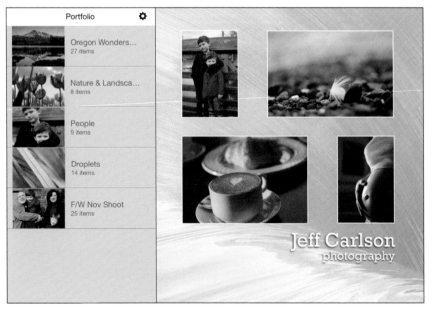

8.2 Multiple portfolios

Prepare Images for the Portfolio

The iPad will dutifully display the photos you add to it, but to make your portfolio look its best, you'll want to prepare the images. Despite having a great screen, the iPad offers no color management. That means the colors you worked so hard to achieve in-camera or on the computer may not match exactly when viewed on the iPad.

You also need to consider the dimensions of the images you transfer to the iPad. Although iOS will scale large images to fit, they may not appear as sharp as you'd like. Both of these limitations are surmountable. Saving images in the sRGB color space (as opposed to Adobe RGB) provides the closest color fidelity between computer and iPad.

For sizes, the Retina screen on third-generation-and-later iPads and the Retina iPad mini have a native resolution of 2048 by 1536 pixels; the first-generation iPad mini, iPad 2, and original iPad screens measure 1024 by 768 pixels. Most apps can handle a 4096 by 2048 pixel size, which provides plenty of resolution to zoom in and appreciate details.

Definitely create some test images to see how they appear on your iPad. Other considerations when preparing the photos include the following:

- **Crop to fill the frame.** To take advantage of the entire iPad screen, you may want to crop the images to avoid empty areas above or below the photo. Personally, I prefer not to crop, so that I retain the same composition in the final photo, but that's more of a general rule than an edict set in stone.

- **Sharpen the image for the screen.** Again, this suggestion is up to you and is worthy of testing. Sharpening the image for the screen can restore some crispness after it's been resized. Since you're outputting to a relatively low-resolution device rather than creating an image for print, I recommend sharpening a little—say, 10 percent—for the iPad.

- **Increase the saturation.** Boosting the saturation of an image can quickly push it into a dangerous realm of Vegas color, but I find that a small push of the Saturation slider (or, better, a Vibrance control if it's available, to avoid messing up skin tones) helps for the iPad's screen.

Using photo editing software on your computer, you can export copies with these characteristics for your iPad portfolio. I'm including a few common solutions here; if you use other software, the steps should be similar.

▶ **TIP** The techniques that follow assume you're optimizing photos for an iPad with a Retina display. The Portfolio for iPad app, which I use as an example later in the chapter, differentiates between Retina and non-Retina devices. If you own an original iPad, iPad 2, or first-generation iPad mini, set the maximum size to 2048 pixels instead of 4096 pixels.

Adobe Photoshop Lightroom

When exporting photos from Lightroom, you can specify the size, the color space, and other attributes, which can then be saved as a preset. For future portfolio images, you need only choose the preset to get files that are iPad-ready.

1. Select one or more photos to export.

2. Choose File > Export to open the Export dialog (8.3).

3. From the top Export To pop-up menu, choose Hard Drive.

4. Choose a location and a method of assigning the filename (such as the image's name or a title you assign).

5. In the File Settings area, set Image Format to JPEG and push the Quality slider to 100. Also make sure the Color Space pop-up menu is set to sRGB.

8.3 Lightroom's export options

6. Under Image Sizing, select the Resize to Fit checkbox and choose Width & Height from the pop-up menu. Set the W field to 4096 and the H field to 2048. (That 4096 value gets applied to the longest dimension, so a photo in portrait orientation will be 4096 pixels tall.) I also recommend selecting the Don't Enlarge checkbox; if the original dimensions are smaller than 4096 by 2048 pixels, enlarging the image can introduce blurring.

7. Scroll down to the Output Sharpening section, select the Sharpen For checkbox, and choose Screen. I keep the Amount value set to Standard.

8. To save these settings as a preset, click the Add button in the lower-left corner of the dialog and give the preset a name. Click Create.

9. Click the Export button to save the file or files.

With the preset created, you can create future portfolio versions by selecting them in Lightroom and choosing File > Export with Preset > [Name of your preset].

Apple Aperture

Apple's photo organizer also offers the ability to create a preset that can output iPad-friendly images for your portfolio. Unlike Lightroom, Aperture does not offer to sharpen the file during export, so you'll need to do that before you export; I recommend choosing Photos > Duplicate Version before sharpening, so you have a separate iteration for export.

1. Select one or more images to export.

2. Choose File > Export > Version(s).

3. In the Save dialog that appears, click the Export Preset pop-up menu and choose Edit.

4. In the Image Export dialog (8.4), click the Add (+) button in the lower-left corner. A duplicate of the currently selected preset is created.

5. Rename the preset to something like "Fit within 4096 x 2048."

6. Set the Image Format pop-up menu to JPEG.

7. Set Image Quality to 12 (the highest).

8. Change the Size To pop-up menu to Fit Within (Pixels), and specify the Width as 4096 and the Height as 2048.

9. Leave the Gamma Adjust slider alone (it should be zero), and set the Color Profile to sRGB IEC61966-2.1.

10. Click OK to return to the Save dialog.

11. Specify a filename and then click the Export Versions button.

Adobe Photoshop

Photoshop's Actions and Automate tools are great for processing a lot of images quickly. Record the steps once to create an action, and you can then use it for other shots.

Create an action

1. Choose Window > Actions to show the Actions panel.

2. Click the New Action (+) button at the bottom of the panel to create a new panel. Give it a name and click Record. Any steps you take within the app will now be recorded.

3. Choose Image > Image Size, and set a width of 4096 for landscape images or a height of 4096 for portrait images. (You'll need to create a separate action for each orientation.)

4. Choose Image > Adjustments > Vibrance, and use the Vibrance setting to boost the image's colors slightly.

5. Choose Filter > Sharpen > Unsharp Mask, and set an amount of sharpening you're comfortable with.

6. Save the file by choosing File > Save As, and specify JPEG as the file format, a quality of 12, and sRGB as the intended color space.

7. In the Actions panel, click the Stop button (a square icon at the bottom of the panel).

Batch-process files

With the initial settings recorded, you can batch-process images.

1. Either open the images you want to send to the iPad, or place them all in one folder on your hard disk.

2. In Photoshop, choose File > Automate > Batch.

3. In the Batch dialog, choose the action you created from the Action pop-up menu.

4. Specify where your images are located (a specific folder or images open in Photoshop) in the Source area of the dialog (8.5).

5. Set the location and the file-naming convention in the Destination area.

6. Click OK to process the files.

8.5 Batch-export files in Photoshop.

Source ✓ Folder
 Import
 Cho Opened Files sers:jeffcarlson:Desktop:testing:
 Bridge
 Ove Commands
 ☐ Include All Subfolders
 ☐ Suppress File Open Options Dialogs
 ☐ Suppress Color Profile Warnings

Destination: Folder ⬍
 Choose... WinterX:Users:jeffcarlson:Dropbox:Photo Portfolio:
 ☑ Override Action "Save As" Commands
 File Naming
 Example: myfile_ipad.gif

▶ **TIP** It's also possible to create a droplet, a small application that handles the automation. Instead of choosing Batch from the Automate submenu, choose Create Droplet, and then specify your iPad portfolio action and a destination. Then, whenever you want to prepare some images for your portfolio, you need only drag the photo files onto the droplet.

Adobe Photoshop Elements

The consumer version of Photoshop can accomplish almost everything its older sibling can, and in one dialog.

1. Open the files you want to process in the Photoshop Elements Editor, or group the files in a folder on your desktop.

2. Choose File > Process Multiple Files (8.6).

3. In the Process Files From area, choose Opened Files or specify the folder where the images are located.

4. Specify a location for the converted files in the Destination field.

8.6 Photoshop Elements export settings

5. Under Image Size, select the Resize Images checkbox and enter 4096 in either the Width or Height field, depending on the orientation of the images you wish to process; you'll need to process the orientations separately.

6. In the Quick Fix area, select the Sharpen checkbox.

7. Under File Type, choose JPEG Max Quality from the Convert Files To pop-up menu.

8. Click OK to process the images.

Apple iPhoto

Apple's consumer photo software doesn't offer export presets, but you can easily save a version of a photo that's sized correctly for the JPEG.

1. Select one or more images to export.

2. Choose File > Export to open the Export dialog (8.7).

3. Make sure you're in the File Export section of the dialog that appears, and set the Kind pop-up menu to JPEG.

4. Change the JPEG Quality setting to Maximum.

8.7 iPhoto export options

5. From the Size pop-up menu, choose Custom.

6. To specify the size, choose Dimension from the Max pop-up menu, and enter 4096 in the field.

7. Choose how the file will be named in the File Name setting.

8. Click the Export button.

▶ **TIP** If you have a brochure or other printed work, save it as a PDF and include it in your portfolio. You can then send it to a client via email.

Create Your Portfolio

A portfolio is essentially a slideshow of your photos, and if you want to stick with the basics, you can use the iPad's built-in Photos app to show off the images. But as you're putting a portfolio together, you'll want more control: over how photos are added and organized, over the way they're presented, and over how your client interacts with the work.

Dedicated portfolio apps offer all of those options, and you'll find many programs at the App Store. I've worked with several of them, and Portfolio for iPad is my favorite. I'll use it as the model for building a portfolio on the iPad in this chapter.

▶ **TIP** If you use Adobe Lightroom mobile, you can use it to show off a portfolio by creating and synchronizing a collection of your best work. There's no way to set a custom order for the images, but you can start a slideshow to use as a presentation.

Using the Built-in Photos App

If you don't want to pay for dedicated portfolio software, you can achieve similar results using the iPad's included Photos app. The trick is in getting the images to appear in the order you wish. In iPhoto or Aperture, create an album that contains the photos, and specify the order there. When you sync, the Photos app honors their placement within that album.

Create and Populate Galleries

Since this is a digital portfolio that will likely change over time, it's impor-tant to be able to easily add images to your collection now and later. The Portfolio app groups multiple portfolios into galleries—you can have just one gallery as your entire portfolio, or you can create several. To create a new gallery, do the following:

1. Tap the Configure button (the gear icon), and then tap the Manage Galleries button (8.8).

2. On the Galleries screen, tap the Add (+) button.

3. Type a name for the gallery and tap Add.

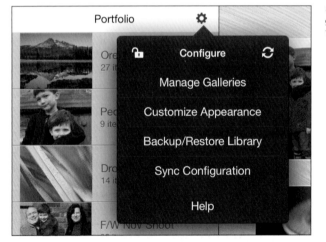

8.8 Configure galleries in Portfolio for iPad.

Repeat the process to create as many galleries as you'd like. If you decide to remove a gallery, tap the Edit button at the top of the page, tap the circular red delete button that appears, and then tap Delete to confirm the deletion.

Add Photos to a Gallery

The best way to load images into a gallery depends on what's most convenient for you. I'm partial to using Dropbox, since I'm a big fan of the service anyway, and it provides a destination for the portfolio-specific images I generated earlier in the chapter. Dropbox also gives me an online

backup of my portfolio images, so if for some reason I can't use Portfolio to run a presentation, I can fall back on the Dropbox app. (If you don't use Dropbox, give it a try at www.dropbox.com—the service is free for up to 2 GB of data storage.)

Other possibilities include loading images you've previously imported or synced to the iPad's Photos app via iTunes, fetching files from specific URLs, downloading from the Box service (similar to Dropbox), or using the free Mac application Portfolio Loader, available from the developer. Here's how to do it from the iPad, from iTunes, and from Dropbox or Box.

Load from iPad media

1. With the gallery selected in the Galleries list, tap the Load button (8.9).

2. Tap the Camera Roll button.

3. Using the iOS Photos picker, navigate to an album containing an image you want (8.10).

4. Tap image thumbnails to select which ones to add.

5. Tap the Add button.

6. Tap Done to finish managing galleries.

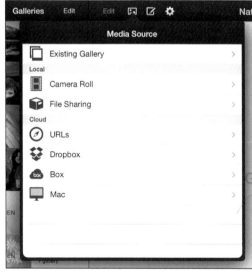

8.9 Load options

8.10 The window to your photo library

Load from iTunes

1. In iTunes on your computer, click the name of your iPad or the Devices button (if you sync multiple iOS devices); or, if the sidebar is visible, select the iPad there. (If you don't see your iPad, make sure it's connected via a sync cable or a Wi-Fi connection.)

2. Click the Apps category at the top of the window.

3. Under File Sharing, scroll down to the Portfolio app and select it (8.11).

4. Click the Add button at the bottom of the Portfolio Documents pane, and locate the files you want to add. Or, drag the files to the pane from the Finder or from Windows Explorer. The files are copied immediately without requiring a sync operation.

5. In the Portfolio app on the iPad, go to the Galleries screen (as described earlier) and tap the Load button.

6. Tap the File Sharing button (8.12).

7. In the File Sharing popover, select the photos you want to import.

8. Tap the Add button.

9. Tap Done to finish managing galleries.

8.11 Add files via iTunes.

Load from Dropbox or Box

1. On your computer, copy any image files destined for your portfolio to a folder within your Dropbox or Box folder.

2. In Portfolio on the iPad, go to the Galleries screen and tap the Load button.

3. Tap the Dropbox or Box button. A popover appears, containing the contents of your shared folder (8.13). (Or, if you're accessing this feature for the first time, you're asked to log in to your account.)

4. Navigate to the folder in which your images are stored.

5. Tap the thumbnails to select the photos you want to load, and then tap the Add button. The images are copied to the Portfolio app and appear in the gallery.

6. Tap Done to finish managing galleries.

8.12 After transferring files via iTunes, import them in Portfolio.

8.13 Adding photos from Dropbox

Edit a Gallery

Here's where you put all that earlier advice to good use. Now that you have a gallery full of images, you need to put them into your preferred order and set a thumbnail for the gallery.

Reorder images

1. Return to the Manage Galleries screen in the Portfolio app.

2. Tap the Edit button above the image thumbnails; the photos appear with close boxes (x).

3. Touch and drag a thumbnail to change its position (8.14). Do the same with the others until the photos are in the order you want them to appear.

4. To remove an image, tap its close box and then tap the Delete button that appears (8.15).

5. Tap Done when you're finished.

8.14 Drag to change the order of photos.

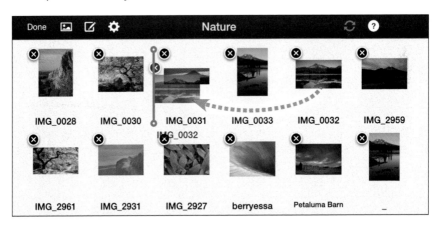

8.15 Remove a photo.

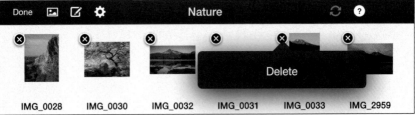

Choose a gallery thumbnail

1. Tap the thumbnail of the photo you wish to use as the gallery's thumbnail.

2. From the popover that appears, tap Set as Thumbnail.

3. In the Choose Target popover, tap the gallery that will get the new thumbnail image.

4. Pinch with two fingers to resize the image to fit the visible area (in the center of the screen, not dimmed); you can also reposition the image by dragging it (8.16).

5. Tap the Crop button to apply the change and assign the image as the thumbnail (8.17).

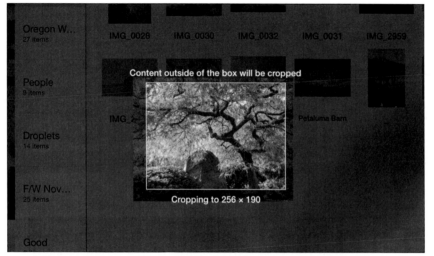

8.16 Choose how the thumbnail will appear.

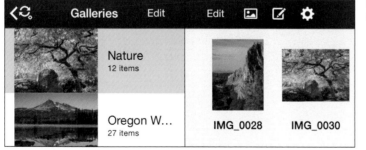

8.17 Thumbnail changed

Customize the Opening Screen

To personalize the opening screen of your portfolio, the Portfolio app can display three logo screens: one for landscape orientation, one for portrait orientation, and one for an external screen when presenting with a video-out connection like a television or projector.

1. Tap the logo area (helpfully marked with "Tap to customize this image"), or tap the Configure button and then tap the Customize Appearance button.

2. In the Customize Appearance screen, tap a theme's Customize button and then choose Edit Appearance.

3. Tap a component to customize it, such as the image area on the right side of the Classic theme.

4. The Media View window that appears lists specific sizes for landscape and portrait images. In separate photo editing software, create a set of images, in those sizes, that will act as a virtual cover for the portfolio. (You can use any photo, but this area is an opportunity for displaying a logo or other branding.)

5. Tap the Landscape and Portrait buttons and locate the images you want to use (8.18).

6. Tap the Close Customization Panel button, and then tap the Set as Theme button to activate the template. Tap Done.

▶ **TIP** If you don't want to be restricted by the app's logo screen dimensions, create black (or white, or anything else suitably forgettable) versions of the logo images. Then, create a 1024 by 768 logo image and set it as the first photo in your portfolio. You can then bypass the initial navigation and launch your presentation from within the gallery.

8.18 Set custom images for the portfolio's main screen.

Present Your Portfolio

Depending on the client or target audience, you may choose to run the presentation yourself on the iPad, let the photos play in a slideshow, hand the iPad to the viewer, or display on an external television or projector.

Before you begin your presentation, it's a great idea to restart the iPad by powering it off and powering it back on again, which resets the memory. That reduces the chances that the software will stall while shuffling large images in and out of active memory.

Rate and Make Notes on Photos in Portfolio for iPad

The Portfolio for iPad app can also be used to get feedback from someone on the images in your portfolio; for example, suppose you're showing your selects from a photo shoot and want the client to choose a set of favorites. They can rate and comment on individual photos.

1. In a gallery, tap the Note button at the bottom of the screen.

2. Tap the Notes field, and type a comment (8.19).

3. Tap outside the popover to dismiss it.

4. Tap a star in the lower-left corner to assign a rating.

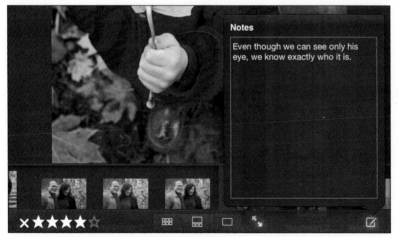

8.19 Rate and make notes in Portfolio for iPad.

Present on the iPad

Presenting your portfolio can be as easy as running a slideshow in the Photos app, but you'll appreciate some of the other features that a dedicated portfolio app can bring. Again, I'll use Portfolio for iPad as an example.

Tap a gallery to view the first photo it contains (8.20). Here, you can tap a thumbnail at the bottom of the screen to jump ahead and view any image in the gallery. For the best presentation, however, I prefer tapping the Full Screen button to view one image at a time. Flick between images by swiping left or right on the screen. (Tap once on the screen to reveal the controls if you want to exit full-screen mode.)

▶ **TIP** With the thumbnail strip visible, double-tap a photo other than the one currently displayed; the two photos appear next to each other (8.21). Double-tap again to return to the thumbnail strip.

To view an image in more detail, pinch outward or double-tap a photo to zoom in. Double-tap again or pinch inward to see the entire image.

For a self-directed presentation, tap the Play button in the upper-right corner to run the photos as a slideshow.

▶ **TIP** If you're handing the iPad to a client, you can lock the editing interface in Portfolio for iPad to prevent them from accidentally editing your gallery. On the Portfolio title screen, tap the gear icon and then tap the Lock button. Specify a four-digit passcode that must be entered to access the editing features. This lock applies only within the app; a client can still access the rest of your iPad by pressing the device's Home button.

Present on an External Display

The iPad's screen is a good size for presenting to one or two people, but if you need to show your portfolio to more, moving the images to a larger display like an HD television or a projector can make quite an impact.

Wired

Connect the iPad to a TV or projector by using an HDMI, VGA, or component cable, depending on the available connections. Apple sells iPad adapters for each type of plug.

Play

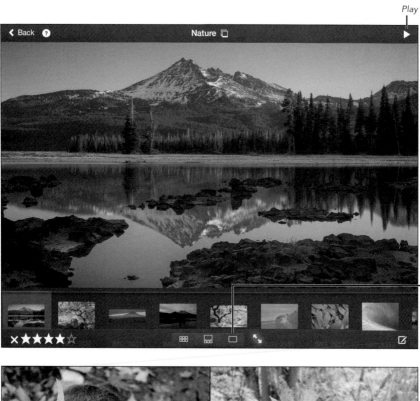

8.20 Presentation with thumbnails visible

Full Screen

8.21 Compare two images side by side.

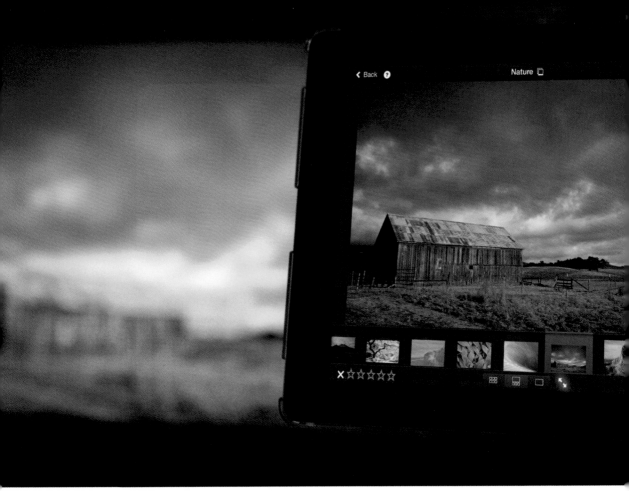

After connecting the iPad to the device, open Portfolio for iPad. If you specified a custom logo page for the largest size, it should appear on the external display. When you enter a gallery, the first image shows up. You can then direct the presentation from the iPad or start a slideshow.

If you're using an iPad 2 or later, connecting it to the device mirrors the screen, so your viewers can see exactly what you see on the iPad. However, in Portfolio for iPad, only the images appear, not the thumbnails. Swipe to switch between photos, or tap the Play button to start a slideshow.

Wireless

If you have an iPad 2 or later and an Apple TV (second-generation or later, the small black model), and they're both on the same Wi-Fi network, you can display the portfolio wirelessly using AirPlay. To make the two devices communicate, do the following:

1. Swipe up from the bottom of the screen to reveal Control Center.

2. Tap the AirPlay button. If the AirPlay button isn't there, verify that the iPad and Apple TV are both connected to the same network, that the Apple TV is powered on, and that AirPlay is enabled in the Apple TV's settings.

3. Tap the name of the Apple TV in the AirPlay popover.

4. Set the Mirroring switch to On (8.22).

Now, without being physically tethered to the TV or projector, run your presentation from the iPad.

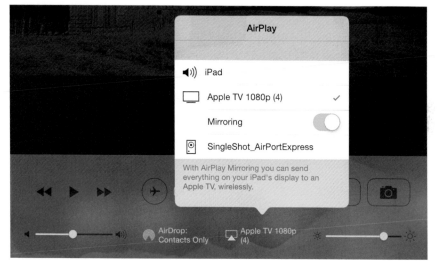

8.22 Connect to the Apple TV using AirPlay.

Book | Slideshow | Print | Web

CHAPTER 9

Share Photos

Yes, it's true. I do, on occasion, import photos from my camera into the iPad, sort and edit them, and then upload selected shots to photo-sharing services…from my couch. Even when my laptop is just elsewhere in the house, I don't want to retreat to my upstairs office and get into working mode. I want to browse shots from the day, get feedback from my family there in the same room, and put something up that friends can view online.

You needn't aspire to be as lazy as me, but there are many opportunities to share photos directly from the iPad before they inevitably end up on a computer. You may want to post shots from a just-concluded wedding, or maybe a client located elsewhere needs to review and rate images quickly. Several options for sharing your photos from the iPad are available beyond simply syncing the photos to a computer.

Upload Images to Photo-Sharing Services

In the early days of the Web (I'm dating myself here), when you wanted to publish a photo online you needed to be savvy enough to upload the image to a server and write the HTML code necessary to make it appear. Now, with popular photo services such as Flickr, Facebook, 500px, and others, you can let the software handle all of that.

Upload from Editing Apps

Most of the photo-editing apps allow you to upload your images directly to Facebook, Flickr, Twitter, Dropbox, and others. The steps are similar in most apps, but since I looked at Snapseed and Photogene in Chapter 5, I'll detail those steps here.

Upload from Snapseed

Snapseed uses the iOS convention of making exporting options available from the Share button; it supports Google+, Facebook, and Twitter.

1. With a photo already loaded in Snapseed's initial screen, tap the Share button (9.1).

2. Tap the name of the service you want to use.

 The first time you share something, you need to log in to the service to grant the app permission to add items to your account. Twitter and Facebook support exists at the operating system level, so if you haven't done so previously, go to Settings and enter your account information. Also make sure that the Allow setting for the app is set to On.

3. Depending on the service, enter a caption, a description, a destination, and privacy options. To share to Facebook, for example, enter a description and tap the thumbnail to choose an album; if you don't choose an album, it creates a Snapseed Photos album.

4. Tap the Post, Send, or Share button (depending on the service) to upload the image.

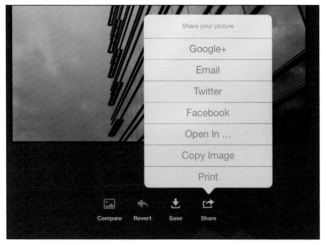

9.1 Snapseed's sharing options

▶ **TIP** To control who views your photos on Facebook, you need to set up privacy options in your Facebook account. Locate your photo albums, and then click the drop-down menu just below each one to specify Public, Friends, Only Me, or Custom. (Facebook changes its interface often enough that I'm not even going to try to walk you through the steps of locating that control. But once you get to the albums, it should be obvious.)

Upload from Photogene

Photogene offers more services to upload to, and it also gives you options such as image size and, in the pro version, a watermark.

1. Open a photo and edit it as you wish.

2. Tap the Export button (**9.2, on the next page**).

3. Tap the Resize button to specify the image size. In most cases you'll probably want to choose Original, but not always; you may want to upload a smaller version when you don't have much available bandwidth (or maybe you just prefer not to upload full-size photos). The numbers in the Resolution\Resize popover represent the image's longest dimension. Choosing 1024, for example, resizes a landscape photo to 1024 pixels wide but resizes a portrait photo to 1024 pixels tall.

 The pro version of the app adds the ability to set the JPEG quality by specifying the level of compression that's applied.

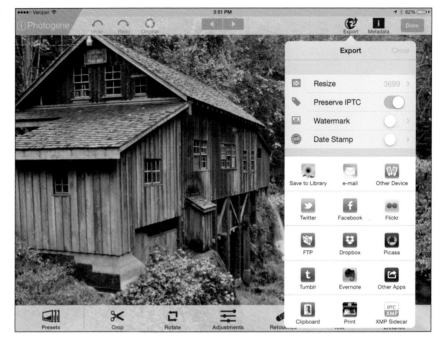

9.2 Export options in Photogene

4. If you want to strip any metadata you added before uploading, switch the Preserve IPTC option to Off.

5. Tap the icon of the service or feature you want to use. If you haven't previously set up a service, you're asked to log in and grant Photogene permission to add photos.

6. In the service's details panel, enter a title, a description, and other information that applies, including the privacy level.

7. Tap the Share button. Photogene prepares the photo and uploads it.

Share to the Web from Lightroom mobile

Lightroom mobile includes the expected set of upload options, but has another option for sharing photos to the Web. Any Lightroom collection you sync to the app is available to you at lightroom.adobe.com. To let others view a collection, click the Share button on the Web site, and post or email the link.

To Watermark or Not?

I find watermarks distracting, so I generally don't bother to watermark my photos. I want viewers to focus on the photo, not the mark. I'm also not too concerned about getting ripped off—unless I splash a watermark over the entire image, someone stealing the photo can easily remove the mark. However, there are instances when a watermark can be appropriate. Wedding photographers can benefit from having their logo, Web address, or other branding appear on photos that many people will see (the final versions that go to the bride and groom, of course, would be free of marks). You can also use a watermark to indicate that a photo is a proof versus a final version.

Photogene's watermark support allows you to specify an image as a watermark and place it on an exported photo. Create your logo or other mark and copy it to the iPad's Photo Library. Then, in Photogene's Export popover, do the following:

1. Tap the Watermark button.

2. Tap Select Image and choose the watermark image you created.

3. Using the sliders in the popover, adjust the opacity of the image and the amount of padding around it (**9.3**).

4. Choose a position for the mark by tapping one of the boxes in the proxy grid. Note that the preview doesn't accurately convey the size of the mark; it's enlarged to show relative position.

5. Tap the Export button at the top of the popover to return to the rest of the Export options.

6. To include the watermark, switch the Watermark option to On. The watermark appears on the photo that's exported (**9.4**).

9.3 Setting a watermark

9.4 Watermark applied

iCloud Photo Stream

iCloud's Photo Stream feature began life as a service that automatically copied photos only to your other devices, but it has since added a limited social aspect. When you create a Shared Photo Stream, images are copied to the devices of anyone subscribed to it (and they can get a notification when new photos are added), saving you the trouble of alerting everyone whenever a new picture is added. I use this feature constantly to share photos of my daughter with family members.

1. In the Photos app, view a photo, or tap Select and select several, and then tap the Share button.

2. Tap the iCloud button.

3. In the Add to a Photo Stream window, choose New Shared Stream (9.5). (If you're adding photos to an existing stream, tap its name.)

4. Give the stream a title in the Name field, and tap Next. Optionally enter the email addresses of people with whom you want to share the stream. Tap Next.

5. Optionally enter a comment that will appear with the photo and in the notification subscribers receive (9.6). Tap the Post button.

To add subscribers to the Shared Photo Stream, go to the Shared window, tap the name of the stream, and then tap the People button. This is where you can also make the gallery public and get its Web link, turn notifications on or off, and choose whether subscribers can post their own photos to the shared stream.

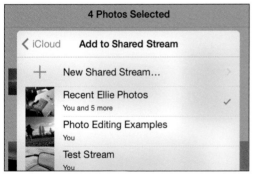

9.5 Add photos to a Shared Photo Stream.

9.6 An optional note becomes a notification to subscribers.

Upload Photos Using Services' Apps

Photo services have been quick to create their own iOS apps, mostly for use with the iPhone so people can upload the shots they take with its camera. For snagging pictures that you imported and don't need to edit, a dedicated app provides a more direct path from your iPad to your online photo album. In some cases, you can upload photos in batches instead of one at a time.

The first step is to visit the iTunes Store and see if your preferred photo service offers an iOS app. You're also sure to find third-party apps that allow you to view photos and upload them to the services. Here are a few that I use, both "official" and third-party apps.

Flickr

Flickr is one of the largest photo-sharing sites on the Web, and thanks to renewed focus by its parent company, Yahoo, the Flickr app is much better than it used to be—even though, at this writing, it's not optimized for the iPad (but the company has hinted that an iPad version is finally coming). It's easy to upload multiple photos to your Flickr photo stream.

1. At the opening screen, touch and hold the Camera button to view your photo library.
2. Choose the album that contains the photos you want to upload.
3. Tap to choose photos, which gain a blue checkmark, and tap Next to continue.
4. Optionally apply edits or filters to the image. Tap Next.
5. On the Details screen that appears, add a title and description, choose whether the shot is public or private, optionally assign the photos to albums, and add a location (9.7, on the next page).
6. Tap the Post button to transmit the photos.

▶ **TIP** If you prefer an iPad-native Flickr client, check out FlickStackr.

Camera Awesome

SmugMug, a popular site for more-experienced photographers, offers an official SmugMug app, but it's geared toward *viewing* photos by you and others. The company ditched its old SmugShot app and now offers Camera Awesome, an app that takes photos and also offers easy upload to one's SmugMug account (9.8).

500px and PhotoStackr for 500px

The 500px site boasts a great viewing experience and a growing number of professionals. The company's 500px app is a model for how to browse photos on a tablet, and also includes the ability to upload new photos to one's account.

A good alternative is PhotoStackr for 500px, which also uploads and adds a few other features to the browsing experience. As with the Flickr app, you can queue several photos to be uploaded together.

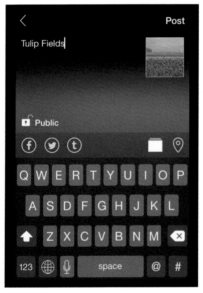

9.7 Uploading photos in the Flickr app

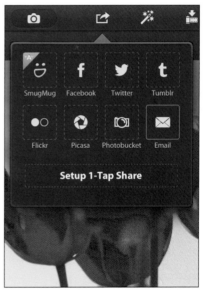

9.8 Camera Awesome

Email Photos

A fallback for getting your photos out there is to send them as email attachments. This capability is built into the core of iOS and is available from nearly every app.

I call this approach a "fallback" because, honestly, the current state of email makes it difficult to guarantee that the message will get through. Image attachments are usually large, which increases the chances that the message will stall at a server en route from you to your recipient. Or, the message could be marked as spam and shunted into a person's queue of suspect emails with the usual assortment of get-rich-quick scams and unwanted product solicitations.

Share a Single Photo

Still, email is convenient and widely supported. The iPad uses two ways to share a photo, depending on where you start. If you're in the Photos app, you choose the photo first and then send it via email, like so:

1. Open the Photos app to view your image library. (If you're in a third-party app that offers email as an export option, follow its steps. I'm starting here as if you have just picked up the iPad and want to share a photo from the built-in library.)

2. Locate the photo you want to share, and tap to view it full screen.

3. Tap the Share button, and tap the Mail button in the popover list of options. A new outgoing message appears, with the photo in the body of the message.

4. Fill in the To and Subject fields to address the message.

5. Tap the "Images" text to the right of the Cc/Bcc field to specify the size of the outgoing image (9.9).

Cancel	Mt Hood Sunset photo	Send
To: Norville Barnes		
Cc/Bcc:		Images: 1.9 MB
Subject: Mt Hood Sunset photo		

9.9 The image-size control is almost invisible.

Cancel	**Mt Hood Sunset photo**		Send

To: Norville Barnes

Cc:

Bcc:

Image Size: | Small 9.5 KB | Medium 34.0 KB | Large 366 KB | **Actual Size** 1.9 MB |

Subject: Mt Hood Sunset photo

6. Choose one of the Image Size options by tapping it (9.10).

7. Tap the Send button to dispatch the message.

The second way to send a photo by email is to start within the Mail app and attach a photo to the message.

1. In the Mail app, create a new outgoing message.

2. Touch and hold within the message body to bring up the options bar (9.11).

3. Tap the Insert Photo or Video option.

4. Locate the photo in your photo library and tap Use.

Cancel	**New Message**	Send

To: Norville Barnes

Cc/Bcc:

| Select | Select All | Paste | Quote Level | Insert Photo or Video |

Share Multiple Photos

To attach more than one photo to an outgoing message (without repeating the previous steps for each image), you need a slightly different approach:

1. In the Photos app, open the album containing the images you want.

2. Instead of viewing one full-size, tap the Select button. The toolbar reads Select Items, and the buttons there change.

3. Tap to select the photos you'll soon be sending.

4. Tap the Share button.

5. Choose Mail from the popover that appears (9.12). If you don't see Mail, select fewer photos. The photos become part of an outgoing message.

6. Fill in the To and Subject lines, set an image size (which applies to all of the photos), and then tap the Send button.

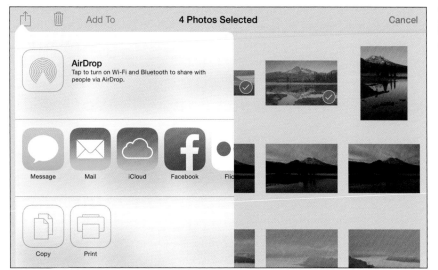

9.12 Mark multiple photos and attach them to one outgoing message.

▶ **TIP** One advantage to email is that it can act as a workaround when other uploading options fail. My Flickr account, for example, gives me a personal email address. Any image attachment I send to that address is added to my photo stream, which uses the contents of the Subject field as the photo's title and the text in the body of the message as the description. Check your favorite service for a similar option.

> ▶ **TIP** One way to circumvent email but deliver a photo to a specific person is to use MMS (Multimedia Messaging Service) or iMessage instant messaging. In the Messages app, tap the camera icon to the left of the text field, locate your image, optionally write a note, and tap the Send button.

Share Photos Using Adobe Revel

As you've no doubt discovered, many photo-sharing services vie for your attention and image libraries. Adobe, digital imaging powerhouse that it is, jumped in with Adobe Revel, which works on iOS devices and in the Revel app for the Mac.

Revel offers a very cool feature that soothes a photography pain point. You can share a library of photos with other people. They can rate the photos, and even use the software's editing tools, without stepping on your versions of the images. So, when I come back from vacation and my wife wants to look through my library and pick out her favorites, I can create a new library for her to browse on her computer or iOS device. I can see her picks in my library, but they don't overwrite mine.

Import Photos to a Revel Library

After you install the app and log in with your Adobe ID (or create a new ID if you don't currently have one), a new library is created. Do the following:

1. Tap the Add button to import photos. The contents of your Camera Roll appear. Tap the Albums button to view a different set of photos.

2. Tap to select the photos you wish to import.

3. Tap Add to Library to begin importing the photos. Revel also uploads the images to Adobe's servers for backup and for syncing to other devices on which you install the software (9.13).

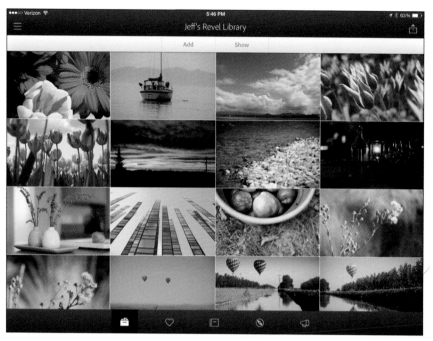

9.13 A library of photos in Adobe Revel

Rate and Edit Photos

When I say "rate" in regard to Revel, what I really mean is to mark a photo as a favorite; there are no multiple-star rankings. Instead, tap a photo to open it, and then tap the heart button in the lower-left corner of the screen.

To edit photos, tap the Edit button (which looks like a +/– icon) and use the controls in the toolbar to apply preset looks, adjust color and tone, fix red-eye, or crop and rotate the image. (See Chapter 6 for more detail on these types of tools, though I don't cover Revel specifically there.)

Collaborate with Others

Here's where I find Revel the most interesting. From within Revel, you can share a library with someone else who has an Adobe ID, even if they don't subscribe to Revel. Here's how:

1. Tap the hamburger icon (the three stacked horizontal lines; yes, that's the accepted generic term for that interface item).

2. Tap the Info button to the right of the library you intend to share.

3. In the Sharing With section, tap the Invite Users button (9.14). (You can share a library with up to five people.)

4. Type the email address of the person who will share the library, and then tap Add.

5. Tap Invite at the top of the popover to send an invitation.

9.14 Share the library with someone else.

When the other person installs the Revel software and signs in, they're asked if they want to join your library. After they do, the same rating and editing features are available. Images are updated nearly in real time, so when they mark a photo as a favorite, the change appears in the Activity screen (9.15).

And because Revel also works on the Mac, when I get back to my computer, the files are already present in the desktop version of Revel. They reflect the ratings and edits made while reviewing.

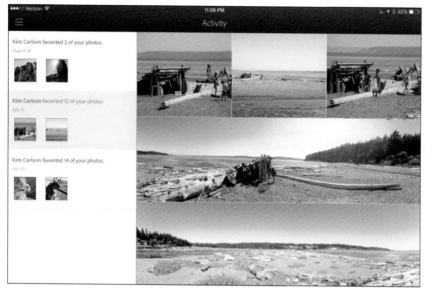

9.15 See which photos another reviewer has marked as favorites.

Print Photos from the iPad

When you think of printing from the iPad, you probably envision making a paper copy of an airline boarding pass or a text-only page of notes. Or, your first thought may be, "The iPad can print?" The options for taking content from the iPad and putting it on paper are still relatively slim; a few Wi-Fi–enabled printers support Apple's AirPrint technology, for example. However, photos originated in the print world, and it is possible to transfer your images into ink-on-paper reproductions.

▶ **NOTE** Keep in mind that the iPad doesn't offer color management, so I wouldn't rely on it for professional output. Run your photos through a color-managed desktop workflow for the best results for clients, gallery shows, and the like.

Print from Nearly Any App

Since it's not possible to plug a printer into an iPad, any printing you do must occur wirelessly. If you own an AirPrint-compatible device, that's no problem: Tap the Share button in the Photos app, tap the Print button, and configure any printer-specific options.

If you own a perfectly good printer that doesn't support AirPrint, it's still possible to make it work. Using a utility called Printopia under OS X, any printer on the network that's accessible by your Mac is available (9.16). In fact, Printopia can also "print" to your Dropbox account, to folders on your computer, or directly to applications (9.17). Under Windows, check out Collobos Software's Presto utility, which does the same thing.

The major printer manufacturers, like Epson, Lexmark, and HP, also offer free printing utilities for iOS that take advantage of their devices' features. (Make sure to check compatibility with your printer.)

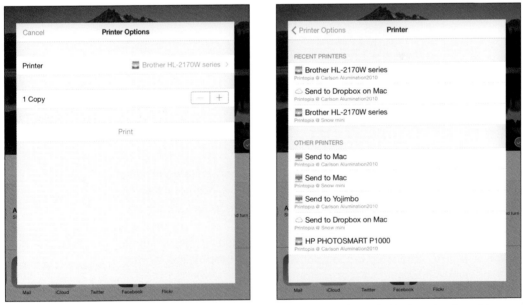

9.16 Choose a printer and the number of copies, and hit Print.

9.17 Printopia prints to destinations other than printers.

Order Prints

A few companies are getting wise to the fact that some people use their iOS devices more than computers (or own just iPads), so they're developing apps that send images directly to print vendors. The app for the drugstore Walgreens, for example, lets you upload photos and then order prints or cards that you can pick up at the closest location.

The app Photogene Books builds photo books and works with Walgreens to print hardbound books that can be picked up the same day they're ordered (9.18). iPhoto also offers the ability to assemble and print photo books.

Other fun apps include PopBooth Photo Booth, which takes photo booth–style snapshots and gives you the option of ordering a physical photo strip, and Sincerely's Ink Cards, which makes greeting cards from templates and your photos.

▶ **NOTE** If you're looking to order a print that's of higher quality than a snapshot from the iPad, a combination of an app and the Web might be the way to go. At the Web site Zenfolio (zenfolio.com), you can use the service Mpix.com to create and distribute prints. From my storefront (jeffcarlson.zenfolio.com), I can upload photos and then access the site in Safari to place an order.

9.18 Building a photo book in Photogene Books

http://...
https://it...

Chapter 8: B...

Portfolio for iPad (Britton...
http://ipadportfolioapp.com/
http://itunes.apple.com/us/app/portfolio-for...

Chapter 9: Share Photos

500px (500px), Free
http://500px.com/ipad
http://itunes.apple.com/us/app/500p...

Adobe Lightroom mobile (...
http://www.adobe.com/
https://itunes.apple.com/us/ar...
* Adobe Creative Cloud sub...

App Reference

I knew there would be a lot of iPad apps mentioned in this book when I started, but I didn't want to pepper every paragraph with an app name, the price, and a lengthy link to the iTunes Store. Instead, this handy reference breaks down all the apps mentioned throughout each chapter, organized alphabetically, so you can find and investigate the apps easily. Where possible, I've included links to developers' Web sites, which often feature videos of the apps in action and more detail than what appears at the iTunes Store.

The iTunes Store links are regular Web addresses: Plug them into your favorite Web browser, which will redirect you to the product's page in iTunes. (Note that prices are current as of press time but may change by the time you read this.)

Chapter 1: Capture Photos with the iPad

AutoStitch Panorama for iPad (Cloudburst Research), $2.99
http://www.cloudburstresearch.com/
https://itunes.apple.com/us/app/autostitch-panorama-for-ipad/
id586682453

Blux Camera for iPad (Blux Touch), $0.99
http://bluxtouch.com/camera/
https://itunes.apple.com/us/app/blux-camera-for-ipad/id573827039

Camera+ for iPad (tap tap tap), $4.99
http://campl.us/
http://itunes.apple.com/us/app/id550902799

Slow Shutter Cam (Cogitap), $0.99
http://www.cogitap.com/slowshutter/instructions.htm
https://itunes.apple.com/us/app/slow-shutter-cam/id357404131

TrueHDR (Pictional LLC), $1.99
http://www.pictional.com/TrueHDR/
https://itunes.apple.com/us/app/true-hdr/id340741871

Chapter 3: The iPad on Location

CamRanger (CamRanger), Free
http://www.camranger/
https://itunes.apple.com/us/app/camranger-wireless-dslr-camera/id552765874

Dark Sky (The Dark Sky Company), $3.99
http://www.darkskyapp.com
https://itunes.apple.com/us/app/dark-sky-weather-radar-hyperlocal/
id517329357

Dropbox (Dropbox), Free
http://www.dropbox.com
http://itunes.apple.com/us/app/dropbox/id327630330

Easy Release (ApplicationGap), $9.99

http://www.applicationgap.com/
https://itunes.apple.com/app/easy-release-model-release/id360835268

Flickr (Yahoo), Free

http://mobile.yahoo.com/flickr/iphone
http://itunes.apple.com/us/app/flickr/id328407587

GarageBand (Apple), Free

http://www.apple.com/apps/garageband/
http://itunes.apple.com/us/app/garageband/id408709785

GeoSnitch (2ndNature), $1.99

http://www.shuttersnitch.com/geosnitch/
https://itunes.apple.com/us/app/geosnitch/id509857234

Geotag Photos Pro (TappyTaps), $3.99

http://www.geotagphotos.net/
http://itunes.apple.com/us/app/geotag-photos-pro/id355503746

Google Plus (Google), Free

http://plus.google.com/
https://itunes.apple.com/us/app/google+/id447119634

HyperDrive Colorspace UDMA 2 (Hyper), From $249

http://www.hypershop.com/HyperDrive/UDMA-2/

iMovie for iOS (Apple), $4.99

http://www.apple.com/ipad/from-the-app-store/apps-by-apple/imovie.html
http://itunes.apple.com/us/app/imovie/id377298193

Kingston MobileLite (Kingston), Free

https://www.kingston.com
https://itunes.apple.com/us/app/kingston-mobilelite/id628221903

Microsoft OneDrive (Microsoft), Free

https://www.microsoft.com
https://itunes.apple.com/us/app/onedrive-formerly-skydrive/id477537958

Picturelife (Picturelife, Inc.), Free

https://picturelife.com
https://itunes.apple.com/us/app/picturelife-cloud-backup-for/id487233339

Pin Drop (Caffeinehit, Ltd.), Free

http://www.pindropapp.com
https://itunes.apple.com/gb/app/pin-drop/id425356789

PhotoSync (touchbyte GmbH), $2.99

http://www.photosync-app.com/
http://itunes.apple.com/us/app/photosync-wirelessly-transfers/id415850124

Rego (Makalu Interactive), $4.99

http://www.regoapp.com
https://itunes.apple.com/app/id603544163

Seagate Media (Seagate Technology), Free

http://www.seagate.com/external-hard-drives/
https://itunes.apple.com/us/app/seagate-media/id431912202

ShutterSnitch (2ndNature), $19.99

http://www.shuttersnitch.com/
http://itunes.apple.com/us/app/shuttersnitch/id364176211

Skype for iPad (Skype), Free

http://www.skype.com/
http://itunes.apple.com/us/app/skype-for-ipad/id442012681

TPE—The Photographer's Ephemeris (Crookneck Consulting), $8.99

http://photoephemeris.com
https://itunes.apple.com/us/app/the-photographers-ephemeris/id366195670

Chapter 4: The iPad in the Studio

Adobe Nav for Photoshop (Adobe), $1.99

http://www.photoshop.com/products/mobile/nav

http://itunes.apple.com/us/app/adobe-nav-for-photoshop/id426614130

Air Display (Avatron Software), $9.99

http://avatron.com/apps

https://itunes.apple.com/us/app/air-display-2/id705578162

Blux Camera for iPad (Blux touch), $0.99

http://bluxtouch.com/camera/

https://itunes.apple.com/us/app/blux-camera-for-ipad/id573827039

Blux Lens (Blux Touch), $0.99

http://bluxtouch.com/camera/lens.html

https://itunes.apple.com/us/app/blux-lens/id598230244

CamRanger (CamRanger), Free

http://www.camranger/

https://itunes.apple.com/us/app/camranger-wireless-dslr-camera/id552765874

Capture Pilot HD (Phase One), Free*

http://www.phaseone.com/capturepilot

http://itunes.apple.com/us/app/capture-pilot/id404906435

Capture Pilot requires Phase One's $299 Capture One Pro software.

FujiFilm Camera Remote (Fuji), Free

http://fujifilmusa.com

https://itunes.apple.com/us/app/fujifilm-camera-remote/id793063045

iUSBportCamera (Sanho), Free

http://www.hypershop.com/HyperDrive-iUSBportCAMERA-p/iusb-cam.htm

https://itunes.apple.com/us/app/iusbcam/id675508754

iStopMotion for iPad (Boinx Software), $9.99

http://boinx.com/istopmotion/ipad/
http://itunes.apple.com/us/app/istopmotion-for-ipad/id484019696

iStopMotion Remote Camera (Boinx Software), Free

http://boinx.com/istopmotion/ipad/
http://itunes.apple.com/us/app/istopmotion-remote-camera/id484024876

Triggertrap (Triggertrap), Free

http://www.triggertrap.com/
https://itunes.apple.com/us/app/triggertrap/id517679831

Chapter 5: Rate and Tag Photos

Adobe Lightroom mobile (Adobe), Free*

http://www.adobe.com/
https://itunes.apple.com/us/app/adobe-lightroom/id804177739
* Adobe Creative Cloud subscription required after demo period.

Photogene for iPad (Mobile Pond), $2.99

http://www.mobile-pond.com/mobile-pond/products.html
http://itunes.apple.com/us/app/photogene-for-ipad/id363448251

PhotoScope (David Ritchie), $4.99

http://photoscopeapp.com
https://itunes.apple.com/us/app/photoscope/id776186713?mt=8

Photosmith (C² Enterprises), $19.99

http://www.photosmithapp.com/
http://itunes.apple.com/us/app/photosmith/id427757668

PhotosInfoPro (Dmitri Toropov), $4.99

http://www.photosinfopro.com/
https://itunes.apple.com/app/photosinfo-pro/id435368159

Chapter 6: Edit Photos on the iPad

Adobe Lightroom mobile (Adobe), Free*
http://www.adobe.com/
https://itunes.apple.com/us/app/adobe-lightroom/id804177739
Adobe Creative Cloud subscription required after demo period.

iPhoto (Apple), $4.99
http://www.apple.com/ios/iphoto/
https://itunes.apple.com/us/app/iphoto/id497786065

Photogene for iPad (Mobile Pond), $2.99
http://www.mobile-pond.com/mobile-pond/products.html
http://itunes.apple.com/us/app/photogene-for-ipad/id363448251

PhotoRaw (Alexander McGuffog), $9.99
http://sites.google.com/site/iphotoraw/
http://itunes.apple.com/us/app/photoraw/id413899112

PhotoRaw Lite (Alexander McGuffog), Free
http://sites.google.com/site/iphotoraw/
https://itunes.apple.com/us/app/photoraw-lite/id423201178

piRAWnha (Cypress Innovations), $9.99
http://pirawnha.com/
http://itunes.apple.com/us/app/pirawnha/id409747795

Snapseed (Google), Free
http://www.snapseed.com/
https://itunes.apple.com/us/app/snapseed/id439438619

Handy Photo (Adva Soft), $1.99
http://adva-soft.com/products/handy-photo/
https://itunes.apple.com/app/handy-photo/id598565205

Chapter 7: Edit Video on the iPad

iMovie for iOS (Apple), $4.99

http://www.apple.com/ios/imovie/

http://itunes.apple.com/us/app/imovie/id377298193

Pinnacle Studio (Corel), $12.99

http://www.pinnaclesys.com/

https://itunes.apple.com/us/app/pinnacle-studio/id552100086

Chapter 8: Build an iPad Portfolio

Portfolio for iPad (Britton Mobile Development), $12.99

http://ipadportfolioapp.com/

http://itunes.apple.com/us/app/portfolio-for-ipad/id384210950

Chapter 9: Share Photos

500px (500px), Free

http://500px.com/ipad

http://itunes.apple.com/us/app/500px/id471965292

Adobe Lightroom mobile (Adobe), Free*

http://www.adobe.com/

https://itunes.apple.com/us/app/adobe-lightroom/id804177739

** Adobe Creative Cloud subscription required after demo period.*

Adobe Revel (Adobe), Free*

http://www.adobe.com/go/revel_learnmore

http://itunes.apple.com/us/app/adobe-revel/id455066445

** Monthly subscription required after demo period.*

Camera Awesome (SmugMug), Free

http://www.awesomize.com/

https://itunes.apple.com/us/app/camera-awesome/id420744028?mt=8

Presto (Collobos Software), $19.95/year
http://www.collobos.com

Flickr (Yahoo), Free
http://mobile.yahoo.com/flickr/iphone
http://itunes.apple.com/us/app/flickr/id328407587

FlickStackr for Flickr (iPont), $1.99
http://ipont.ca/ip/flickstackr/
https://itunes.apple.com/us/app/flickstackr-for-flickr/id364895358

Ink Cards (Sincerely, Inc.), Free
http://www.sincerely.com/ink
http://itunes.apple.com/us/app/sincerely-ink-cards-create/id477296657

Photogene Books (Mobile Pond), Free
http://mobile-pond.com/PhotogeneBooks/
https://itunes.apple.com/us/app/photogene-books/id824730600

Photogene for iPad (Mobile Pond), $2.99
http://www.mobile-pond.com/mobile-pond/products.html
http://itunes.apple.com/us/app/photogene-for-ipad/id363448251

PhotoStackr for 500px (iPont), $0.99
http://ipont.ca/
http://itunes.apple.com/us/app/photostackr-for-500px/id468659684

PopBooth Photo Booth (Sincerely, Inc.), $0.99
http://popbooth.com/
http://itunes.apple.com/us/app/popbooth-photo-booth/id432092216

Printopia (Ecamm), $19.95
http://www.ecamm.com/mac/printopia/

SmugMug (SmugMug), Free
http://www.smugmug.com/ipad
http://itunes.apple.com/us/app/smugmug/id364894061

Snapseed (Google), Free

http://www.snapseed.com/
https://itunes.apple.com/us/app/snapseed/id439438619

Walgreens for iPad (Walgreen Co.), Free

http://www.walgreens.com
https://itunes.apple.com/us/app/walgreens-for-ipad/id430444027

INDEX

360p resolution, 154
500px app, 188, 206
540p resolution, 154
720p resolution, 154
1080p resolution, 154

A

Adobe Creative Cloud, xvi
Adobe Lightroom mobile. *See*
 Lightroom mobile
Adobe Lightroom mobile: Your
 Lightroom on the Go, 119
Adobe Nav app, 59, 203
Adobe Photoshop. *See* Photoshop
Adobe Photoshop Elements. *See*
 Photoshop Elements
Adobe Photoshop Lightroom. *See*
 Photoshop Lightroom
Adobe Revel app, 192–195, 206
AE/AF Lock indicator, 4
Air Display app, 59, 203
AirDrop, 137, 154
AirPlay, 150, 179
AirPrint technology, 195
albums
 adding photos to, 39
 All Imported, 27, 81
 creating, 39, 167
 Facebook, 183
 Flickr, 187
 Imported Photos & Videos, 27
 Last Import, 27, 41, 81
 naming, 39
 Photo Stream, 39, 186
 Snapseed, 182–183
 viewing photos in, 146
Aperture
 exporting photos from, 162–163
 Import GPS feature, 36
 PhotoScope app, 93
 reviewing/rating photos, 93
app reference, 199–208
App Store, 167
Apple Aperture. *See* Aperture

Apple Fairplay DRM scheme, 150
Apple iPhoto. *See* iPhoto
Apple iTunes Match service, 150
Apple TV, 150, 179
apps
 500px, 188, 206
 Adobe Nav, 59, 203
 Adobe Revel, 192–195, 206
 advanced, 5–9
 Air Display, 203
 AutoStitch Panorama for iPad, 9, 200
 Blux Camera for iPad, 7, 53, 200, 203
 Blux Lens, 53, 203
 Box, 171, 200
 Camera, 4–5
 Camera Awesome, 188, 206
 Camera+ for iPad, 6–7, 200
 Camera Remote, 53
 CamRanger, 46–51, 200, 203
 Capture Pilot HD, 46, 203
 Carousel, 40
 Dark Sky, 22, 200
 Dropbox. *See* Dropbox
 Easy Release, 23, 201
 Flickr, 201
 FlickStackr, 187, 207
 FujiFilm Camera Remote, 53, 203
 GarageBand, 28, 201
 GeoSnitch, 34, 35–36, 201
 Geotag Photos Pro, 34–35, 201
 Google Plus, 40, 41, 201
 Handy Photo, 129–130, 205
 HyperDrive Colorspace UDMA 2, 201
 image pixel size and, 160
 iMovie. *See* iMovie for iOS
 Ink Cards, 197, 207
 iStopMotion for iPad, 54–56, 204
 iStopMotion Remote Camera, 54, 204
 iUSBportCamera, 204
 Kingston MobileLite, 201
 Lightroom. *See* Lightroom mobile
 Loom, 40
 Messages, 192
 Microsoft OneDrive, 201
 Music, 150
 Phase One, 46
 photo editing, 7, 182–185
 photo service, 187–188

apps, *continued*
 Photogene. *See* Photogene app
 Photogene Books, 207
 PhotoRaw, 127, 205
 PhotoRaw Lite, 205
 Photos. *See* Photos app
 PhotoScope, xvi, 93, 204
 PhotosInfoPro, 81–84, 204
 Photosmith. *See* Photosmith app
 PhotoStackr 500px, 188, 207
 PhotoSync, 33, 202
 Picturelife, 202
 Pin Drop, 23, 202
 Pinnacle Studio, 134, 206
 piRAWnha, 96, 127, 205
 PlainText, 202
 PopBooth Photo Booth, 197, 207
 Portfolio for iPad. *See* Portfolio
 for iPad app
 Portfolio Loader, 169
 printing from, 195–197
 Rego, 202
 remote photo, 46–53
 Seagate Media, 202
 ShutterSnitch, 31–33, 35, 36, 63, 202
 Sincerely Ink, 197
 Skype for iPad, 28, 202
 SlowShutter, 7
 SmugMug, 188, 207
 SmugShot, 188
 Snapseed. *See* Snapseed app
 SoftBox Pro, 202
 Stuck On Earth, 22
 for studio use, 45–59
 SugarSync, 202
 Triggertrap, 52, 204
 TrueHDR, 8, 200
 Walgreens for iPad, 197, 208
 weather-related, 22, 200
Artistic effects, 117
aspect ratio, 97, 113, 119
audio
 adjusting volume, 148
 background music, 148, 149–150
 fading, 150
 in movies, 148–152
 moving clips forward/backward, 151
 recording in iMovie, 151

sound effects, 118, 148, 151
 sounds while editing, 118
 voiceovers, 152
audio clips, 148–151
audio tracks, 149, 152
Auto-Lock setting, iPad, 33
AutoStitch Panorama for iPad, 9, 200
Avatron Air Display, 59

B

background music, 148, 149–150
backups
 dedicated storage devices, 42
 to Dropbox, 38, 40, 41
 to hard disks, 42–43
 to iCloud Photo Stream, 38–39
 importance of, 38
 to Kingston MobileLite Wireless, 43
 on memory cards, 36
 online services for, 40–41
 overview, 36–38
 portable storage for, 42–43
 to Seagate Wireless Plus, 42–43
 wireless connections and, 38
batch-processing images, 164–165
Beam button, 118
black levels, 105
black values, 122
black and white effects, 118, 125
black and white photos, 118, 125
Blux Camera for iPad app, 7, 53, 200, 203
Blux Lens app, 53, 203
Box app, 171, 200
Box service, 169
bracketing, 50–51
brightness
 adjusting in iPhoto, 114–115
 adjusting in Lightroom mobile, 122
 adjusting in Photogene, 105–107
 adjusting in Snapseed, 102
Brightness setting, iPad, 102
brush tools
 Handy Photo, 130
 iPhoto, 116–117
 Photogene, 109
Brushes and Effects tools, 116–117
Burst mode, 7

C

cables
 component, 176
 considerations, 30, 46
 display, 176
 HDMI, 176
 iPhone sync, 29
 USB, 25
 VGA, 176
Camera app, 4–5
Camera Awesome app, 188, 206
Camera Connection Kit
 connecting microphone/
 headset, 28, 152
 importing photos with, 24–29
 importing video with, 137
Camera+ for iPad, 6–7, 200
Camera Remote app, 53
Camera Roll
 adding photos to collections, 90
 automatic photo uploads, 40–41
 considerations, 4, 41
 Dropbox uploads, 40
 iCloud uploads, 38
 Lightroom mobile and, 90
 moving clips to, 137
 Photo Stream, 38
 Photo Stream uploads, 186
 sharing iMovie projects to, 154
camera sensors, 105
Camera Switch button, 4, 5
cameras
 controlling from iPad/iPhone, 46–53
 importing photos from, 25–28
 iPhone vs. iPad, 118
 tethered, 46, 57–58
 wireless, 30, 53
CamRanger app, 46–51, 200, 203
CamRanger device, 46
Capture Pilot HD app, 46, 203
capturing video, 4, 137
card readers, 43
Carousel app, 40
CF (CompactFlash) card readers, 28
clarity, 123
Clip Settings window, 148
clipping, 122, 124

clips. *See* audio clips; video clips
cloud services, 40–41
 automatic photo uploads, 40–41
 for backups, 40–41
 Dropbox. *See* Dropbox
 Flickr, 22, 40, 187, 191, 201
 Google Plus, 40, 41, 201
 iCloud. *See* iCloud
 manual photo uploads, 41
 Microsoft OneDrive, 40, 201
 overview, 40
 Picturelife, 40, 202
CNN iReport, 153
collections, 73, 77, 88–91
color
 adjusting, 96
 adjusting in iPhoto, 115–116
 adjusting in Lightroom mobile, 121–124
 adjusting in Snapseed, 100–103
 in portfolios, 160
 saturation, 96, 108, 115, 124, 160
 vibrance, 96, 108, 124
color cast, 108
color management, 98, 160, 195
color temperature, 96, 108, 109, 116,
 121–122
CompactFlash (CF) card readers, 28
component cables, 176
compression, 14, 183
contrast
 adjusting in iPhoto, 114–115
 adjusting in Lightroom mobile, 123
 adjusting in Photogene, 105–107
 adjusting in Snapseed, 102
cropping photos
 considerations, 96, 160
 in iPhoto, 113
 in Lightroom mobile, 119, 120
 in Photogene, 104
 in Photos app, 97
 in Snapseed, 99

D

Dark Sky app, 22, 200
dedicated storage devices, 42
deleting collections, 91
deleting photos, 80, 91

iMovie for iOS, *continued*
 obtaining, 201, 205
 opening project browser, 134
 playhead, 135, 138
 playing video, 138, 153
 previewing video, 137
 skimming video, 138
 timeline, 135, 136–140, 152
 Viewer, 135, 138
iMovie projects. *See also* movies;
 video clips
 adding background
 music, 148, 149–150
 adding clips from Media
 Library, 136–137
 adding photos to, 145–147
 adding titles, 142–143, 153
 adding video to, 136–137
 adding voiceovers, 152
 applying fade in/out, 135
 audio in. *See* audio; audio clips
 capturing video directly, 137
 choosing themes for, 134
 creating, 134
 editing. *See* video editing
 exporting to iTunes, 154–155
 getting information about, 134
 importing video from iPhone/
 iPod touch, 136, 137
 Ken Burns effect, 146–147
 location data, 144–145
 opening existing, 134
 playing, 138, 153
 resolution, 154
 reversing actions, 145
 sending to devices via iTunes, 154–155
 sharing options, 153–155
 skimming, 138
 theme music, 149
 transitions, 140, 141, 142
 using Precision Editor, 141
 working with timeline, 135,
 136–140, 152
importing photos
 from camera, 25–28
 considerations, 30
 Direct Mode, 31
 with iPad Camera Connection
 Kit, 24–29

 from iPhone, 29
 from memory card, 25–28
 from other iOS device, 33
 with PhotosInfoPro, 81
 with Photosmith, 62–63
 to Revel library, 192–193
 with ShutterSnitch, 31–33, 63
 wirelessly, 30–33
importing video, 136, 137
Ink Cards app, 197, 207
International Press Telecommunications
 Council. *See* IPTC
intervalometer, 51
iOS 7, xvi
iOS devices. *See also specific devices*
 controlling, 53
 importing video from, 136
 Photo Stream, 38–39, 186
 as remote camera, 54
 screenshots captured, 38
 sharing iMovie projects with, 154–155
iPad. *See also* iOS devices
 audio, 118
 Auto-Lock setting, 33
 camera, 118
 capabilities of, xiii
 cases/stands, 57–59
 cellular vs. Wi-Fi, xv
 considerations, xiii–xiv, 3
 controlling DSLR cameras from, 46–53
 controlling iOS devices from, 53
 deleting photos from, 80
 as external monitor, 59
 HDR mode, 8
 on location, xiii–xiv, 21–43
 memory, xiii–xiv, 42, 175
 models, xiv–xv, xvii
 mounting, 57–59
 new/changed features, xv–xvi
 photo capacity, 80
 printing photos from, 195–197
 resolution, 160
 Retina display, xiii, xv
 size/weight, xv
 using in studio, 45–59
 workflow, 11–19
iPad 2, 3, 144
iPad adapters, 176
iPad Air, xv

iPad camera. *See* cameras
iPad Camera Connection Kit
 connecting microphone/
 headset, 28, 152
 importing photos with, 24–29
 importing video with, 137
iPad for Photographers community, xvii
iPad mini
 considerations, xv, xvii, 3, 77
 Lightning adapters, 24
 on location, 21, 24
 for portfolios, 159
iPad Pocket Guide, xvii
iPad portfolio. *See* portfolios
ipadforphotographers.com, xvii
iPhone. *See also* iOS devices
 controlling DSLR cameras from, 46–53
 importing photos from, 29
 importing video from, 136, 137
 location data, 23
 panorama feature, 9
iPhone camera, 118
iPhone sync cable, 29
iPhoto, 111–118. *See also* Photo
 Library
 adjusting color, 115–116
 adjusting exposure, 114–115
 adjusting specific areas, 116–117
 brightness adjustment, 114–115
 Brushes and Effects tools, 116–117
 considerations, 111
 contrast adjustment, 114–115
 creative effects, 117–118
 cropping photos, 113
 exporting images from, 166–167
 image editing in, 111–118
 obtaining, 205
 recomposing photos, 112–113
 Revert, 111
 Show Original, 111
 showing/hiding thumbnails, 112
 straightening photos, 112–113
 tone adjustment, 114, 116
iPod touch. *See also* iOS devices
 controlling DSLR cameras from, 46–53
 importing video from, 136
IPTC fields, 68, 87

IPTC information, 86–87
IPTC sets, 86–87
ISO setting, 32
iStopMotion for iPad app, 54–56, 204
iStopMotion Remote
 Camera app, 54, 204
iTunes
 accessing music library, 149, 150
 file sharing, 170, 171
 loading images into gallery, 170, 171
 sharing iMovie projects via, 154–155
iTunes Match service, 150
iUSBportCamera, 46, 204

J

JPEG compression, 14
JPEG files, xiv, 12–14, 18, 84, 127
JPEG format
 capturing photos in, 13–14
 considerations, xiv, 12, 14, 96
 pros/cons, 14
 proxy JPEG workflow, 80
 vs. raw format, 12–19
JPEG previews, 14, 16, 96, 127

K

Ken Burns effect, 146–147
keyboards, 28
keyword hierarchies, 67
keywords
 assigning with PhotosInfoPro, 82, 83
 assigning with Photosmith, 66–67
 considerations, 61, 62, 66
 Lightroom and, 61, 76–77
 metadata presets and, 69
 removing, 67, 82
 syncing, 76–77
Kingston MobileLite app, 201
Kingston MobileLite Wireless device, 43

L

LePage, Rick, 23
Lightning to USB Camera Connector, 137
Lightning adapters, 24

Lightroom mobile
 adding photos to collection, 90
 adjusting clarity, 123
 adjusting color, 121–124
 adjusting contrast, 123
 adjusting exposure, 122–123
 adjusting saturation, 124
 applying previous edits, 125
 color temperature, 121–122
 considerations, xvi, 119
 creating/syncing collections, 88–89
 cropping photos, 119, 120
 Develop controls/settings, 76, 121,
 124, 125–126
 flagging photos as picks/rejects, 92
 histogram, 124
 image editing in, 119–126
 metadata and, 76, 92
 navigating photos, 91
 obtaining, 204, 205, 206
 offline editing, 126
 portfolio display, 167
 presets, 125
 recomposing photos, 119–126
 removing collections from, 91
 removing photos from collection, 91
 reset adjustments, 126
 rotating photos, 119
 sharing to Web from, 184
 straightening photos, 119
 synchronizing photos, 88–89, 120
 tint adjustments, 121–122
 tone adjustment, 121–124
 white balance, 121–122
Lightroom program. See Photoshop
 Lightroom
Live View option, 49–50
location data, 22–23, 34–36
location releases, 23
locations, photo, 22–23, 34–36
Lock button, 176
logo screen/page, 174, 178
Loom app, 40
lossy compression, 14

M

Media Library
 adding clips from, 136–137
 interface, 135
 sound effects in, 151
 viewing photos in, 146
memory card adapter, 24–25
memory card readers, 28
memory cards
 for backups, 36
 capacity, 30
 considerations, xiii, xiv, 25–28
 deleting images from, 27
 Eyefi, 30–33, 63
 importing photos from, 25–28
 SD cards, 24–27
 wireless, 30–33
memory, iPad, xiii–xiv, 42, 175
Messages app, 192
metadata
 adding with PhotosInfoPro, 82–83
 editing, 68–69
 exporting, 84
 IPTC information, 68, 82, 86–87
 JPEG files and, 18
 Lightroom and, 76, 92
 in Photosmith, 68–69, 76
 presets, 68–69, 76
 raw files and, 14, 79–80
microphones, 28, 152
Microsoft OneDrive app, 201
Microsoft OneDrive service, 40, 201
midtones, 123
MMS (multimedia messaging
 service), 192
MobileLite Wireless, 43
model releases, 23
modes, 4, 5
monitors
 cables, 176
 color management, 98
 iPad as external monitor, 59
 presenting portfolio on, 176–179
movies. See also iMovie entries; video
 adding photos to, 145–147
 audio in. See audio; audio clips

background music in, 148, 149–150
choosing themes for, 134
editing. *See* video editing
fading in/out, 135
Ken Burns effect, 146–147
playing, 138
previewing, 137
sharing options, 153–155
skimming, 138
theme music, 149
titles, 142–143, 153
transitions, 140, 142
voiceovers, 152
Mpix.com, 197
multimedia messaging
 service (MMS), 192
Music app, 150
music, background, 148, 149–150

N

networks, wireless, 30, 38, 46, 179
New Collection button, 73
newsletter, xvii
notes, photos, 175

O

onscreen grid, 4
ordering prints, 197

P

paint effects, 116–117
panorama images, 4, 9, 200
passcode, 176
PDF files, 23
Phase One app, 46
photo editing apps, 7, 182–185
Photo Library. *See also* iPhoto
 Photogene and, 104
 Photosmith and, 62–63
 Snapseed and, 99
 viewing with Photos app, 189
photo locations, 22–23, 34–36
photo service apps, 187–188
photo sharing services, 182–188

photo shoots. *See* shooting photos
Photo Stream, 38–39, 186
Photogene app
 applying selective edits, 109–110
 Auto button, 106
 brightness adjustment, 105–107
 color adjustment, 105–109
 contrast adjustment, 105–107
 cropping photos, 104
 image editing in, 104–111
 obtaining, 204, 207
 presets, 110–111
 printing photos, 197
 rating photos, 85
 raw format and, 104
 recomposing photos, 104–105
 retouching photos, 128–129
 straightening photos, 104–105
 tone adjustment, 105–109
 uploading photos from, 183–184
 watermarks, 185
Photogene Books app, 207
Photogene for iPad app, 205
PhotoRaw app, 127, 205
PhotoRaw Lite app, 205
photos
 adding to movies, 145–147
 in albums. *See* albums
 backing up. *See* backups
 batch-processing, 164–165
 black and white, 118, 125
 capacity, 80
 capturing. *See* shooting photos
 collections, 73, 77, 88–91
 copying to Dropbox, 40–41, 78–79
 copying to hard drive, 42–43
 criteria, 71
 cropping. *See* cropping photos
 deleting from iPad, 80, 91
 deleting from Photo Stream, 39
 dimensions, 160
 displaying in Photos app, 25–26
 editing. *See* image editing
 emailing, 189–192, 194
 enhancing, 98
 exporting. *See* exporting photos
 filtering. *See* filtering photos
 flagging in Lightroom mobile, 92

photos, *continued*
 galleries. *See* galleries
 grouping. *See* grouping photos
 HDR, 4, 8, 50–51
 iCloud Photo Stream, 38–39, 186
 importing. *See* importing photos
 lining up with grid, 4, 5
 location data, 22–23
 metadata. *See* metadata
 notes, 175
 ordering prints, 197
 panorama, 4, 9, 200
 preparing for portfolio, 160–167
 printing from iPad, 195–197
 rating. *See* rating photos
 raw format. *See* raw images
 recomposing. *See* recomposing
 photos
 reference, 36
 rejected, 64, 70, 82, 92
 reviewing, 24–33
 rotating. *See* rotating photos
 screenshots, 38
 sharing. *See* sharing photos
 sharpening, 160, 162
 shooting. *See* shooting photos
 slideshows, 158, 167, 176
 straightening. *See* straightening
 photos
 time-lapse, 51, 52
 vignettes, 118
 watermarks, 185
 workflow, 11–19
 zooming in on, 96
Photos app
 considerations, 167
 cropping photos, 97
 displaying photos, 25–26
 image editing in, 97–98
 launching, 25
 sharing photos, 189–192
 straightening photos, 97
PhotoScope app, xvi, 93, 204
Photoshop, 163–165
 Adobe Nav app, 59
 batch-processing images, 164–165
 creating actions, 163–165
 exporting/processing images, 163–165

Photoshop Elements, 165–166
Photoshop Lightroom. *See also*
 Lightroom mobile
 exporting photos from, 161–162
 exporting to Photosmith, 78
 keywords and, 61, 67, 76–77
 publishing service, 74, 75, 77
 rating/tagging and, 61, 92
 syncing with Photosmith, 74–78
PhotosInfoPro app, xvi, 81–84, 204
Photosmith app
 assigning keywords, 66–67
 copying photos to, 78
 deleting photos, 80
 export options, 78–80
 as export target, 78
 filtering photos, 70–72
 importing photos from iPad, 62–63
 importing photos from
 ShutterSnitch, 63
 obtaining, 204
 photo collections, 73, 77
 PhotoCopy option, 80
 rating photos, 64–65
 rejected photos, 64, 70
 setting up, 74
 Smart Group feature, 71–72
 sorting photos, 71
 syncing keywords, 76–77
 syncing with Lightroom, 74–78
 transferring photos to Dropbox, 78–79
 XMP export, 79–80
Photosmith plug-in, 74, 75
Photosmith publish service, 74, 75, 77
photosmithapp.com, 74
PhotoStackr 500px, 188, 207
PhotoSync app, 33, 202
Picturelife app, 202
Picturelife service, 40, 202
Pin Drop app, 23, 202
Pinnacle Studio app, 134, 206
piRAWnha app, 96, 127, 205
pixels, blown, 105
PlainText app, 202
playhead, 135, 138
playing video, 138, 153
podcasting, 28
PopBooth Photo Booth app, 197, 207

portable storage. *See* hard disks
Portfolio for iPad app. *See also*
 portfolios
 creating portfolio, 167–174
 obtaining, 206
 opening screen, 174, 178
 photo notes, 175
 presenting portfolio, 175–179
Portfolio Loader app, 169
portfolios, 157–179. *See also*
 slideshows
 advantages of, 157
 color issues, 160
 considerations, 157, 167
 creating, 167–174
 galleries. *See* galleries
 iPad vs. iPad mini, 159
 Lightroom mobile, 167
 multiple, 159
 online, 159
 opening screen, 174, 178
 preparing images for, 160–167
 presenting, 175–179
 tips for, 158–159
 updating, 159
 wired connections, 176–178
 wireless connections, 179
Precision Editor, 141
presets
 image editing, 96, 103, 110–111
 iPhoto effects, 117–118
 Lightroom mobile, 125
 metadata, 68–69, 76
 Photogene app, 110–111
Presto (Collobos Software), 196, 207
previews
 JPEG, 14, 16, 96, 127
 Smart Previews, 120, 126
 video, 137
printing photos, 195–197
printing utilities, 195–197, 207
Printopia utility, 196, 207
prints, ordering, 197
projectors
 wired connections to, 176–178
 wireless connections to, 179
projects, iMovie. *See* iMovie projects
proxy JPEG workflow, 80

R

rating photos
 in Adobe Revel, 193
 considerations, 61, 62
 Lightroom and, 61, 92
 in Photogene, 85
 in PhotoScope, 93
 in PhotosInfoPro, 81–82
 in Photosmith, 64–65
 in Portfolio for iPad, 175
raw format
 capturing photos in, 14–16
 considerations, xiv, 12, 14, 16
 vs. JPEG format, 12–19
 Photogene and, 104
 pros/cons, 16
raw images
 considerations, 30, 62
 described, 12
 editing, 14–16, 96, 127
 geo-tagging and, 35
 metadata and, 14, 79–80
Raw+JPEG format
 capturing photos in, 16–19
 considerations, 12, 26, 96
 importing, 26
 pros/cons, 18
recomposing photos
 considerations, 96
 in iPhoto, 112–113
 with Lightroom mobile, 119–126
 in Photogene, 104–105
 in Snapseed, 99
record button, 4
recording video, 4, 137
red-eye correction, 98
reference materials, 23
reference photos, 36
Rego app, 23, 202
releases, model, 23
remote camera, 54–56
remote control devices, 46–53
remote photo apps, 46–53
resolution, 154, 160
Retina display, 160, 161
retouching photos, 96, 128–130
Revel, 192–195

"revisit" tags, 23
rotating photos
 in iPhoto, 112–113
 in Lightroom mobile, 119
 in Photogene, 104–105
 in Photos app, 98
 in Snapseed, 99

S

saturation, 96, 108, 115, 124, 160
screen. *See* monitors
screenshot capture, 38
SD card adapter, 24–25
SD cards, 24–27
Seagate Media app, 202
Seagate Wireless Plus disk, 42–43, 202
searches, Google, 22
sepia effects, 118
shadows, 105, 106, 115, 122
Share button, 118
Shared Photo Stream, 186
sharing items
 iMovie projects, 153–155
 via AirDrop, 137, 154
 video to Camera Roll, 137, 154
sharing photos, 181–197. *See also*
 uploading photos
 between devices, 118
 emailing photos, 189–192, 194
 photo sharing services, 182–188
 via Adobe Revel, 192–195
 via Box, 171
 via Dropbox, 168–171
 via iCloud Photo Stream, 186
 via iTunes, 170, 171
 via Lightroom mobile, 184
sharpening images, 160, 162
shooting photos
 with Camera app, 4–5
 with Camera+ for iPad, 6–7
 finding photo locations, 22
 preparing for, 22–23
 timer, 7
shooting video, 4
shutter button, 4, 5

shutter speed, 7
ShutterSnitch app, 31–33, 35, 36, 63, 202
Sincerely Ink Cards app, 197, 207
skin tones, 116
Skype for iPad app, 28, 202
slideshows, 158, 167, 176. *See also*
 portfolios
SlowShutter app, 7
Smart Group feature, 71–72
Smart Previews, 120, 126
SmugMug app, 188, 207
SmugShot app, 188
Snapseed app
 brightness adjustment, 102
 contrast adjustment, 102
 cropping photos, 99
 HDR Scape filter, 8
 image editing in, 99–103
 obtaining, 205, 208
 previewing edits, 100
 recomposing photos, 99
 uploading photos from, 182–183
SoftBox Pro app, 202
sorting photos, 71
sound. *See* audio
sound effects, 118, 148, 151
special effects. *See* effects
splitting clips, 140
stabilization, image, 6
stands, 57–59
star ratings. *See* rating photos
star trail effect, 7
stop-motion video, 54–55
store locations, 23
straightening photos
 in iPhoto, 112–113
 in Lightroom mobile, 119
 in Photogene, 104–105
 in Photos app, 97
 in Snapseed, 99
Stuck On Earth app, 22
studio, using iPad in, 45–59
The Stump, 58–59
SugarSync app, 202
sunrises, 22
sunsets, 22
sync cable, 29

T

tagging. *See* keywords
terminology, xvii
Tether Tools, 57–58
tethered cameras, 46, 57–58
The Photographer's Ephemeris (TPE), 22
theme music, 149
themes, movies, 134
thumbnails
 galleries, 173, 177
 showing/hiding in iPhoto, 112
 video, 140
time-lapse shots, 51, 52
time-lapse video, 54, 56
timeline, iMovie, 135, 136–140, 152
timer, 7, 51, 53, 56
tone
 adjusting in iPhoto, 114, 116
 adjusting in Lightroom
 mobile, 121–124
 adjusting in Photogene, 105–109
 adjusting in Snapseed, 100–103
 considerations, 96
Toshiba wireless memory cards, 30
TPE (The Photographer's Ephemeris), 22
Transcend wireless memory cards, 30
transitions, video, 140, 141, 142
Triggertrap app, 52, 204
Triggertrap Flash Adapter, 52
trimming clips, 139
TrueHDR app, 8, 200
TVs
 wired connections to, 176–178
 wireless connections to, 179
Twitter, 130, 182

U

uploading photos. *See also* exporting
 photos; sharing photos
 Camera Awesome, 188
 Dropbox, 38
 to from editing apps, 182–185
 Flickr, 187
 iCloud Photo Stream, 38–39, 186
 to photo sharing services, 182–185
 from Photogene, 183–184

PhotoStackr 500px, 188
 from Snapseed, 182–183
 via photo service apps, 187–188
USB adapter, 24–25, 28
USB cables, 25
USB headsets, 28, 152
USB keyboards, 28
USB microphones, 28, 152

V

VGA cables, 176
vibrance, 96, 108, 124
vibrance control, 96
video, 133–155. *See also iMovie*
 entries; movies
 adding clips from Media
 Library, 136–137
 adding to iMovie projects, 136–137
 audio in. *See* audio; audio clips
 capturing directly, 137
 editing. *See* video editing
 importing from iPhone/
 iPod touch, 136, 137
 playing, 138, 153
 previewing, 137
 recording, 4, 137
 resolution, 154
 sharing options, 153–155
 shooting, 4
 skimming, 138
 stop-motion, 54–55
 thumbnails, 140
 time-lapse, 54, 56
video clips. *See also* movies; video
 adding titles to, 142–143, 153
 deleting, 140–141
 editing, 139–142
 Ken Burns effect, 146–147
 from Media Library, 136–137
 moving on timeline, 139
 splitting, 140
 transitions between, 140, 141, 142
 trimming, 139
video editing, 138–145
 considerations, 133, 134
 deleting clips, 140–141
 editing audio clips, 148–152

video editing, *continued*
 moving clips, 139
 with Precision Editor, 141
 splitting clips, 140
 transitions, 140, 141, 142
 trimming clips, 139
video editors, 134
Video/Photo/Square option, 4
Viewer, 135, 138
vignettes, 118
Vimeo, 153
Vintage effects, 117
voiceovers, 152
volume, audio clips, 148

W

Walgreens for iPad app, 197, 208
Wallee Connect system, 57–58
watermarks, 185
weather, 22, 23
weather apps, 22, 200
website, companion to book, xvii
white balance
 adjusting in iPhoto, 116
 adjusting in Photogene, 108, 109
 considerations, 96
 Lightroom mobile, 121–122

white levels, 105
white values, 122
wired connections, 176–178
wireless cameras, 30, 53
wireless connections, 179
wireless keyboards, 28
wireless memory cards, 30–33
wireless networks, 30, 38, 46, 179
Wireless Plus disk, 42–43, 202
wireless printers, 195–196
wireless remote control devices, 46–53
workflow, 11–19

X

XMP export, 79–80
XMP files, 79–80

Y

YouTube, 153

Z

Zenfolio.com, 197